David Pogue's
Digital Photography
The Missing Manual

David Pogue's Digital Photography: The Missing Manual

BY DAVID POGUE

Published by O'Reilly Media, Inc., 1005 Gravenstein Highway North, Sebastopol, CA 95472.

O'Reilly books may be purchased for educational, business, or sales promotional use. Online editions are also available for most titles *(safari.oreilly.com)*. For more information, contact our corporate/institutional sales department: 800.998.9938 or *corporate@oreilly.com*.

Executive Editor: Laurie Petrycki

Copy Editor: Julie Van Keuren

Proofreaders: Julie Van Keuren, Diana D'Abruzzo

Indexer: David Pogue, David Pierce

Cover Designers: Steve Fehler and Phil Simpson

Interior Designer: Phil Simpson (based on a design by Ron Bilodeau)

Print History:

January 2009: First Edition.

ISBN-13: 978-0-596-15403-5

Contents

The Missing Credits

David Pogue (author, photographer, indexer) is the weekly tech columnist for the *New York Times*, an Emmy-winning correspondent for *CBS News Sunday Morning*, weekly CNBC contributor, and the creator of the Missing Manual series. He's the author or co-author of 49 books, including 24 in this series and six in the *"For Dummies"* line (including *Macs*, *Magic*, *Opera*, and *Classical Music*). In his other life, David is a former Broadway show conductor, a piano player, and a magician. He lives in Connecticut with his wife and three awesome children.

Links to his columns and weekly videos await at *www.davidpogue.com*. He welcomes feedback about his books by email at *david@pogueman.com*.

Julie Van Keuren (copy editor, proofreader) is a freelance editor, writer, and desktop publisher who runs her "little media empire" from her home in Billings, Montana. Before starting her own business in 2006, Julie edited for *The Virginian-Pilot* of Norfolk, Va.; *The Olympian* of Olympia, Wash.; and *The Seattle Times*. She was honored for her work by the Virginia Press Association in 2004 and 2005 and received the Pacific Northwest Excellence in Journalism Award in 1996. She holds a bachelor's degree in journalism from Northwestern University. Email: *little_media@yahoo.com*.

Tim Geaney (consultant, photo editor, photographer) has shot editorial photographs for magazines like *British Vogue, Harper's Bazaar, Glamour, GQ, Self,* and *InStyle,* and his commercial work appears in catalogs like Victoria's Secret,

Nautica, J.Crew, Spiegel, Krizia, Nordstroms, Burdines, Neiman Marcus, Talbots, Saks Fifth Avenue, and Polo Ralph Lauren. He's also done commercials for Avon, video and CD covers for Harry Connick Jr., Internet video for Polo, and music videos. He lives in Connecticut with his wife Nancy and their children Genevieve (20) and Jack (18). He loves playing the piano, golf, and eating Mexican food. He's currently represented by Ford Artists in New York.

Saurabh Wahi (technical reviewer) has been a photographer for over a decade, taking pictures in over 20 different countries. He's a public relations consultant at MWW Group, where he has represented Nikon since 2001. He has helped to launch dozens of Nikon's digital cameras, including every SLR since the introduction of D1x and D1H cameras in 2001. Saurabh lives in New York with his wife, Pooja. *www.saurabhwahi.com*

Acknowledgments

The Missing Manual series is a joint venture between the dream team introduced on these pages and O'Reilly Media. I'm grateful to all of them, especially designer Phil Simpson, who has now seen me through 24 books, and prose queen Julie Van Keuren, who answered my Craigslist ad for an InDesign expert with years of copy-editing and proofing experience—and did a spectacular job. Maybe someday I'll meet her.

A few other friends did great favors for this book. They include my un-stump-able intern David Pierce, who sought out answers, wrote a few bits for the book, and assisted me on the index; company reps Kevin McCarthy (Canon), Geoff Coalter (Nikon), Kyle Kappmeier (Samsung), MeeJin Annan-Brady (Panasonic), Betsy Brill (Lightscoop), and John Nack (Adobe); and Lesa Snider King.

Thanks to David Rogelberg for believing in the idea and Laurie Petrycki for the deadline extension. Above all, my love and appreciation go to Jennifer, Kelly, Tia, and Jeffrey. They make these books—and everything else—possible.

—David Pogue

The Missing Manual Series

Missing Manual books are superbly written guides to computer products that don't come with printed manuals (which is just about all of them). Each book features a handcrafted index; cross-references to specific page numbers (not just "See Chapter 14"); and RepKover, a detached-spine binding that lets the book lie perfectly flat without the assistance of weights or cinder blocks.

Recent and upcoming books include:

Access 2007: The Missing Manual by Matthew MacDonald

AppleScript: The Missing Manual by Adam Goldstein

AppleWorks 6: The Missing Manual by Jim Elferdink and David Reynolds

CSS: The Missing Manual by David Sawyer McFarland

Creating Web Sites: The Missing Manual by Matthew MacDonald

Dreamweaver CS4: The Missing Manual by David Sawyer McFarland

eBay: The Missing Manual by Nancy Conner

Excel 2007: The Missing Manual by Matthew MacDonald

Facebook: The Missing Manual by E.A. Vander Veer

FileMaker Pro 9: The Missing Manual by Geoff Coffey and Susan Prosser

Flash CS4: The Missing Manual by Chris Grover

FrontPage 2003: The Missing Manual by Jessica Mantaro

Google Apps: The Missing Manual by Nancy Conner

The Internet: The Missing Manual by David Pogue and J.D. Biersdorfer

iMovie '08 & iDVD: The Missing Manual by David Pogue

iPhone: The Missing Manual, 2nd Edition by David Pogue

iPhoto '08: The Missing Manual by David Pogue

iPod: The Missing Manual, 7th Edition by J.D. Biersdorfer

JavaScript: The Missing Manual by David Sawyer McFarland

Mac OS X Leopard: The Missing Manual by David Pogue

Microsoft Project 2007: The Missing Manual by Bonnie Biafore

Office 2007: The Missing Manual by Chris Grover, Matthew MacDonald, and E.A. Vander Veer

Office 2008 for Macintosh: The Missing Manual by Jim Elferdink

PCs: The Missing Manual by Andy Rathbone

Photoshop CS4: The Missing Manual by Lesa Snider King

Photoshop Elements 7: The Missing Manual by Barbara Brundage

Photoshop Elements 6 for Mac: The Missing Manual by Barbara Brundage

PowerPoint 2007: The Missing Manual by E.A. Vander Veer

QuickBase: The Missing Manual by Nancy Conner

QuickBooks 2009: The Missing Manual by Bonnie Biafore

Quicken 2009: The Missing Manual by Bonnie Biafore

Switching to the Mac: The Missing Manual, Tiger Edition by David Pogue and Adam Goldstein

Switching to the Mac: The Missing Manual, Leopard Edition by David Pogue

Wikipedia: The Missing Manual by John Broughton

Windows XP Home Edition: The Missing Manual, 2nd Edition by David Pogue

Windows XP Pro: The Missing Manual, 2nd Edition by David Pogue, Craig Zacker, and Linda Zacker

Windows Vista: The Missing Manual by David Pogue

Windows Vista for Starters: The Missing Manual by David Pogue

Word 2007: The Missing Manual by Chris Grover

Your Brain: The Missing Manual by Matthew MacDonald

Introduction

Digital photography is just about the only kind of photography left these days. At this point, 99 percent of all cameras sold are digital. Yes, it's taken awhile—the first consumer digital camera came out in 1994—but film photography has been reduced to a niche activity. No new film cameras are being designed, and very few companies still sell film.

It's easy to understand why digital has taken off.

- **The quality is there.** Practically nobody is still arguing that film photos look better than digital ones. The color, the tonal range, the resolution—it's all caught up with and even exceeded film.

- **It's free—and freeing.** When you shoot digitally, you don't pay a cent for film or photo processing. You can shoot dozens of variations of a shot, experimenting with angle, camera settings, lighting—and then throw away all but the winners.

 That's incredibly liberating. You'll become a much better photographer much faster, because you can experiment forever without spending any money.

- **Feedback is instantaneous.** You can examine a photo on the screen a second after taking it. If something bothers you—like the telephone pole growing out of your best friend's head—you can just delete it and try again.

 Digital photographers sleep much better at night. They never worry about how the day's pictures will turn out; they already know.

- **You can be your own darkroom tech.** Even an amateur can retouch and enhance photos, experiment with cropping and effects, and make prints and enlargements right at home.

- **People will *see* your pictures.** What's happened to most film photos taken by most people? Where are they at this moment? Probably still in their drugstore envelopes, stashed in attic boxes. Very few of them ever really saw the light of day.

 Digital photos are another story. You can blast them to your friends by email or post them on a Web page. You can turn them into screensavers or desktop pictures. You can watch them play all day on a digital picture frame. You can create gorgeous slideshows, with music and crossfades, that play on your computer or TV.

 And you can have them printed on just about anything with a surface: posters, mugs, towels, underwear, Christmas ornaments, mouse pads, U.S. postage stamps, blankets, and on and on.

But this is just rational stuff. Creative freedom, instant gratification, economy, and easy distribution—what people really love about all that is the *emotional* high it gives them. So many obstacles have been taken out of the way that there's almost nothing left standing between your vision and your audience. It's a *blast!*

All right, all right—down boy.

It turns out that this kind of talk really bugs veteran film photographers. Plenty of them resent all of this breathless digital-camera hype—or secretly fear it, thinking it might make all of their hard-won expertise obsolete.

The truth is, though, that veteran shutterbugs usually wind up becoming the best *digital* photographers. The basics of photography haven't changed. It's still your moment, your vision, and how you see the light falling on your subjects and backgrounds. All you're really losing is a lot of expense and chemicals pouring down the drain.

Even so, the curmudgeons are right about one thing: There *are* still some "negatives" in digital photography.

Digital cameras are generally more expensive than film cameras. True, you make up the cost very quickly with the savings from film and developing. But technology marches on ridiculously fast; the big camera companies come out with new camera models (and retire old ones) *every six months.* It's critical that you buy your camera carefully and spend those dollars well. (See Chapters 1 and 2.)

There's plenty of complexity, too, both in the "digital" part and in the "photography" part. Now you're expected to learn both photography jargon (ISO, white balance, depth of field, shutter-priority mode...) *and* computer jargon (JPEG compression, EXIF tags, image resolution...).

Finally, there's the little issue of what to *do* with all those pictures. People wind up taking a lot more digital photos than they ever did with film, simply because it's free and easy. Before you know it, your hard drive creaks with 60,000 pictures of your kid playing soccer.

But what then? Dump them all on your hard drive, tens of thousands of JPEG files, stashed in folders?

People can still look at and enjoy photos (the paper kind) that were made 200 years ago. But will our JPEG files still be there for our ancestors in 200 years? Will the JPEG format even *exist* in 200 years? How about 50?

About This Book

This book was born to address all of these issues, and more. It's divided roughly in half, which you can think of as "photography" and then "digital":

- **Photography.** First, this book provides a complete grounding in professional photography. It gives careful consideration to the *artistic* factors involved in shooting—composition, lighting, and exposure—and how to apply them using the 37 billion features in the modern digital camera.

 And by the way: Unlike most photography books, which concern themselves primarily with SLR cameras (those big black ones with removable lenses), this one lavishes equal love on the compact pocket cameras. They do, after all, represent 91 percent of all cameras sold.

- **Digital.** Second, this book provides a full course on what to do *after* you've taken the pictures. It follows the entire life cycle of those photos: transferring them to your Mac or PC, using free "digital shoebox" software to organize and edit them, and finally sending your pictures out to find their audience. Every conceivable distribution method is covered in this book: email, Web, prints, slideshows, desktop wallpaper, collages, movies, screensavers, even jigsaw puzzles and underwear.

 Note This book provides a guide to two photo-management programs: Picasa (for Windows, free from Google) and iPhoto (from Apple, preinstalled on every Mac). It covers these two programs because they're (a) brilliant, (b) easy to use, and (c) free.

If you own Photoshop or Photoshop Elements, which are much more hard-core photo editors, then congratulations—you're ahead of the game. Picking up either *Photoshop: The Missing Manual* or *Photoshop Elements: The Missing Manual* will bring you 900 more pages of digital-photography goodness.

About the Outline

This book is divided into four parts, each containing several chapters:

- Part 1, **The Camera**, is a distillation of everything that I, your cheerful author, have learned in eight years of testing and reviewing digital cameras for the *New York Times.* It's the ultimate buying guide. It tells you which features are worth looking for, and which are just marketing blather.

- Part 2, **The Shoot,** is a course in photography and digital cameras. These chapters cover composition, lighting, shutter speed, aperture, when to use the flash, eliminating blur—and how your digital camera controls all of these parameters. Chapter 6, in particular, is a gold mine: It features all the classic professional photo types (frozen action, silky-smooth waterfall, car-headlight trails at night, and so on) and tells you precisely how to achieve those effects yourself.

 This section of the book creates a bridge between everyday snapshots and the kinds of emotionally powerful shots you see in magazines and newspapers.

- Part 3, **The Lab**, covers the fundamentals of getting your photos into iPhoto or Picasa, organizing and filing them, searching them, and editing them to compensate for weak lighting (or weak photography).

- Part 4, **The Audience**, is all about the payoff. This is the moment you've presumably been waiting for ever since you snapped the shots: showing them off. It covers the many ways you can present those photos to other people: as a slideshow, as prints you order from the Internet or make yourself, as a published custom book, as a Web page, as an email attachment, as a slideshow movie that you post on the Web, as a photo gift, and so on.

At the end of the book, Appendix A offers some Web sites and magazines that will help fuel your growing addiction to digital photography; Appendix B offers a tidy summary of the 10 best tips in this book; and Appendix C lists the credits for the photos in this book.

About→These→Arrows

Throughout this book, and throughout the Missing Manual series, you'll find sentences like this one: "Choose File→Open." That's shorthand for a much longer instruction: "Click the File menu to open it; from the menu, choose the Open command."

About MissingManuals.com

At *www.missingmanuals.com,* you'll find news, articles, and updates to the books in this series.

But if you click the name of this book and then the Errata link, you'll find a unique resource: a list of corrections and updates that have been made in successive printings of this book. You can mark important corrections right into your own copy of the book, if you like.

In fact, the same page offers an invitation for you to submit such corrections and updates yourself. In an effort to keep the book as up-to-date and accurate as possible, each time we print more copies of this book, we'll make any confirmed corrections you've suggested. Thanks in advance for reporting any glitches you find!

In the meantime, we'd love to hear your suggestions for new books in the Missing Manual line. There's a place for that on the Web site, too, as well as a place to sign up for free email notification of new titles in the series.

The Very Basics

You'll find very little nerd terminology in this book. You will, however, encounter a few terms and concepts that you'll see frequently in your computing life:

- **Clicking.** To *click* means to point the arrow cursor at something onscreen and then—without moving the cursor at all—press and release the clicker button on the mouse (or laptop trackpad). To *double-click,* of course, means to click twice in rapid succession, again without moving the cursor at all. And to *drag* means to move the cursor while keeping the button continuously pressed.

When you're told to *Shift-click* something, you click while pressing the Shift key. Ctrl-clicking (in Windows) and ⌘-clicking (on the Mac) work the same way—just click while pressing the corresponding key on your keyboard.

 Note On Windows PCs, the mouse has two buttons. The left one is for clicking normally; the right one produces a tiny shortcut menu of useful commands.

Desktop Macs come with a mouse that *looks* like it has only one button but can actually detect which side of its rounded front you're pressing. If you've turned on the feature in the Keyboard & Mouse pane of System Preferences, you, too, can right-click things on the screen. You can right-click on a Mac *laptop* by clicking while resting two fingers on the trackpad.

So if you have a Mac, and you see the phrase, "Right-click the photo," well, right-click the photo. If nothing happens, then you haven't turn on this feature in System Preferences. If you can't be bothered, then Control-clicking achieves the same effect.

- **Keyboard shortcuts.** Every time you take your hand off the keyboard to move the mouse, you lose time and potentially disrupt your creative flow. That's why many experienced computer fans use keystroke combinations instead of menu commands wherever possible. Pressing ⌘-P (on the Mac) or Ctrl+P (on the PC) opens the Print dialog box, for example.

 When you see a shortcut like ⌘-Q, it's telling you to hold down the ⌘ key, and, while it's down, type the letter Q, and then release both keys.

If you've mastered this much information, you have all the technical background you need to enjoy *Digital Photography: The Missing Manual.*

Chapter 1: Camera Kinds

Year after year, the digital camera is one of the hottest-selling products on the face of the earth. Every year, 15 million people snap them up, spend $42 billion in the process, and take 50 billion photos with them.

All that popularity is good, because it means the marketplace is crowded. Competition means lower prices, nicer features, and better cameras.

But it's also bad, because all those hundreds of models make camera shopping much more complicated. And not to depress you or anything, but camera companies generally update their lineups *twice a year* (in October and February). Each generation offers better features, improved resolution, and lower prices. That's right: Whatever camera you buy today will be obsolete—well, at least no longer sold—in about six months.

On top of all that, the features and specs that *should* matter when you shop for a camera usually aren't easy to figure out. (Just try, for example, to find out the *sensor size* for a camera you're considering; it's not on the box and not in the brochure.) Meanwhile, the camera makers and camera stores often flog features and specs that don't matter *at all,* like the number of megapixels the camera has. (Yes, that's right. Read Chapter 2 to find out why having a lot of megapixels is irrelevant—or even a bad thing.)

The major players include companies like Canon, Nikon, Sony, Kodak, Panasonic, Olympus, HP, Casio, and Fujifilm. Each company offers a variety of models and a prices to compete for your dollars.

Before you learn how to use a camera, of course, you have to *have* a camera. This chapter and the next provide an overview of every kind of camera, and every feature *on* those cameras, accompanied by notes that tell you

whether each one is genuinely useful or just marketing blather. May these chapters guide you the next time you're shopping for a digital camera.

Small, Medium, or Large?

Cameras come in an enormous range of sizes—a much bigger variation than you'd find in, say, music players or cellphones. They're so differentiated, they almost constitute different product categories.

Pocket Cameras

The huge majority of people—more than 90 percent—wind up buying those little shirt-pocket cameras, about the size of an iPod or cellphone. There's an overwhelmingly convincing reason for this: If the camera is small, you'll be more likely to have it with you when life's great photo ops arise.

And real life proves them right. You can carry these minicams in your pocket, purse, or glove compartment, or toss one into your carry-on bag for a trip, without adding any real weight or bulk. Even professional photographers, usually laden with 30-pound bags of camera gear, often carry around a pocket cam when they're "off duty," just in case (or as a backup).

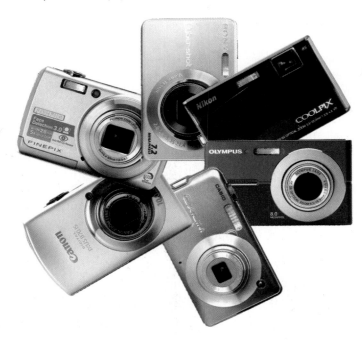

Pocket cams usually take perfectly good photos; occasionally, terrific ones. They also take *movies,* which is a huge advantage (and one that accounts for the slow but steady crashing of the camcorder market). But there's a big difference between usually and always, and there's a huge gulf between perfectly good photos and amazing ones.

Here, for example, are some of the frustrations with pocket cams:

- **Shutter lag.** This is it: the one that drives everybody crazy. *Shutter lag* is the delay between the time you press the shutter button and the time you get the shot. It's only half a second, or even less, but that delay can make all the difference. In that time, the kid has left the diving board, the expression you wanted is gone, and you've missed the home-run swing.

 Technically speaking, shutter lag is the time it takes for the camera to calculate focus and *exposure* (how bright to make the scene). Little cameras don't sell unless they're inexpensive, so they contain fairly feeble circuitry—slowish chips that take their time doing those calculations.

 Tip There is, of course, a simple way to eliminate shutter lag: Use the *half-press* technique. It's described on page 41.

- **Lousy low-light shots.** Tiny cameras usually have tiny *sensors*—the small, rectangular light-sensing chips that do what film used to do in the cameras of old. Sensors improve each year; but in general, the smaller the sensor, the worse the photos. Tiny sensors mean that less light is used to capture the image, which means color that isn't as true and, above all, poor performance in low light.

What does that mean? First, blur. To compensate for the tiny sensor, the shutter has to stay open longer to let in more light; during that time, the slightest movement of the camera creates a blurry image. Pocket cameras take a *lot* of blurry pictures at night, indoors, and indoors at night.

The second problem is *noise.* "Noise" is the geek term for tiny, grainy, colored speckles that ruin a lot of nighttime photos from small cameras.

To compensate for their lack of light sensitivity, little cameras wind up firing their flashes a lot. Which is fine for snapshots. But the light from the flash, especially the flash on little cameras, tends to be harsh and white and superbright, making even your dearest loved ones look like they've been nuked. It's not a very attractive look.

- **Limited zoom.** The last problem with small cameras is that you're stuck with the lenses that come with them. You can't swap a telephoto lens (good for magnifying distant scenes) with a macro lens (good for extreme closeups).

 The camera makers generally give you a good compromise: a general-purpose, basic lens that can magnify a scene by three or four times (that is, it's a 3X or 4X zoom lens). As you'll soon discover, however, that makes small cameras pretty much useless for shooting soccer games, rock concerts, school plays, or anything else where you want to be able to identify individual faces in the resulting pictures.

As you can see, pocket cameras have their limits. They'll disappoint you now and then, especially in low light and when you're far from the action.

Fortunately, the other 80 percent of the time, you wind up very happy with your pictures—especially because you had the camera *with* you.

 Tip Year after year, Canon's small cameras (called PowerShots) take top honors for picture quality and reduced shutter lag. Fujifilm cameras are unusually good in low light. And Kodak models have a reputation for being simple to use.

Superzoom Cameras

If you're willing to put up with a little more bulk, you can move up to a midsize camera whose chief advantage is a powerful zoom. It's not unusual for these models to offer 12X, 15X, or even 20X zoom powers, which ought to solve your soccer game/rock concert/school play dilemma quite nicely.

Why is a powerful zoom such a big deal? Because so many of life's great photographic moments happen at a distance: on a stage (school play, graduation

ceremony, dance recital, wedding), a playing field (soccer, baseball), or some other kind of field (lion, elephant, buff-breasted pipit).

Midsize cameras also have room for another disappearing luxury: an eyepiece viewfinder, which comes in handy when the sun washes out the back-panel screen. These models, however, employ *electronic* viewfinders—that is, a tiny video screen inside the eyepiece, rather than a clear piece of glass. It shows exactly what you're about to shoot, but the image isn't as clear, nuanced, or smooth as a see-through viewfinder.

Most of them have flip-out screens, too, so you can shoot around corners, over people's heads, and down low at baby level without stooping. More on this topic in Chapter 2.

The downside is that, apart from the superzoom lens, these cameras aren't any better than shirt-pocket cameras, photographically speaking. The sensor inside is still pretty tiny.

Outdoors, or wherever there's copious light, these cameras take terrific, clear shots with vivid colors. But indoors and after dinnertime, it's another story. You'll probably have to throw out a significant number of your indoor, no-flash photos, which are often victims of horrible graininess or blur.

Furthermore, these cameras are generally squat and bulky—no pants pocket for you, pal—so you pretty much have to carry yours around over your shoulder or in a camera bag. And if you're going to endure that, then you may as well consider a full-blown SLR, described next.

SLRs

You may be perfectly satisfied with the snapshots taken by your sleek, slim, silver shirt-pocket digital camera. But then you see pictures in magazines that you just *know* were taken with better equipment. You know: razor-sharp por-

traits with softly blurred backgrounds. Car taillights drawing bright orange tracks across the nighttime frame. A waterfall, smoothed by a slow shutter into a silky veil. Or just about anything that happens fast.

Shots like these are child's play, however, for a digital SLR. (SLR stands for "single-lens reflex," which obviously doesn't make the term any clearer. But the basic idea is that you're looking out *through the lens* when you hold the eyepiece viewfinder to your eye.)

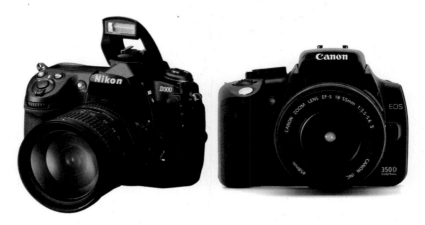

These big, black, interchangeable-lens cameras won't fit in your pocket, unless you're a kangaroo. And they scream, "I'm a tourist" when they're hanging from your neck.

But their photos blow those little shirt-pocket cams out of the water. They're photographically superior in every regard. They turn on instantly; take stunning, magazine-quality photos; have zero shutter lag; can fire three shots a second; offer infinite manual control (white balance, exposure, and so on); and go for days or weeks on a battery charge. (A pocket camera manages about 300 shots per battery charge. An SLR might take 2,500.)

These cameras make you understand why people get hooked on photography. It starts with the feel of the huge, rugged body in your hands, a shape that's been refined over the decades. It continues with the satisfying, instantaneous click of the shutter—not a chirpy audio recording from a speaker, but the actual clack of the SLR's mirror snapping out of the way.

You may be perfectly happy with the starter lens that comes in the box. Even so, you can rest easy, knowing that if you ever need it, a catalog of additional lenses awaits. You can pop on a fish-eye lens and snap a complete 180-degree

vista in a single photo. Or just get a wide-angle lens for shooting room interiors or landscapes without the rounded-cornered look of fish-eye photos.

With a macro lens, you can shoot a bumblebee or a splinter, huge and clear as though it were in National Geographic. Or snap on a huge telephoto lens and sit in the bleachers at a tennis tournament, snapping hyper-closeups of the players' sweaty faces.

You can read more about SLRs—and lenses—in Chapter 7.

 Tip Yes, lenses are expensive—some cost more than the camera. But keep in mind that you can also rent them, either from camera shops or from a Web-based company like *www.lensprotogo.com.*

Cameraphones and iPhones

Oh, yeah—cameraphones. Let's not forget the most popular kind of camera in the world, with annual sales in the billions.

Most cellphones have cameras built in, yes, but "camera" is a generous term. The quality of the pictures, as you've probably discovered, is pretty horrible except in bright light when your subject is standing still.

That's not to knock cameras on phones; they're a lot better than *not* having cameras on phones. You at least have *some* record of funny or interesting sights. And there are hundreds of times when camera + phone makes a lot of sense: You're shopping and want your spouse's opinion on some item you're looking at, for example, or you're parking your car in some infinite garage and want to remember that it's right under the "LEVEL 2B SOUTH" sign.

Just don't expect the photo quality to get you hired at *Sports Illustrated.*

Even so, believe it or not, a lot of this book's advice applies even to cameraphones. All the techniques for composing a shot, for example, make sense even if you're packing only a cellphone. The chapters on editing and using your photos generally apply, too.

That's the beauty of photography. Master the basics, and you'll improve your art— no matter what gear you're packing.

Where to Buy a Camera

The nice thing about marching into a store, of course, is that you can see and handle the cameras. You may even be able to find a salesperson who knows what he's talking about. (It's been known to happen.)

But shopping online can save a ton of money. Price-comparison sites like *PriceGrabber.com* and *Shopping.com* make that point painfully clear. You'll plug in some camera's model number and discover that mail-order Web shops are selling the exact same camera for anywhere from $210 to $430.

Unfortunately, some of the shadier Web shops game the system. They advertise a camera at a price that's lower than anyone else's—lower, in fact, than the camera cost *them*—and then, after you've placed your order, they call you up and say: "Would you like a battery with that? It's $40 more." Sleazy, man.

So when you shop online, pay attention to the ratings *other people* have given the shops. At *Shopping.com,* for example, buy your camera from the store with the Smart Buy logo. It identifies the lowest price from a store that has high customer-satisfaction ratings.

Chapter 2:
The Only Features
That Matter

The people in charge of marketing digital cameras these days—the stores, Web sites, and camera makers—seem to have a pretty simple approach: Blast your brain to smithereens.

Quick, which is better: a 12-megapixel camera with antishake, 60 fps AVI-format videos, face detection, and red-eye removal? Or a 10-megapixel model with 4X optical zoom, an electronic viewfinder, an autofocus assist lamp, and Wi-Fi uploading?

Most people wind up buying whichever one is prettier.

But you—you're different. You've gone to the trouble of picking up a book on digital photography. So the feature *you* might be most interested in might be—oh, I don't know—*picture quality?*

It could happen.

So here's a tour of the various features and specs of today's digital cameras, listed roughly in order of importance. It's a pretty long list, and it's a pretty long chapter, because cameras today are extremely sophisticated bits of machinery. But by the time you've slogged all the way to the end, you'll have a solid appreciation for the things these little gadgets can do.

 This chapter presents a list of features your camera candidate *might* have.

There are some features, though, that *all* cameras have: an LCD screen on the back; a Play button to review your shots; a power button; a threaded hole underneath for a tripod mount; a loop for a hand strap or shoulder strap; a removable battery; a lens cap, either built-in or detachable; tiny locking, hinged doors for the memory card and battery; and a USB jack for transferring the pictures.

Oh, yeah—and a shutter button. They all have that.

All *small* cameras also have a built-in flash, a microphone, a speaker, zoom in/zoom out buttons, a video-output jack (so you can watch your pix and movies on a TV set), and a few logos.

A Big Sensor

If there's a single factor that predicts the quality of the photos you'll get from a camera, a single letter grade that lets you compare cameras, it's this: the sensor size.

I know, I know. The *what?*

Inside every camera is a rectangular chip that receives light from the lens and records the image. It's the "film" of the camera.

Big sensors absorb more light, so you get sharper detail, better color, and clearer low-light images. Small sensors, on the other hand, pack too many light-absorbing pixels into a tiny space. So heat builds up, creating digital "noise" (random speckles) in your photos.

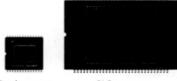

Pocket-cam sensor SLR sensor

Sensor size is the primary reason why SLRs take far superior pictures than pocket cameras. The light sensor inside these bulkier models is gigantic: 10 times the size of a typical compact's sensors, for 10 times the light sensitivity. (Some, the so-called "full-frame" SLRs, contain a sensor the size of a frame of 35mm film, which is huge indeed. But they're expensive.)

 Technically, what you really, *really* care about is the size of the sensor's *individual photosites* (tiny, light-sensitive pixels). You can calculate it by dividing the sensor size by the number of megapixels. That is, a *10*-megapixel camera with a 1-inch sensor is better than a *14*-megapixel camera with a 1-inch sensor.

Photography geeks will be certain to point this out at cocktail parties. Still, in general, sensor size and photosite size are proportional. Furthermore, the photosite size is not published anywhere; sensor size is. So if you're looking for a single, knowable measurement, go with sensor size.

Great—so how are you supposed to find out how big a camera's sensor is?

It's not easy. The manufacturers diligently bury this detail. It's not on the box, it's not in the ads, and sometimes it's not even on the camera's Web site. (Why? Because after so many years of brainwashing the public into thinking that *megapixels* is the important number, the companies would look like idiots if they suddenly started focusing on the *really* important measurement.)

You can find the sensor size, though. Usually, you can look it up quickly using Google; just type, for example, *Canon SD890 sensor size*. Or you can go directly to some of the popular camera Web sites like *DPreview.com* or *DCresource.com* to find it.

Even then, you'll be astonished to find out how confusing it can be to *compare* the sensor sizes of different cameras. The companies publish this spec in two different formats. For small cameras, they use a bizarre fraction like "1/2.5 inches." This is a diagonal measurement; divide 1 by 2.5, and you find out that it's actually 0.4 inches. In other words, a smaller denominator is better.

For SLRs, though, sensor sizes are published as millimeters on a side, like "24 × 16mm." If you convert that to inches and then calculate the diagonal, you find out that that's 1.14 inches diagonally.

In short, it's a lot of work to find out the true measurement of a camera's sensor. But it's effort that will pay off with every click of the shutter for years to come. (Or, at the current rate of camera life cycles, at least for *months* to come.)

 Tip For a quick way to convert those crazy, user-hostile measurements into something you can understand, visit the sensor calculator at *www.sensor-size.com*.

Stabilizer

The second most important feature is probably image stabilization (also called antishake, antiblur, or vibration reduction). This feature, available in all types of cameras, improves your photos' clarity by ironing out your little hand jiggles.

It's especially useful in three situations:

- **In low light.** In dim scenes, the shutter has to stay open a long time to soak up enough light. The longer it's open, the more chance there is that the camera might move a little—and blur the shot.

- **When you're zoomed in all the way.** Zooming amplifies hand jitters.

- **When there's no eyepiece viewfinder.** If your camera doesn't have an optical viewfinder, then the only way to frame the picture is to hold the camera with your arms out. That's a less stable position than holding the camera with two hands, close to your body. Less stable = more blur.

In photographic terms, the stabilizer means you can slow down the shutter to admit more light without any additional blur.

Now, the camera makers know perfectly well that stabilization is a hot ticket these days. So just about every current model offers some form of it.

Be careful, though. Real, *mechanical* image stabilizers work amazingly well; they actually jiggle the lens or the sensor to counter camera movement. But a lot of less expensive cameras use cheap tricks to *simulate* a stabilizer. They might apply antiblur software after you take the shot, for example, or they might just bump up the light sensitivity (page 82) so the shutter doesn't stay open as long. In both cases, no actual shifting of the sensor or lens elements is going on, so the pictures aren't as sharp.

Zoom Power

When you read the specs for a camera—or read the logos painted on its body—you frequently encounter numbers like "3X" or "10X." This number tells you how many times the camera can magnify a distant image, much like a telescope. Unless there's fine print, it's a measure of *optical zoom*, the actual amount that the lenses can zoom in (to magnify a subject that's far away).

Then there's *digital zoom*, which you may also see on the box. Camera makers seem to think that what consumers want most in a digital camera is a powerful digital zoom. "7X!" your camera's box may scream. "10X!" "20X!"

But when a camera uses its *digital* zoom, it basically blows up the image. The image gets bigger, but its quality deteriorates.

Avoid digital zoom altogether, and base your camera-buying decision on the *optical* zoom power. That's the zoom that counts.

Shutter Lag

In small cameras, shutter lag (page 9) is the number one cause of owner frustration. (There's virtually no shutter lag in SLRs, which is one reason they're so awesome.)

Unfortunately, you won't see a camera's shutter lag touted in the ads, or even mentioned at all by the camera companies. (Can you imagine? "The new Sony TX44C-273IW! Ten megapixels, 1-second shutter lag!")

It is, however, possible to research this information. It's on the camera-nut Web sites described in Appendix A. Even then, there's no standard way of measuring shutter lag—the different Web sites don't use the same testing methods—and shutter lag is a lot worse in low light than in bright light.

The point, then, is simply to keep this pitfall in mind as you shop. Do a little research on the Web, for example, or just keep your eyes open to shutter lag references when you're reading camera magazines and camera reviews.

Optical Viewfinder

Every year, digital camera screens get bigger. That's good, because framing photos is much more satisfying when you can see what you're doing. Big screens are also great when it's time to show your pictures to other people.

On some cameras today, though, the screen fills the whole back of the camera—and there's no room for an *optical viewfinder* (the little glass hole).

Clearly, most people don't care; they don't find themselves using the optical viewfinder much and would rather have the bigger screen. As a result, optical view-finders are disappearing. Some companies have eliminated them from *all* of their pocket cameras.

That's fine, but the optical viewfinder does come in handy now and then. In bright sunshine, the screen may fade, making it hard to frame your shots. In dim light, you may not see much of an image on the screen at all as you compose a photo. And eliminating the viewfinder means you can't use an old battery-life trick: turning off the screen.

Finally, holding a camera up to your face helps to brace it, reducing the likeli-hood of blur that's introduced by handheld jitters. Without an optical view-finder, you're forced to hold the camera out away from your body.

Manual Controls

The least expensive digital cameras are called *point-and-shoot* models for a reason: You point, you shoot. You don't have any control over the more advanced photographic controls.

More expensive cameras, on the other hand, let you take your camera out of Auto mode and fool around with the shutter speed, aperture size, white bal-ance, exposure, light sensitivity, and so on. You may not need these controls every day. But if your ambitions ever grow, or if you want to try some of the artier shots described in Chapter 6, you'll be grateful to have these options.

Face Recognition

Face recognition hit the big time in 2008. It sounds gimmicky, but it's actually a great feature.

Without face detection, a photo of two friends might wind up with only the background between them in focus; a flash photo might nuke your boss's face into a bleached blob.

But modern cameras try to recognize faces in the scene—usually up to a dozen at once—and then calculate focus and exposure accordingly. Now the two friends' faces are in focus, and the flash is throttled back to properly expose your boss's delicate skin tones.

You know the feature is at work when face-framing squares appear on the camera's screen. The squares actually move around with your subjects.

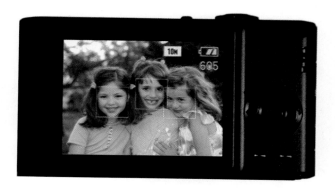

It's getting worse/better. Some cameras now offer a feature, like Sony's Smile Shutter and Canon's Smile Shot, that waits to fire until your subject manages a grin. (Canon is also working on something called Blink Shot. As you can probably guess, it will prevent the camera from taking the picture when your subject's eyes are closed. At last!)

Autofocus Assist Lamp

The autofocus assist lamp is a little light. When you half press the shutter button (page 41) in low light, it provides just enough illumination for the camera to focus. And especially on little cameras, it makes all the difference in the world.

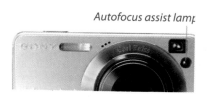

Autofocus assist lamp

Cameras that don't have this lamp can only guess at how far away the subject is, and they usually do a terrible job of it.

How do you know if a camera has this lamp? Look at the front. Usually, you can see a little circular dark spot near the lens—not the same round spot that's the viewfinder.

Flip-Out Screen

On some cameras, the LCD screen on the back can rotate and pivot, like the one on a camcorder. This arrangement lets you shoot a parade over the crowd in front of you. You can shoot pets and babies without having to squat or kneel. And you get infinitely better photos of camera-shy subjects, because you can smile and make eye contact instead of hiding your face behind a piece of Darth Vader equipment.

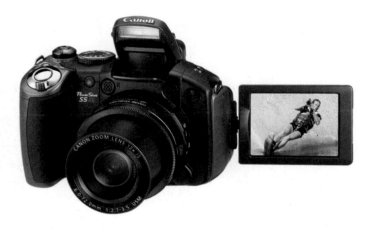

Memory Card

A digital camera stores photos on a removable memory card. That's good, because even a $10 memory card holds more pictures than a roll of film ever did.

The card that came with your camera, if you got one at all, is a joke. It's a 10-cent card that holds only about six pictures. It's a cost-saving placeholder.

When you're shopping for a camera, then, it's imperative that you also factor in the cost of a bigger card.

It's impossible to overstate how glorious it is to have a huge memory card in your camera (or several smaller ones in your camera bag). You quit worrying that you're about to run out of storage, so you shoot more freely, increasing the odds that you'll get great pictures. You can go on longer trips without dragging a laptop along, too, because you don't feel the urge to run back to your hotel room every three hours to off-load your latest pictures.

 Tip More and more inexpensive pocket cameras have a little chunk (or a big chunk) of *built-in* memory. It's great to have when you've just opened the camera and want to try it out without bothering to buy a memory card. It's also great to have when you're out shooting somewhere and discover that your memory card is full. Now you've got enough extra storage for a few more shots.

Memory Card Types

The *kind* of memory card your camera uses isn't nearly as important as the amount of memory you get. But once you've narrowed down your purchase to a short list of candidates, it's worth considering the cards they use.

- **SD cards.** These tiny cards are by far the most common type, both in SLRs and pocket cams. They're available in huge capacities—32 gigabytes or more, big enough for thousands and thousands of photos—at very low prices. A 2 GB card costs about $15. Get a couple.

 Note You might also hear about *SDHC* cards (Secure Digital High Capacity). That just means "an SD card that holds 4 gigabytes or more." Older cameras and card readers can't accept SDHC cards, so shop carefully.

- **Compact Flash.** Compact Flash cards are rugged, inexpensive, and easy to handle. They're bigger, though—about the size of a Wheat Thin—so they're disappearing from all cameras except professional models. You can buy them in capacities up to 32 GB.

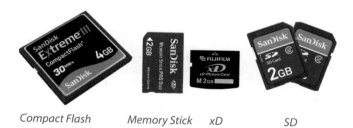

Compact Flash *Memory Stick xD* *SD*

- **Memory Stick.** Many Sony cameras require a proprietary format called Memory Stick (or Memory Stick Duo, or Memory Stick Pro). They're more expensive, harder to find, and less compatible with other machines than SD cards; don't get stuck with Memory Stick unless you have to.

- **xD Card.** Many Fuji and Olympus cameras require this card. It's small—so small that the manual warns that it can be "accidentally swallowed by small children." It's small in desirability, too. It's even more expensive, harder to find, and less compatible than a Memory Stick.

If you already own some memory cards from a previous camera or gadget, you can consider that one factor in favor of buying a new camera that uses the same kinds of cards. Otherwise, choose a camera that takes Compact Flash or SD cards. They're plentiful, inexpensive, and have huge capacity.

Burst Mode

Burst mode, also called motor drive, means rapid-fire shooting as you keep the shutter button pressed—on the best cameras, several shots per second. Little cameras don't offer much in the way of burst mode, but SLRs can rattle off 3, 5, or even 7 shots per second.

(Some cameras let you keep firing like this until the memory card is full. More commonly, though, there's a maximum burst of, say, 10 or 20 shots.)

Why is burst mode so high on this "important features" list? Because it's great for sports and wildlife. It's also fantastic for portraits, because you can choose from multiple gradations of smile and expression.

Finally, for group shots, it's essential; it's the only prayer you have of getting a single photo where nobody's blinking.

Hi-Def Jack

Virtually every camera can connect to a TV set. Not nearly enough people take advantage of this feature; it's really, really great to turn on your camera's slideshow mode at parties so your guests can watch themselves as they chat, munch, and drink.

The thing is, a digital photo these days has *much* higher resolution (more tiny dots) than even the highest-definition TV set. When you connect a typical camera's TV cable, you're looking at an unbelievably coarse "down-rezzed" standard-definition version of the pictures.

A few cameras, though, come with a special cable—called an *HDMI* or *component* cable—that connects to high-definition TV sets. You won't believe how amazing your pictures look in high definition.

Battery

In many ways, digital cameras have arrived. They're not like cellphones, which still drop calls, or computers, which still crash and freeze. Digital cameras are reliable, high quality, and generally extremely rewarding.

Except for battery life.

Thanks to that screen on the back, digital cameras plow through battery charges like Kleenex. The battery capacity, not the memory card, is usually what determines how long your photo shoot lasts. When the juice is gone, your session is over.

Here's what you'll find as you shop for various cameras:

- **Proprietary, built-in rechargeable.** Most small cameras come with a "brick" battery: a dark gray, lithium-ion rechargeable battery.

 The problem with proprietary batteries is that you can't replace them when you're on the road. If you're only three hours into your day at Disney World when the battery dies, that's just tough—your shooting session is over. You can't exactly duck into a drugstore to buy a new one.

 Sometimes, you have to recharge the battery by plugging in the *camera*. That's a drag, because you can't shoot while the charging is going on.

Other times, you can recharge the battery in a separate battery charger that plugs into the wall. That's a better system, because you can buy a second battery (usually for $50 or so) and keep one in the charger at all times.

- **AA-size batteries.** A few cameras accept two or four AA batteries and may even come with a set of alkalines to get you started.

If you learn nothing else from this chapter, however, learn this: *Don't use standard alkaline AAs.* You'll get a better return on your investment by tossing $5 bills out the window.

Alkalines are no match for the massive power drain of the modern camera. A set might last 20 minutes in a digital camera, if you're lucky.

Instead, you should use *rechargeable nickel-metal hydride (NiMH)* AAs. They last *much* longer than alkalines, and because you can use them over and over again, they're far less expensive.

The beauty of cameras that accept AAs is that they accommodate so many different kinds of batteries. In addition to NiMHs, most cameras can also accept AA *photo lithium* batteries. They're a lot like alkalines, in that they're disposable and can't be recharged, but they last much longer.

The final advantage of this kind of camera is that, in a pinch, you can hit up a drugstore for a set of standard alkalines. Sure, you'll be tossing them in the trash after about 20 minutes—but in an emergency, 20 minutes is a lot better than nothing.

Movies

As late as 2005, still cameras and video cameras were each terrible at doing the other's job. And even today, camcorders still take crummy photos.

But still cameras can now take very high-quality movies. Almost all current models can record video that fills a standard TV screen (640 × 480 pixels) with TV-quality smoothness (30 frames per second). And plenty of them can record in high definition. That doesn't guarantee great-looking video—lots of companies abuse the term "hi-def"—but some cameras produce *amazing* video.

Canon's S series can even film and snap stills simultaneously, thanks to separate shutter and start/stop buttons.

Early cameras couldn't zoom or refocus *while* you were filming, as on a camcorder. But that's changing; many models handle those jobs with aplomb.

 For years, *SLRs* could not record video. That's changing, too. In 2008, Nikon and Canon both unveiled new SLRs that take great stills *and* record hi-def video that'll blow your socks off. The best part: you can use all of those cameras' photographic controls and different lenses for *video*. Other cameras will soon join them.

Scene Modes

All pocket cameras, and all but the most expensive SLRs, have scene modes. These are canned settings for common photographic situations like Sports, Portraits, Landscapes, Macro (super-closeup), and so on. Usually, tiny icons for the scene modes appear right on the main Mode dial; see page 53 for details. (Sometimes, the Mode dial has only one setting called Scene; you're then supposed to choose *which* mode you want by choosing on the screen.)

Cameras are getting smarter lately; some compact models now have Auto-Scene or Intelligent Scenes. That is, they can switch modes *automatically* by studying the scene. (A little icon identifies its selection.) A very nice feature.

Wireless

Nikon, Canon, and Kodak make cameras with built-in Wi-Fi (wireless networking). The idea is that you can send your photos by email or post them on the Web directly from the camera the next time you're in a Wi-Fi hot spot. (Or you can just upload them from the camera to your computer without having to hunt around for a USB cable.)

 If this feature appeals to you, then you don't have to buy a special camera to get it. There's an amazing, weird little SD card called the Eye-Fi ($100) that endows *any* camera with these features. It looks and works exactly like any other SD card; it's a regular memory card. But as soon as you're in a Wi-Fi hot spot, the card automatically starts sending your photos to your computer and to the Web.

Touch Screens

Another hot new camera trend: touch screens on the back, complete with controls that you can operate with either a finger or a stylus. The advantage here is that the camera itself needs fewer physical buttons, because its functions appear as needed right on the screen. As a result, the screen can be bigger even as the camera gets smaller.

There are other perks, too. On some cameras, you can tell the camera what to focus on just by tapping its image on the screen; the camera stays focused on it (and correctly exposed for it) even if that object moves. You can also zoom and pan by dragging your finger, or even draw mustaches on your subjects. On the other hand, touch screens can be a little fussy.

Megapixels

The first number in the description of a camera is usually how many *megapixels* it has. And that's probably the *least* important detail of the camera.

A pixel (short for *picture element*) is one tiny colored dot, one of the thousands or millions that compose a single digital photograph.

You need at least a million pixels—that is, 1 megapixel—to make a 4 × 6-inch print. Much fewer than that, and the print might look a little coarse; you might be able to see the individual dots. That's why we have the shorthand: Instead of saying that your camera has 8,100,000 pixels, you'd say that it's an 8.1-megapixel camera.

What you're describing is its *resolution*. For instance, an 8-megapixel camera has a higher resolution than a 4-megapixel camera. (It also costs more.)

So how many pixels do you need?

- **Pictures on the screen.** Many photos are destined to be shown solely on a computer screen: to be sent by email, posted on a Web page (like eBay), turned into a screen saver, or used as a desktop picture.

 If this is what you have in mind, congratulations. You're about to save a lot of money, because you don't need a lot of megapixels *at all*. Even *2 megapixels* (as you might find on a cameraphone) is way, way too big for use in email or on an auction site. In fact, it's probably about 1600 × 1200 pixels—even too big to fit on a typical 12-inch laptop screen without zooming out or scrolling.

- **Pictures on paper.** If you intend to print your photos, however, it's a different story. A *printer* must cram the dots much closer together on paper than you'd need on a computer screen—150 pixels per inch or more.

 Remember the 2-megapixel photo too big for a laptop screen?

It's got plenty of resolution for a 5 × 7 print. But if you tried to print out a movie poster with it, the dots might become visible and blocky-looking.

For years, articles and Web sites published ridiculous tables that showed how many megapixels you needed for certain print sizes. But nobody ever bothered to *test* that old wives' tale.

As it turns out, the megapixel hype has been *hugely* overblown by the camera industry. There are stunning, sharp, poster-size prints made from 2-megapixel photos, and there are horrible, blurry shots taken by 14-megapixel ones.

 Note For a technology TV show, I once performed a little test. I had poster-size prints made from 5-, 8-, and 13-megapixel photos. Then I mounted them and invited passersby to see if they could guess which was which. Most said they absolutely could not, even with their faces mashed up close to the photos. The rest guessed—and got it wrong. In the end, only 1 person in 50 correctly ranked the three. Trust me: The megapixel myth is just that.

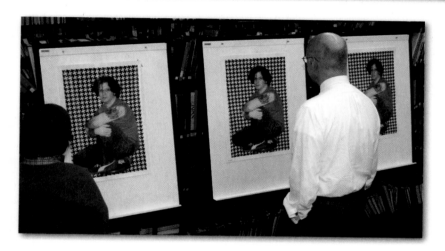

In fact, picture quality depends on a long list of features that are far more important than the number of megapixels: sensor size, lens quality, file compression, exposure, camera shake, paper quality, the number of different color cartridges your printer has, and so on.

Meanwhile, high-megapixel photos have a lot of downsides. They fill up your memory card faster, and fill up your hard drive faster. Worse, in small cameras, cramming more millions of pixels into a tiny chip area increases heat, which increases the "noise" (speckles) in the finished photos.

There is *one* case when having megapixels to spare is handy, and that's when you want to crop away a lot of the photo and still have enough resolution in the remainder to make a decent print.

But otherwise, it is *not* true that you need a lot of megapixels to make a huge print. They don't even *make* cameras today with less than 8 megapixels—plenty of resolution for even poster-size prints, even with some cropping.

SLR Shopping

So far, every camera feature described in this chapter could apply equally well to compact cameras and SLRs. A few features, though, are unique to SLRs. Consider them well, since you're going to be spending at least twice as much as you would if you bought a pocket cam.

SLR Stabilizers

Stabilizing your shots is just as important for SLRs as it is for pocket cams. If you're a professional, sure, you haul around the ultimate image stabilizer: a tripod. But come on—who else is really going to carry around that heavy, bulky piece of gear?

Fortunately, all SLRs come with image-stabilizing features these days.

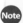 **Note** Different camera companies have different cute names for stabilization: VR (for vibration reduction), OIS (optical image stabilization), Super Steady Shot, VC (vibration compensation), and SR (shake reduction). It's all the same thing.

But there's an ideology war afoot: Should the stabilizing system be built into the lens, or into the body of the camera?

Some companies, like Sony and Pentax, say inside the camera body. They argue that when using this scheme, all of your lenses, old or new, are automatically stabilized. You don't have to pay for image stabilization over and over again with each lens you buy.

Nikon and Canon, however, don't sell image-stabilized digital SLR cameras—only stabilized *lenses.* Yes, this means you have to buy stabilization over again with each new lens, which can get expensive.

But this approach has some advantages. For example, any stabilizer is more effective when it's tailored to the characteristics of a particular lens, especially when you're zoomed in. That's why in-camera-body stabilizers are particularly weak in longer lenses. So in-lens stabilizers do *more* stabilizing.

And only an in-lens stabilizer shows you the effect of the steadying right in the viewfinder, which helps with framing and timing.

Either way, stabilizers can't stabilize your *subject*. If it's moving, you may still get motion blur, and you must still use the traditional tricks to eliminate it (see Chapter 4). Note, too, that not even a stabilized lens can ensure sharpness at very slow shutter speeds—for example, 1 second. Then it's tripod time.

Body Size

SLRs offer super speed, enormous sensors, stunning photo quality, interchangeable lenses, and other perks. Their one enormous downside is their size and weight. Eventually, some executive at a camera company realized: "Hey, what if we could offer the photo quality of an SLR—in a smaller camera?"

If you'd be up for that, you have two options. First, just buy a small SLR. Each company offers at least one smallish model, usually on the inexpensive end.

Second, you can opt for a Micro Four Thirds model. These cameras, from Panasonic and Olympus, maintain the large sensor size of an SLR—but in a much smaller body. They did it by removing a big chunk of the guts: the mirrors and prisms that bounce the light from the lens into your eye. Instead, you get an electronic viewfinder (EVF), which is basically a tiny little screen inside the eyepiece. Not everyone's cup of tea, but not a bad tradeoff overall.

In any case, the quest to shrink the SLR isn't over yet.

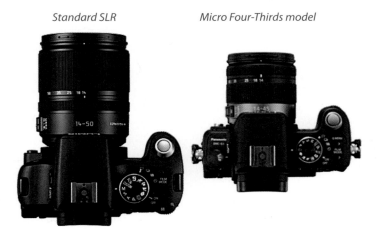

Standard SLR *Micro Four-Thirds model*

Sensor Cleaning

Every time you change an SLR's lens, you leave its guts exposed to the air around you. In that short time, dust can drift inside and wind up landing on the sensor. There's nothing quite so crushing as returning to your tent after a

day of shooting magnificent lions in the African brush, dumping the photos to your computer, and discovering a blurry shadow, cast by a speck of dust, marring the same spot on every picture.

The sensors inside many current SLR models, therefore, do a little shudder every time you turn the camera on, like a dog shaking off water. Dust is flung onto a strip of waiting adhesive, leaving the sensor clean.

Top-Mounted Status Screen

As camera makers make SLRs ever smaller, something's got to go—and more and more often, it's the digital status screen on the top of the camera. This screen shows you, at a glance, your camera's settings, number of shots remaining, battery level, and so on. On better cameras, this screen is even illuminated so you can read it at night.

On smaller cameras, you don't get this screen at all. You can call up the same information on the back-panel screen, but that's not quite as convenient.

Live View

Live View, which became standard on SLRs in 2007, lets you compose your shots on the camera's screen, rather than peering through the viewfinder.

If your reaction to that is, "Well, duh! Isn't that how all digital cameras work?" then you must not have used older SLRs. Until Live View was invented, the *only* way to frame a photo on an SLR was to look through its optical viewfinder.

Live View makes an SLR work just like a pocket camera does. For example, it's great for angled shots when you can't bring the camera up to your face. It helps with manual focusing, since you can magnify the preview on the screen. It lets you see changes in exposure, white balance, and other settings before you actually snap the shot. And because your view isn't blocked by the camera, you're less likely to miss potential photo ops that are happening off to the side.

Unfortunately, Live View focusing is usually slow, and there's a weird, sluggish double-clank noise as the mirror inside the camera flips back and forth, admitting light first to the sensor (so you can see what's on the screen) and then bouncing it to the autofocus mechanism.

Even so, Live View can contribute mightily to your photographic success. Since almost all modern SLRs have it, you may as well try it. If you don't like it, you can always ignore this feature completely.

Chapter 3:
Taking the Shot

Y ou already know from Chapters 1 and 2 that choosing a camera can be a complex task. But let's say that you made it through that ordeal alive. Now you've got a shiny new camera, the battery's charged, and a memory card is installed. There's only one little task remaining: learning to *use* the darned thing.

Chapter 4 is a breathtaking safari through the jungle of technical options on your camera: white balance, exposure, scene modes, and so on. But it's perfectly possible to take beautiful photos, even award-winning ones, without ever adjusting any of that stuff. Plenty of people live full and rewarding lives without ever taking their cameras out of Auto mode. They point, they click, they're happy.

That's what this chapter is all about: the basics of using your camera, including superior composition of the photos themselves. Even if you have only minor photographic ambitions, you can still improve the quality of your fully Auto shots.

Let's assume, for the moment, that you know how to take the *very* first steps, which are turning on the camera and (if necessary) taking off its lens cap.

 You know that dainty little wrist strap that came with your pocket camera? (Or the beefy black neck strap that came with your SLR?) It's a *really* good idea to fasten it to your camera—and to wear it when you're out shooting. Nothing makes you feel like an idiot quite as much as accidentally dropping and breaking (or dropping and submerging) your expensive camera.

Compose the Shot

Composing a photo means framing it: strategically arranging your subjects, your camera, and the background. Where are they in the shot? How do they relate to one another? How much of the frame do they fill?

Most amateur photographers, most of the time, use the age-old Beginner's Law of Composition: "Put the subject in the middle."

That's why most snapshots are composed like these:

And that's fine. Really. On the great scale of photographic artistry, this approach is a little tame, maybe a little predictable, even boring. But it shows that you were there, and maybe that's all you're after.

On the other hand, it's fun to learn a little more about composition, and shoot for something more interesting. Even if all you ever shoot are vacation snapshots, there's no reason they can't be *good* vacation snapshots. Here are a few guidelines for composing a shot that might not have occurred to you.

Fill the Frame

The first secret is so basic to professionals that they'd probably forget even to mention it: A close-cropped subject has more impact.

It works every time. Which photo here has greater impact?

Use your zoom, or just walk closer. Presto: instantly better photos.

Add Interest

Another characteristic of many good photos is that there's something *going on* in them. There's more than one thing to look at.

Often, obeying this law just means positioning yourself so there's something interesting in the foreground—maybe just to get you curious, or maybe to act as a "curtain" or a frame for the shot, like this:

At other times, it's about including something alive, like a person or an animal, in what would otherwise be a straight landscape shot. No matter how beautiful that landscape, including something living lends a sense of scale and sort of makes your audience think about what it would be like to *be* there.

Lead the Eye

Now we're getting into academic territory, something you might hear in a photography course. But it's true: Many effective photos include elements

that *draw the eye* in a certain direction. Most frequently, it's diagonally:

But it could be a winding road, too, or a jagged cliff dropping away to the sea. If your photo has some elements that suggest a path through the scene, you've got yourself built-in interest.

The ~~Rule~~ Guideline of Thirds

The Rule of Thirds, long held as gospel by painters and photographers, suggests that you imagine a tic-tac-toe grid superimposed on your frame. (Many cameras, in fact, relieve you of having to imagine this grid—they offer an option to display one right on the screen.)

Now, as you frame the shot, position the important parts of the photo on those lines, or better yet, at their intersections, like this:

According to the Rule of Thirds, this setup creates a stronger composition than putting everything in dead center, which is most people's instinct.

If you're a believer in The Rule, then you'll draw conclusions like these:

- When you're shooting a close-up portrait, put the person's eyes on one of those grid-intersection lines.

- Never, ever, let the *horizon line* run across the *center* of the photo. (Horrors!) Instead, choose the element you wish to emphasize—either the sky or the sea, for example. Reframe the shot so the horizon line falls either on the upper-third line or the lower-third line.

Does it work? Well, it certainly works to get you *thinking* about composition. It gets you out of the automatic Rule of Putting Everything Dead Center.

But is it mandatory? No. There are plenty of stunning photos where the horizon line, or the subject's eyes, are in the middle of the shot. Like here, for example. Is the center-horizon photo here better or worse than the flanking shots, which comply with the Rule of Thirds?

If it's a good shot, it's a good shot. Don't let the Rule of Thirds make you feel any less pleased with the effect.

Simplify the Background

This one's easy: Be aware of the background. That's it.

If you're aware, then you won't wind up with a telephone pole growing from your beloved's head. Your compositions won't be so busy that your audience isn't quite sure where to look.

Simple backgrounds work especially well for portraits—especially if they're darker than your subject.

> **Tip** When people see *parts* of things in your picture—the front of a tractor, the leg of a ladder, the rear end of a camel—they can't help but wonder what the rest of it looks like. They get distracted. They don't focus on your subject. Scan all four corners of your frame before you shoot, and avoid including parts of things.

Patterns are Fun

Repetition and patterns are always sure-fire winners. Fence posts. Parked cars. Identical arrays of anything. They're easy to find, and they create automatic interest.

Blur the Background (or the Foreground)

Surely you've seen this effect, where the subject of the photo is in sharp focus, and the background is softly blurred. It looks *really* cool and professional—and unless you have an SLR, your photos probably don't look like that.

Actually, there's some hope. See page 113.

Change Your Point of View

Changing the camera angle can have a big effect on the photos you take, too. Think about it: How many of your life's photos were taken with the camera capturing a *your*-eye-view?

If you're five foot two, you probably have a whole passel of pictures taken with the camera held about five feet off the ground.

But it doesn't have to be that way:

- **Get down low** to shoot pets and babies in their own world; the pictures are much more interesting than the usual parent's-eye-view. Get down low to shoot flowers, too. That gives your viewers a perspective they

don't ordinarily have, which is automatically more interesting than the person's-eye-view.

- **Climb up high** for a much more interesting photographic vantage point.

 Tip These are the situations where a flip-out screen on the camera comes in handy (page 22); it lets you get "up high" or "down low" without climbing or bending.

- **Shoot downward** to make things look small.
- **Shoot upward** to emphasize the height of your subject.

Try shooting from the side, or from behind. Fresh angles make fresh photos.

Screen Displays

Your camera's screen and viewfinder almost always show more than just the scene before you. They can also display focusing marks, a battery meter, the current settings, and so on.

In fact, even cheapo cameras usually offer a Display button, right on the back, that cycles through various options for overlaying information on the screen:

- **Standard info.** Usually, you see a full-screen preview of what you're about to shoot, overlaid with a few key details: the battery gauge; the

number of shots remaining on the memory card; and maybe some photographic settings like the flash mode, the ISO setting (page 82), and so on. Crosshairs help you find the center point for composing and focusing your shot.

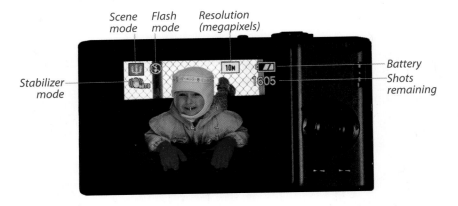

- **Grid.** This option draws a tic-tac-toe board over the entire preview screen, dividing it into thirds vertically and horizontally. It's supposed to be a guideline in case you abide by the Rule of Thirds, described above.

- **Nothing.** If you press the Display button enough times, you eventually come to a setting that removes *all* overlays from the screen. Now you see only the preview of your shot, which is useful for (a) purists and (b) anyone who has no idea what all of those symbols and readouts even mean.

- **Histogram.** On an SLR or advanced pocket cam, you may also be able to call up the *histogram*—a graph that shows you how the lights and darks are distributed in the scene. It shows you right away whether the whole thing is going to come out as a dark, muddy mess; a blown-out, superwhite ghostfest; or a nicely exposed photo. Details are on page 65.

- **Highlight warning.** Expensive cameras and SLRs also offer a *highlight warning* mode. It's described on page 66.

Take the Shot

All right. After that crash course in composition, you're ready to capture the image—but even that's not as simple as it seems.

The Half-Press Trick

The following information is extremely important. If you learn nothing else from reading this book, then—well, then it wasn't a very good book. But if the half-press trick is new to you, then your life is about to change.

Pocket cameras are awesome. The smaller a camera is, the more likely you are to have it with you when a great photo moment occurs.

But small cameras have one wildly annoying quirk: They take as much as half a second to compute the focus and exposure for each shot. In other words, if you just mash the shutter button, one of two things will happen:

- **You'll get shutter lag.** *Shutter lag* (page 9) may be less than a second, but a delay that long is death to photos of sports, action, and children. You'll miss the critical instant every time.

> **Tip** Camera companies define shutter lag as, "the microseconds between achieving focus and recording the shot." Normal people define it as, "the eternity between *pressing the button* and getting the shot." In other words, the manufacturers start the clock *after* the time-consuming part—the half-second it takes for the camera calculate focus and exposure! Thought you should know that, so you won't be fooled by camera-company specs.

There's virtually no shutter lag in SLRs. (An SLR has a separate sensor dedicated to performing the prefocusing routine; a pocket cam is designed to be as cheap as possible, so the main sensor has to do that job.) But on little cameras, shutter lag is a never-ending source of frustration and missed opportunities.

- **You'll get a worthless, blurry photo.** A few camera models snap right away when you mash the shutter button—because they *skip* the calculation of focus and exposure. They snap whatever they've got, which means you usually get a blurry, too-bright, or too-dark photo. Which, you could argue, is not ideal.

Fortunately, there's a simple solution: Use the *half-press trick*. Unless you have an SLR, you should use this trick on *every single shot you ever take*.

This technique appears in every camera manual, compact or SLR, right up front. But it's astonishing how many people don't know about it.

To execute the half-press trick, aim the camera at the subject *before* you're ready to take the picture. Half press the shutter button. You'll feel it stop part-way down; it's designed for this.

In under half a second, you'll hear a beep and see some indication on the screen that the focus and exposure have been locked. (For example, the crosshairs in the viewfinder might turn green.)

You've just made the camera calculate the exposure and focus *in advance.*

Keep the button half pressed until the moment of truth. *Now* squeeze the the rest of the way. This technique eliminates shutter lag, freezing the action closer to the critical moment.

All right, so what if your subject isn't *here* yet? What if you're trying to photo-graph your son's baseball swing, or your daughter on the merry-go-round, or a ski jumper in flight?

In that case, there's yet another trick to learn: Do the half-press trick while aim-ing at something *about the same distance away.* Half press when the *previ-ous* kid is at bat, or at the *base* of the merry-go-round where your daughter will arrive, or at the *flag* flapping beside the ski jump. Once you've heard the beep, you know that your camera has computed the focus and exposure—and as long as you keep the button half-pressed, it will lock in those settings even if you point the camera somewhere else.

Then when the ballplayer, carousel horse, or ski jumper finally shows up, you'll get instant response when you push down the rest of the way.

 Tip If you're taking a picture of a person or animal, *focus on the eyes.* That's where the soul and the personality are, and that's where your audience will naturally look first. So that's the most important part to have in focus.

Review and Repeat

After you take a shot, the camera displays it for a moment on the screen. It's a chance for you to see how it came out—maybe you need to adjust some-thing and take the shot again—but it's also a confirmation that you actually got the shot. (We've all met those timid friends who don't press the shutter button hard enough; they make the camera half press and maybe fire the redeye flash, but they never do trigger the shot.)

 Tip In the menus of your camera, you can specify *how long* this playback lasts. You might have choices like 2 seconds, 5 seconds, 10 seconds—and even Off. That would mean no playback at all, so you can take another shot immediately without waiting for playback. (Then again, you can *always* cut short the playback by tapping the shutter button. That means, "Hey—I'd like to shoot again now.")

Now, here's the thing about digital photography—the really, really big thing: There's no film to develop, no price to pay for bad shots. Your memory card probably holds hundreds or thousands of shots. In other words, there is *no penalty* for taking lots of pictures.

Later, you can always delete the duds. In the meantime, for every additional shot you take—from a different angle, with different settings, with a different zoom —you're increasing your odds of getting a masterpiece. So shoot a *lot*.

Shoot 200 photos at the graduation. Shoot 500 at the wedding. Shoot 2,000 during your cruise. So what? When you get them on your computer, you can always throw away (or file away) the 90 percent that aren't so impressive. But the remaining subset of photos will be the crème de la crème—just incredibly great pictures. You'll be *amazed* at your abilities as a photographer.

The best part of *Popular Photography* magazine, month after month, is the "How I Shot This" feature. There you'll see a breathtaking professional photo—accompanied by the two shots the photographer took just *before and after* the winner. At the time, the photographer had no idea which one would turn out to be the masterpiece. Seeing the outtakes on either side drills it home: The more you shoot, the better the *best* ones will be.

Deleting on the Camera

Should you delete the lousy shots right from the camera? Or wait until you get them transferred to your computer? It's another issue that photographers can debate until the cows come home and turn blue in the face:

- **Deleting right on the camera** takes time while you're on location. And you don't *really* know how bad the shot was, because you're examining it on a tiny screen about one gazillionth its actual size. And if you're in a hurry, you run the risk of deleting something good by accident.

 On the other hand, deleting bad shots makes more room on the memory card while you're still there to enjoy it. And when the pictures finally arrive on the computer, you get a much better feeling about your abilities, because only the good to great ones are left.

- **Deleting photos later, on the computer** means you wait longer for the transfer, because the camera has to send over a lot of pictures you're going to delete later anyway.

 On the other hand, how can you really be sure that a photo is no good, or unfixable, until you've seen it big and up close on the computer screen?

In any case, you can wrestle with your own personal demons to arrive at a decision on that one. In the meantime, note that deleting a picture from an inexpensive camera usually takes several steps involving different buttons. The idea behind that design is to prevent you from deleting an important photo by accident.

On an SLR, deleting a shot is usually slightly simpler. But it still involves at least one confirmation step, just as a safety.

Tip Even if you delete photos from your memory card accidentally, all is not lost. There are lots of memory-card recovery programs (usually $30) on the Web; in general, they really work. Use Google ("memory card recovery" or whatever) to find them.

But the sooner you use the recovery software, the happier you'll be. If you've used the memory card since the deletions (that is, saved new files onto it), your chances of recovery go down, because the camera might store the new photos right on top of the space previously occupied by the old ones.

Chapter 4:
The Ten Decisions

Every camera—*every* camera, from the cheesiest cameraphone to a $5,000 digital SLR—has an auto mode. You point, you click. The end. Next chapter!

But the fact that you've gone to the trouble of reading a book about photography suggests that—just maybe—you're interested in going *beyond* auto.

That's what this chapter is for. It's the heart of the book. It breaks down that one-second event (point, click) into a many-pages-long sequence of the 10 large and small decisions that go into taking a single picture.

Of course, you'll probably never actually have to make *all 10* of these decisions for a single shot. It's just that these are the photographic choices you *can* make. The trick is to learn when to call up each option.

In other words, read it all anyway. You may discover camera features you didn't know existed, approaches you might not have considered, and a tip or trick that sticks with you for the rest of your life.

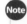 **Note** This chapter also gives you some insight into why photography is something of a black art. With so many variables at play, it's virtually impossible to say, "These settings are the *correct* settings." As a result, there are few more opinionated, cantankerous citizens of the Internet than photographers. Canon or Nikon? RAW or JPEG? Auto or manual? It's a parade of religious battles that will never end.

Beep On or Off?

Every camera beeps. At the very least, it beeps at the moment when it's acquired focus or locked in the proper exposure settings. Many pocket models also play a digital recording at the moment of capture. Usually it sounds like a camera shutter (duh!), but it's only a *recording* of a camera shutter—on these models, there's no real mirror clacking up out of the way in there. (Sometimes, the menus even let you change that sound to something different.)

All of this is well and good—unless you're someplace where those beeps and clicks would be distracting (string quartet concerts, plays, speeches) or frowned upon (neurosurgery, museums, church).

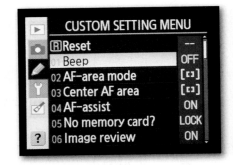

For that reason, every digital camera offers, somewhere deep in its menus, a chance to turn *off* those beeps. Hit your Menu button and start flailing away on those arrow buttons until you find it.

Flash On or Off?

Ah, the flash. If ever there was a photographic function that not enough people consider, this is it.

You can understand why it's there, of course. Cameras love light. Light is every-thing to a photograph: It provides the color, sharpness, and shadow.

And if there's not enough light for a decent exposure, well, by golly, your camera stands ready to provide that light all by itself.

What most people don't consider, though, is that the flash generally provides *horrible* light. It's harsh, it's white, it's direct, and it comes from a single point: your camera.

The results are usually *nothing* like what you're seeing with your eye. If you're close to the subject, the flash can blow out the picture, giving your best friend a ghost face that looks like it was photographed during a nuclear test. Worse, the flash illuminates only about the first 10 feet of the scene; everything beyond that comes out black.

The flash on small cameras can also produce *redeye,* the disturbing phenomenon where your dearly beloved's pupils turn red like the devil's (see page 50). And forget trying to take pictures through glass—at aquariums, in art museums, and through windows. Most of the time, you wind up with nothing but a big white splash of flash reflection. Enjoy, for example, this once-in-a-lifetime glimpse of the rare Estonian bifurcated snout shark:

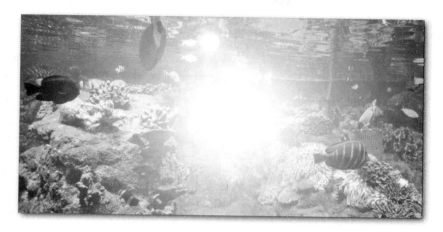

To make matters worse, most consumer cameras are flash-happy. Unless you step in, they fire the flash way too often.

In any case, most people make two mistakes with the flash: using it when they shouldn't, and *not* using it when they should.

When to Avoid the Flash

Your camera's flash probably has a range of about 10 feet. Beyond that distance, it does nothing at all—except waste battery power and annoy people.

You know when thousands of flashes go off at a rock concert, football game, or school play? Don't be one of those clueless people. They're all firing their flashes for *nothing.* Do they really think they're going to illuminate a singer, football player, or actor from 200 yards away? Remember: Beyond about 10 feet, the flash does absolutely nothing.

(Some of those people probably realize that the flash is pointless at that distance—but they don't know how to turn it *off.* More on this in a moment.)

The second time to avoid using the flash is, well, *whenever possible.* A no-flash picture is just about always better-looking and more realistic than a flash picture.

Now, plenty of times, you have no choice. Small cameras in particular may not be able to take certain pictures *at all* without the flash, like nighttime pictures and indoor shots where people are moving. (Without the flash, you'd get blur.) And sometimes the flash is essential for certain special effects, as described in Chapter 6.

But there are dozens of edge cases: situations where your camera is convinced that it needs the flash but in fact could do without it. If you can learn to identify these situations, you'll get much more realistic, attractive pictures.

For example, suppose you're in someone's garage, looking at a beautifully restored antique car with wood-spoke wheels. You take a shot in auto mode, and your flash fires. Well, guess what? The car isn't moving, and neither are you. So if you can keep the camera steady, or maybe bump up the ISO (page 82), you should be able to get away with turning off the flash. (See the next chapter for more on blur and ways to annihilate it.)

Or take two. Shoot one with the flash, and then try another with the flash off, holding the camera as still as possible. That way, you'll have a backup if the second one is blurry.

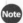 **Note** **To make sure your flash doesn't fire, see "Flash Modes," page 51.**

When to Force the Flash

This may sound nuts. But there's a very good reason to use the flash even on a bright, sunny day.

Suppose, for example, that you're taking a picture of a person outdoors. (Hey—it could happen.)

You aim the camera and half press the shutter button; the camera "reads" the scene and concludes that there's tons of sunlight. It would never dream of using the flash.

And it's correct that there's enough light *in the entire frame.* But it's not smart enough to recognize that the *face* you're photographing is in shadow.

The solution is to *force* the flash on—a very common photographer's trick. The flash can provide just the right amount of *fill light* to brighten your subject's face—without affecting the exposure of the background. (This presumes, of course, that you're standing within flash range—eight to 10 feet.)

No flash Fill flash (forced flash)

A fill flash like this makes outdoor portraits look a *lot* better. It eliminates the silhouette effect when your subject is standing in front of a bright background. Better yet, it provides very flattering front light. It softens smile lines and wrinkles, and it puts a nice twinkle in the eyes. (It also lets you ignore the old "rule" about taking photos on a sunny day: "Stand with the sun behind you.")

 Note To force the flash, see "Flash Modes," page 51.

These instructions, of course, apply primarily to cameras with a *built-in* flash. If you're using an SLR and you've bought an external flash, use *that* for your fill flash instead. Its more powerful light provides better illumination and flash range. It lets you supply light from any angle. And it lets you shoot people wearing glasses without getting a reflection.

Ways to Control the Flash

There are some ways to finesse the flash. If your camera has a face recognition feature, it's usually smart enough to throttle back the flash's power to avoid nuking your subjects' faces. On some cameras, you can actually adjust the strength of the flash using manual controls. As a last resort, you may even get away with blocking part of your camera's flash with your finger.

 These disparaging remarks refer mainly to pocket cameras. An SLR's flash is much better. First, it pops up high above the lens, which reduces the likelihood that you'll get redeye, described below. Second, you have manual control over its brightness.

Professional photographers, of course, don't use the camera's on-board flash at all. (In fact, high-end digital don't even *have* a built-in flash.) The pros generally use an external flash, which they hold or mount off to the side. The resulting off-axis light is a lot more flattering and natural than Ol' Lightning Bolt.

In fact, when possible, the pros even use white, gauzy reflectors, like those weird white discs or umbrellas, to soften and diffuse the flash's light, which is more flattering yet. (You can simulate the effect by—no joke—draping a piece of Kleenex over your flash.) And in the studio, they use *several* flashes—behind you, beside you, in front of you—for maximally amazing lighting.

Notes on Redeye

You've snapped the perfect family portrait. The focus is sharp, the composition is balanced, everyone's smiling. And then you notice it: The 10-year-old standing dead center in the picture looks like a vampire bat. His eyes are glowing red, as though illuminated by the evil within.

You've been victimized by *redeye*, a common problem in flash photography.

This creepy possessed-by-aliens look has ruined many an otherwise-great photo.

Redeye is actually light reflected back from your subjects' eyes. (On animals, it's more like green-eye or white-eye.) The bright light of your flash passes through the pupil of each eye, illuminating the blood-red retinal tissue at the back of the eye. Redeye problems worsen when you shoot pictures in a dim room, because your subject's pupils are dilated wider, allowing even more light from the flash to illuminate the retinas. Redeye is also a problem primarily with pocket cameras, where the flash is sitting within an inch of the lens. As a result, the flash's light goes out and back along roughly the same line.

Here are the solutions the world has come up with so far:

- **Don't use the flash.** Kind of obvious, but the truth is, you may do yourself a big favor by stifling the flash. Turn on some lights. Move closer to the window. Goose the ISO (page 82). Do something to give the camera more light to work with so it doesn't need the flash at all.

- **Use redeye-reduction flash.** You've almost certainly seen this feature in action: Instead of just flashing once, the camera emits a series of bright, strobing flashes right before the picture is taken. The subject's pupils are supposed to shrink in reaction to those blinding flashes, thereby admitting less light, so there will be less reflection.

 Unfortunately, there are two problems with the redeye-reduction mode: (a) It doesn't work very well, and (b) it's highly annoying.

 Tip If you do decide to use the redeye-reduction mode, don't make the common mistake of dropping your hands too soon, thinking that the camera's job is done. The photo isn't taken until the *last* flash, and it's hard to predict which one that will be—at least until you get to know your camera very well.

- **Move the flash away from the lens.** That way, the reflection from the retina doesn't bounce directly back at the camera. Unfortunately, on small cameras, it's a little tough to achieve much separation of flash and lens.

 As noted above, redeye is much less of an issue on SLRs. They have a greater separation of lens and flash—especially if it's an *external*, separate flash unit.

- **Fix it in software.** If you transfer your photos to the computer and discover, too late, that you've got redeye in some of your pictures, all is not lost. Photo-editing programs like iPhoto and Picasa (Chapter 8) have redeye-*removal* tools. They don't work perfectly, and they turn everybody's pupils jet black. But as a last resort, they're not bad.

 Tip In fact, some recent cameras detect redeye automatically—and fix it in real time, right in the camera.

Flash Modes

All right: Now you know that you're not a slave to the whims of your camera's flash. You can make it fire when the camera doesn't consider it necessary, or make it stay off when the camera's inclined to use it.

So what, exactly, are the steps?

To control your flash's behavior, press the flash mode button. It's a dedicated physical button, marked by the universal lightning-bolt-with-an-arrow-on-one-end symbol. Use it to open a menu of the camera's flash modes, or, on some cameras, press it repeatedly to cycle through the different flash modes.

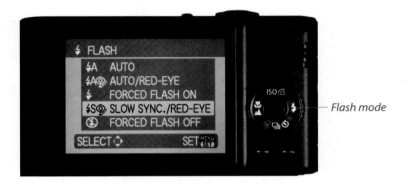

Flash mode

Here's what you'll probably have to choose from:

- **Auto.** The camera chooses when to fire the flash. (It's wrong about half the time.) Usually denoted by the word "Auto" or the letter A.

- **Redeye reduction,** as described above. Marked by an eyeball.

- **No flash.** Usually represented by a circle with a slash through it. Great for whenever you can get away with it.

- **Forced flash.** This is the mode for outdoor portraits. It's usually marked by a lightning bolt or the words "Flash on," "Force flash on," or "Fill flash."

- **Slow-synchro flash.** This mode, also known as *front curtain sync,* isn't as common as the previous four, but it's available on most of the nicer cameras. (On pocket cams, it may be called Nighttime mode, and its icon usually looks like a star or a moon over someone's shoulder.)

 The idea here is to flash once, illuminating your companion nicely—but then to leave the shutter open for a moment while it drinks in some light from the surrounding background. If it didn't do that, you'd get just a totally inky black background. This way, though, you can see the city lights, the campfire, the dusky street, or whatever's beyond your subject.

 As you can imagine, however, slow-synchro flash requires a steady camera. A tripod (or another immovable object) helps, although you can get away with a handheld shot if the subject is within about six feet away.

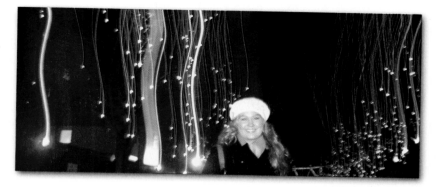

- **Second-curtain flash.** This one, also called *rear curtain sync,* is probably the least-used flash effect, chiefly because (a) it's hard to understand what it does and (b) it's hard to understand when it might be useful.

In essence, it's the same thing as the slow-synchro flash, but in the reverse sequence. That is, the shutter opens up to soak up the background *first*—and then the flash fires at the *end* of that interval.

The usual example people give for second-curtain flash is reversing the direction of moving lights (car taillight trails, for example). With slow-synchro flash, the trails seem to extend *forward* from the cars; with second-curtain flash, they seem to trail from *behind* the cars.

 Tip Usually, you can't control the flash in Auto mode. It goes off if the camera wants it to go off, which can be frustrating. In that case, consider switching to Portrait or Program mode, which are similar to Auto but let *you* control the flash.

If you have an SLR, you can control the built-in flash. You can throttle it down when you don't need quite so much light, for example. (Check the manual.)

Auto or Scene Mode?

Here's a dirty little secret: Plenty of professionals leave their cameras in auto mode most of the time.

It's true. Oh, they still duck into manual mode when necessary. (And there are also plenty who *never* use auto mode.) But today's digital cameras have extremely sophisticated light metering, white-balance detection, and autofocus; why not exploit their powers?

It probably goes without saying that auto mode works well for the huge majority of amateurs, too.

All SLRs, and a fair number of compact cameras, nonetheless offer manual controls, too—overrides for shutter speed, aperture size, focus, and so on. If you have them, you gain a lot flexibility you don't get in auto. Only with manual shutter-speed controls can you blur a brook into a milky, silky ribbon; only with manual focus can you specify *exactly* which element of a photo is in sharp focus. Chapter 6 gives these controls a workout.

Nowadays, though, there's something in between auto and manual: *scene modes*. If you've lived your life so far in auto, scene modes should be your first step up.

Camera companies have realized that learning to use manual controls is beyond the patience of casual shutterbugs. So, in their never-ending quest to make photography idiot-proof, camera makers routinely stock their latest models with a bunch of scene modes. These are prefab, memorized settings for common lighting and subject situations like Sports, Night Portrait, Beach/Snow, and so on. These canned modes exploit the flexibility of the camera without requiring you to know how to dial in specific settings.

 Note The most expensive SLRs generally don't have scene modes. The logic: If you're serious enough to buy a professional model, you probably know how to dial up the proper settings yourself. (In fact, to many professional photographers, the very *presence* of scene modes is insulting.)

You'll find the scene modes in one of two places:

- **On the Mode dial.** If there are just a handful of scene modes, they're probably right on the Mode dial itself, marked by tiny icons: a silhouetted person for Portrait mode, a pair of mountains for Landscape mode, and so on, as in the first two examples here.

- **On the screen.** If there are too many modes to fit on the dial, then calling up a scene preset is usually a two-step process. First, you turn the

Mode dial to Scene, or press the Scene button—and then, on the screen, you cycle through the various options until you find the one you want.

Truth is, there's no real magic to scene modes. They make pretty predictable changes to the camera's photographic settings. For example:

- **Auto mode.** The camera makes all decisions for you. It analyzes the brightness of the scene, distance to your subject, and so on, and chooses settings accordingly. Many newer pocket cameras actually switch to one of the *other* modes (like Landscape or Sunset, described below), if an examination of the scene suggests that that would be appropriate.

- **Sports mode.** (*Usual icon:* Running man.) Fast shutter speed. No flash. (Works only in bright light—like sunshine.) On nicer cameras, burst mode is turned on (page 57).

- **Portrait mode.** (*Usual icon:* Lady's head, often wearing a hat.) Large aperture, which increases the pleasant blurry-background effect. Especially receptive to skin tones.

- **Landscape mode.** (*Usual icon:* Mountains; sometimes there's a tiny cloud.) No flash (because the scenery is presumably farther away than 10 feet). Large aperture, creating a large depth of field—in other words, everything is in focus, near and far.

- **Night Portrait.** (*Usual icon:* Person with a star or moon over his shoulder.) A flash to illuminate the subject, then the shutter stays open to capture the background. In other words, the same thing as slow-synchro flash, described previously.

- **Night Landscape.** (*Usual icon:* Mountain with a star or moon over his shoulder.) No flash, slow shutter, wide aperture. Keep 'er steady!

- **Macro.** (*Usual icon:* A tulip, for some reason.) Macro, in photography, means super close up. Usually, the Macro setting has its own dedicated button, right there opposite the Flash button.

- **Kids & Pets mode.** Continuous autofocus. Once you've aimed the camera and half pressed the shutter button to lock focus, the camera continuously refocuses as you or your subject move around. (The idea here is that children and animals typically don't hold still.)

- **Candlelight.** No flash. Slow shutter speed. High ISO (page 82).

- **Underwater.** Sunlight becomes more diffuse the deeper you go, and different colors of the spectrum drop out at different rates; red being

the first to go. So Underwater mode adjusts the camera's white-balance controls to balance out the overwhelming blue tint.

- **Beach/Snow.** Throttles back exposure so the brightness doesn't nuke the details out of the bright areas. Adjusts white balance for proper colors in sunshine. Boosts color *saturation* (vividness) to avoid pale sand and sky.

- **Fireworks.** No flash. Long exposures (slow shutter) to capture those fireworks trails—so the camera really has to be sitting still (tripod, wall). Autofocus at infinity (because it's so dark, the camera wouldn't otherwise know what to focus on). Large aperture to keep everything in focus. Low ISO to minimize digital noise (page 82).

- **Sunset.** Boosts saturation of reds, oranges, and yellows. Large aperture to keep everything, near and far, in focus.

- **Panorama.** Very cool. The point here is to let you take several side-by-side photos—and the camera stitches them all together. Step-by-step instructions are in Chapter 6.

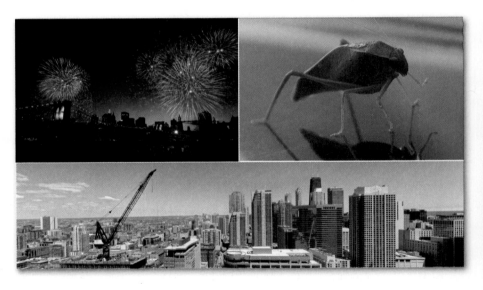

Use a Manual Mode?

All SLRs, and some fancier compact cameras, offer the mystifying but ultimately rewarding modes labeled P, A, S, and M. They're designed to give you much more manual control over the exposure of each shot than you'd get in a scene mode or auto mode.

You can read much more about these manual modes in the next two chapters. But here's a quick rundown:

- **P (program mode).** Program mode is a lot like auto, really; the camera chooses the aperture size and shutter speed on its own, ensuring a correctly exposed photo almost every time.

 The difference is that you can override a *few* of the choices the camera usually makes itself—like white balance, ISO, drive (burst) mode, and, most useful of all, whether or not the flash goes off. If you have an SLR, in particular, you can think of P mode as, "Just like auto, except *I* get to say when the flash fires." It's terrific.

 Note Not to split your head open or anything, but there's also something called program *shift* mode on some SLRs. Once you've half pressed the shutter button in P mode, the camera displays the shutter speed and aperture that it would like to use—but it permits you to tweak either of those settings; it compensates by adjusting the *other* setting, exactly as in A or S modes (described next). The steps vary by camera, but it might entail half pressing the shutter button while you turn a control dial.

- **S (shutter-priority mode).** A famous semiautomatic feature. You adjust the shutter speed, usually by turning a dial (on an SLR) or pressing the arrow buttons (on a compact)—but as you do so, the camera helps you out by adjusting the *aperture* size (f-stop) to compensate for the change in shutter speed. That way, you don't have to worry that you'll wind up with a crazy exposure. Details on page 74.

- **A (aperture-priority mode).** Just the opposite. You adjust the aperture size, and the camera compensates by changing the shutter speed. Details on page 77.

- **M (manual mode).** For veteran shutterbugs only. In fully manual mode, the camera doesn't compensate for *anything.* You can change the shutter speed and aperture size completely independently, potentially creating absolutely hideous exposures, and the camera simply sits back and keeps its little mouth shut. It makes no attempt to warn you that at f22 and 1/500th of a second, shot indoors at night without the flash, your photo will look like a slab of onyx in a coal mine at midnight.

Burst Mode or One-Shot?

Most people think that the shutter button does only one thing: Press it once, get one photo. But on many cameras, it also has a *burst mode.* That's where

the camera keeps taking pictures for as long as you hold the button down. (Sometimes there's a limit on the total number, dictated by the camera's electronic memory or the memory card you're using. But you get the point.)

On your basic $200 pocket cam, the *speed* of those rapid-fire shots won't exactly set your hair on fire; you might get two photos every three seconds.

 Note Usually, the screen image pauses momentarily to show you each photo after it's snapped—which means you can no longer see the high-speed subject (biker, diver, dancer) you were trying to shoot.

This is yet another good argument for having a camera with an optical viewfinder, which would bypass that entire problem.

On an SLR, though, you can get some excellent bursts—three shots *per second* on the less expensive cameras, seven or more on the pricier ones.

Burst mode is great for sports and wildlife photography, of course, because those are famously *brief* photo ops; you want to fire as many shots as you can during those fleeting moments. (You can see an example of the result on page 24.) Later, you can pluck out the one best shot.

But Burst mode is also great for portraits, because you can choose from multiple gradations of smile and expression.

In any case, the steps for changing your camera from single-shot mode to burst mode are different on every camera (and cheapo cameras may not even offer burst mode). On an SLR, you may have a physical Drive-mode button right on the camera, marked with a series of overlapping rectangles (representing burst mode); as you press this button and turn the control dial, the camera cycles from single-shot mode, to burst mode, to self-timer mode.

Drive mode

On a pocket cam, you may have to hunt through the menus for this option.

White Balance: Manual or Auto?

Most people new to photography have never even heard of white balance. And the truth is, not many people fiddle with this setting, especially among pocket cam owners.

Anyway, here's the deal: It might freak you out to find out that your brain is constantly playing tricks on you, and *color casts* are a case in point. Fluorescent lighting is slightly bluish; traditional incandescent indoor lights are a bit yellow; snowy scenes are often bluish, too. But the weird thing is that it doesn't look that way when you're there! Your brain instantly adapts to these lighting casts, making the lighting seem normal.

Cameras, as you've probably learned by now, are brainless. So those varying *color temperatures,* as they're called, affect your finished photos. From "coolest" (most blue) to "warmest" (most red), the common lighting conditions that produce color casts are candlelight, tungsten (incandescent) bulbs, sunrise/sunset, fluorescent bulbs, camera flash, bright and sunny, daylight with overcast skies, and, finally, outdoors in the shade.

In the days of film, you'd have to correct these color casts by installing a tinted filter on your lens. On a digital camera, though, life's a lot easier: The sensor can do the correcting.

It's supposed to do that automatically, in fact—and generally does, which is why so few people muddle with white balance. Still, there are two reasons why you might want to set the white-balance mode manually:

- Because the camera is not doing a good job, and the pictures are looking color-casty.

- Because you want to try a special effect by deliberately choosing the *wrong* white-balance setting. In this picture, for example, the snowy scene looks fine with the auto white-balance setting (left). The version on the right was shot with the Tungsten white-balance setting, even though there wasn't a single lightbulb shining on the yard. The Tungsten setting gives the scene a bluer, chillier look.

An SLR has a WB (white balance) button right there on the back. A pocket camera's white-balance controls are, almost always, in the menus somewhere.

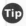 **Tip** If you're shooting RAW (see below), you don't have to worry about getting the white balance right when you shoot. You'll have complete retroactive control over the white balance later, on the computer.

Either way, you'll generally find that there are presets for precisely the common conditions listed above: Tungsten, Fluorescent, Daylight, Flash, Cloudy, and Shade, for example. You have nothing to lose by experimenting—take a shot, see how it looks on the screen, change the setting, try again—but again, white balance is generally the least of your worries. Besides, you can always correct a color cast later, once the photo's on your computer (page 206).

 Tip Better cameras offer one more white-balance option, called Custom. Here, you're supposed to *teach* the camera what "white" is in the current lighting conditions, so it knows exactly *which* color cast to subtract. You're supposed to fill the frame with something white or light gray—a shirt cardboard, piece of paper, or even a white-balance *card* sold just for the purpose—and then hit the OK button.

RAW or JPEG?

If you have a typical pocket camera, skip this section. It's reserved for the owners of SLRs and a very few advanced, more expensive smaller cameras.

It's about the *RAW* file format. Understanding it requires some background.

See, most cameras work like this: When you squeeze the shutter button, the camera studies the data picked up by its sensors. Based on this analysis, the software makes decisions about how much to sharpen the photo, which white balance setting to use, how to set the exposure levels, how saturated the colors should be, how high the contrast ought to be, and so on. The camera crunches the raw data from the sensor, locks in all of these settings, and spits out, onto your memory card, a processed, finished JPEG graphics file.

For millions of people—including plenty of professionals—the resulting picture quality is just fine, even terrific.

But there's another crowd, consisting of professionals and advanced amateurs, who can't stand the thought of all that in-camera processing. They'd much rather make all of those creative decisions themselves. They'd prefer that the camera not process the original image data at all, and instead deliver *every*

iota of original picture information onto the memory card. That way, later, these pros can process the file *by hand* once it's been safely transferred to the computer, using a program like Photoshop, Photoshop Elements, Picasa, iPhoto, Lightroom, or Aperture.

That's the idea behind the RAW file format, an option in every SLR and a few pricier compacts.

 RAW stands for nothing in particular, and it's usually written in all capital letters like that just to denote how important serious photographers think it is. (In fact, it's not even a standard file format. Every camera company has its own RAW file format. The Nikon format is called .NEF; the Canon format is .CRW; and so on. Now you know why owning Adobe Photoshop entails downloading frequent updates; Adobe is constantly releasing new RAW file interpreters to keep up with the new camera models on the market.)

You choose what you want the camera to capture—RAW files, JPEG files, or both at once—using its menus.

The beauty of RAW files is that once you open them up on the Mac or PC, you can perform astounding acts of editing on them. For example, you can change the white balance or the exposure of the scene *after the fact.* And you don't lose a single speck of image quality along the way.

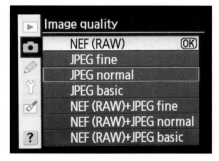

Note, however, that there are two huge downsides to shooting in the RAW format (or "shooting RAW," as shutterbugs say).

First, a RAW image isn't compressed to save space; it's a complete record of all the data passed along by the camera's sensors. As a result, it's huge. It fills up your memory card much faster, fills up your hard drive much faster, and takes much longer to transfer from the former to the latter. For example, on a 12-megapixel camera, a JPEG photo is around 3 MB, but the same picture is over 10 MB when saved as a RAW file. Most cameras take longer to store RAW photos on the card, too, which can really put a damper on burst mode shots.

Second, RAW editing is a serious time drain. You wind up spending several minutes, or maybe many minutes, on *each* photo, tweaking it to perfection as your life ticks away. It's worth it for a professional wedding photographer or someone on assignment for a magazine.

But in the meantime, remember that you can edit regular JPEG files in many of the same ways (just not as radically). Depending on the kind of shooting you do, the reasons you shoot, and the importance of your photos to the outside world, opting for the RAW format may not be worth it.

How Much Exposure?

Every camera has a *light metering* system built in. It's supposed to measure the brightness of the scene and to adjust the overall exposure accordingly.

 Exposure means "How bright or dark the overall shot comes out." It comes, of course, from the days of film, when it referred to how long you *exposed* the film to light.

There are times, though, when this circuit gets confused. Bright windows behind the Christmas tree will make the camera say, "Ooh, very bright scene. I'll darken things a bit to compensate"—but that makes the tree come out too dark, with all the detail lost in shadow. Or imagine a campfire at night. The camera will say, "Wow, this scene is 70 percent pure black! I'd better brighten it up"—and the photo will wind up so bright that the flames become pure, blown-out white, with none of the cool colors you saw with your eye.

Most cameras offer two ways to handle these situations. (Often, you'll make these adjustments *after* you've seen what the camera does on its own—which is botch the shot.)

Exposure Modes

First, you can change *how* the camera assesses the scene. All SLRs, and some smaller cameras, let you choose from a selection of metering modes (they're in the menus somewhere):

- **Center-weighted.** The name says it all: The camera assesses the light in the entire scene but gives special consideration to the exposure of the *center* chunk of the frame. Remember the Christmas tree example? If the exposure were center-weighted, it would have been more likely to come out properly exposed. The windows on either side would probably be "blown out" (that is, *way* too bright, practically white), but at least the tree would look right.

 This is the oldest and least precise exposure method. Most modern cameras come set to use one of the following alternatives.

- **Matrix (multisegment) mode.** In this mode, the camera chops up the scene into segments of various sizes and shapes. It measures the brightness, contrast, and sometimes even the color temperature of each segment separately, and then analyzes them, giving special weight to the part that's in focus.

 Finally, the camera decides which parts of the scene are important for calculating exposure, and which parts it can ignore. This sophisticated anlaysis usually results in a very accurate assessment of exposure.

- **Spot-metering mode.** This one's a lot like center-weighted, except the camera assesses the light on only a *tiny spot*, usually coinciding with the spot that's in focus, constituting maybe 1 or 2 percent of the entire photo. This is a good option when there's high contrast in the scene—very bright areas and very dark areas—and you want to make sure one *particular* object, face, or spot isn't lost in brightness or darkness. (If that item isn't in the center of the shot, aim the camera so it is, half press, and then move the camera to reframe the scene.)

- **Face recognition.** Here again, using the face recognition option in most modern cameras (shown on page 21) is a great solution when you're photographing people. It avoids all the fussiness of the other exposure modes and just tells the camera, "Make sure the faces come out. I don't care about the rest of it."

Exposure Compensation

There may be times when, despite all of its options, the camera still guesses wrong about the exposure. You try the shot a couple of times, and it's still coming out too dark or too light. There's just something about the lighting in the scene that's throwing it off. (Bright snow or beach scenes tend to make cameras darken up too much; twilight or forest scenes can make it overbrighten.)

In those cases, you can manually override the camera's choices. You can *dial up* a darker or brighter scene, thanks to a little adjustment called *exposure compensation*. This one's so common, it even has a sliding scale and a special notation. On most cameras, you can nudge the exposure upward or downward by two or three steps, in third-of-a-step units.

Behind the scenes, you're actually telling the camera to adjust its aperture or shutter speed slightly to brighten or darken the shot.

On an SLR, there's a dedicated button just for exposure tweaks like this. It has a standard icon, shown on the next page at left.

On a compact camera, exposure compensation is usually hidden in the menus, if you have it at all. But once again you'll find a sliding scale, marked with values from, for example, EV–2 (much darker) to EV 0 (normal) to EV+2 (much brighter).

On both types of cameras, you may need to switch out of Auto mode to get access to these controls.

Tip Whatever you do, don't forget to *reset the exposure compensation to 0* when you're finished with this shot. Otherwise, you might go the entire day shooting precious photos at a cranked-up or cranked-down brightness. And you might not discover that all of your shots are ruined until it's too late: when you see them on the computer screen for the first time.

Exposure compensation

 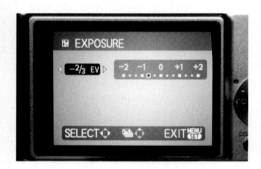

Exposure Bracketing

On an SLR, and on rare advanced compacts, you can request a useful little feature called exposure *bracketing.* That's when the camera takes three shots in a row, of the same thing, with the same settings each time—except for the exposure. The second shot uses the exposure that the camera considers best. But the first and third shots use slightly lower and higher exposure settings. So you wind up with three shots: one a tad darker than, one squarely on, and one a tad brighter than what the camera would choose for itself.

Since you're shooting digital, taking three shots instead of one costs you nothing. Later, you can look through the three and throw out the two that weren't quite right. In the meantime, you've just tripled your chances of getting *exactly* the right exposure.

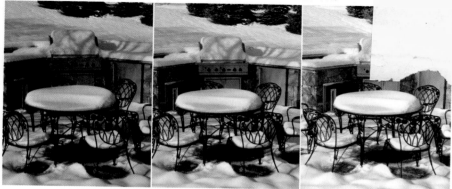

EV –1.0 EV 0.0 EV +1.0

If you burrow into the menus far enough, you'll find that you can specify how *much* darker and lighter those two bookend shots are, in EVs (steps of exposure). On some cameras, you can even opt for *more* than three shots in a bracket burst—five, for example.

When you're shooting a very important photo, or if you're having any trouble with exposure, bracketing is a very useful option. Don't forget about it.

> **Note** Exposure bracketing isn't the only kind of bracketing. SLRs may also offer white-balance bracketing (you get several shots of the same scene, each with a different white-balance setting); flash bracketing (several shots, each with the flash set to a different power); and focus bracketing (several shots, each focusing at a slightly different distance). Focus bracketing is handy in macro (super-close-up) photography, because when it's all over, you can choose the shot where the largest section of your bug, flower, or coin appears to be sharp.

The Histogram

The *histogram* is a little graph you can call up onto the screens of SLRs and advanced compacts. It's a self-updating visual representation of the dark and light tones that make up your photograph.

> **Note** Sometimes it's a white graph on a black background; on advanced cameras, you can see each of the component photo colors (red, green, blue) in its own histogram.

The amount of the photo's darker shades appears toward the left side of the graph; the lighter tones are graphed on the right side.

Therefore, in a very dark photograph—a coal mine at midnight, say—you'll see big mountain peaks at the left side of the graph, trailing off to nothing toward the right. A shot of a brilliantly sunny snowscape, on the other hand, would show lots of information on the right, and probably very little on the left.

The best-balanced pictures have some data spread across the entire histogram, with a few spikes here and there. As long as there's visual information across the entire histogram—and the mountains reach ground level at the edges of the screen—then you've got a nicely exposed picture.

A severely under- or overexposed photo, meanwhile, has mountains all bunched at one end or the other. And if the mountains seem to get *chopped off* at one side, then you're going to lose some details in either the shadows or the bright spots of your photo. Fiddle with the exposure until the mountain ranges fit entirely on the screen.

This is, to be sure, an advanced topic, and plenty of people never lose a wink of sleep worrying about the histogram. In the meantime, it's good to know that the histogram is there, another tool in your arsenal for getting the exposure right.

The Highlights Warning

If you turn on the highlights warning (page 40) on your SLR or advanced compact, then certain parts of the preview on the screen—the brightest parts of the scene—slowly blink pure white, on and off. The camera is warning you that these are the parts of the shot that will be *blown out;* they'll be so overexposed, so white, that no detail will remain.

That could be a bad thing. If *important* parts of the picture are blinking, the scene is too bright and you need to back off the exposure—maybe by using the exposure compensation controls.

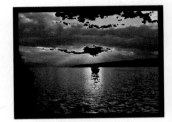

On the other hand, a little bit of that blinking is no big deal, especially if it's in unimportant parts of the shot, or parts that are *supposed* to be pure brilliant white, like sunlit twinkles from a lake. No digital camera can handle as great a range of darks to lights as your eye can, so getting perfect detail in both the darkest *and* the brightest parts of the same shot may be impossible.

Which Focus Mode?

Just as most cameras offer different ways to analyze the light in the scene, most also offer different ways to analyze the *focus* of the scene. In essence, you have two questions to answer: *where* to focus and *when* to focus.

Where to Focus

All cameras can focus automatically. But SLRs and some advanced small cameras let you *override* that autofocus—and, in fact, let you indicate which part of the scene you want to be in focus. Here are your options:

- **Center focus.** Unless you change the settings, most cameras, out of the box, use this method: They focus on whatever's in the center of the frame. And most of the time, that works fine.

> **Tip** Here's an oldie but a goodie. Suppose you don't want your subject to be in the center of the picture, but you do want the subject to be in sharp focus. In that case, aim the camera so the subject is in the center. *Half press* the shutter button (sounding familiar?). When you hear the beep or see the indicators change, you've locked in the focus. Keep the shutter button half pressed and then re-aim the camera, recomposing the shot so the subject is no longer in the center. Doesn't matter—that person or thing is still in sharp focus. Push down the rest of the way to get the shot.

- **Spot focus.** On an SLR, you can switch to a *spot-focus* mode. That's where you see little boxes or + signs arrayed on the scene; using the arrow keys on the back, you highlight the one you want to be in focus.

 So why use this method instead of the focus-and-recompose trick described in the previous tip?

 Because if you're using a tripod, or if you've carefully leaned your camera against some immovable object in low light, it's much easier to adjust your focus spot on the screen than to move the camera and recompose the shot.

 Furthermore, half-pressing locks in focus *and* exposure. In some cases, that could mess up the exposure for the final shot. There may be a patch of light, for example, that's present when you half-press, but not when you re-aim—so the camera locks in the wrong exposure. Spot focusing avoids the whole problem, because you're not changing where the camera is pointing.

- **Face recognition.** Talk about a mega-hit feature! Face recognition circuits first appeared in cameras in 2006; these days, almost every camera model on earth offers them.

 When face recognition is turned on (and most pocket cameras come with it turned on, at least in auto and Portrait modes), the camera identifies faces in the scene—as many as 20 of them at once. The latest models even recognize faces that aren't looking straight forward at the camera.

 Little rectangles appear around the faces in the scene, even as your subjects move around (shown on page 21). The idea, of course, is that the camera intends to calculate its focus and exposure based on the faces. After all, *people* are the most common subject of amateur photos.

 Face recognition mode is better than the usual center focus mode, because it keeps the face in focus even if it's not centered in the frame. And it's better than spot focus mode, because you don't have to fuss with moving a little cursor around the screen. It's all automatic and, in general, very successful.

- **Manual focus.** SLRs and advanced pocket cams also let you use *manual* focus, much beloved by many experienced photographers. In this mode, of course, *you* —not the camera—do the focusing. On an SLR, you focus by turning the black ring on the lens; on a pocket camera, you generally use the arrow buttons to adjust focus so that the in-focus spot is closer or farther away.

 On some cameras, you can zoom in to the image while you're using manual focus—that is, you can enlarge the preview on the screen or in the viewfinder. That's incredibly helpful in assessing your success as you focus; without zooming in like this, it's tough to tell when you've achieved the perfect focus position. The method for triggering this feature is different on every camera, so cuddle up with your manual for this one.

Truth is, all cameras generally do an excellent job of autofocus. So who would fiddle with the slower, fussier manual focus in this day and age?

Consider shooting through fence posts, zoo cage bars, or, worse, a chain-link fence. You might find that the autofocus insists on focusing on the *closest* element in the scene—the fence—rather than what's beyond it. Switching to manual focus neatly overcomes that problem.

Dark situations sometimes stymie the autofocus, too. Manual focus, in those cases, may be your only chance of getting the photo at all.

Then there are close-up portraits. Many cameras come set to focus on whatever is *closest*—in this case, the tip of your model's nose. Not the eyes, which is what should get the focus in a portrait.

Finally, autofocus also takes more time—as you now know, it's a key contributor to shutter lag—so manual-focus mode is also handy when split-second timing is of the essence.

When to Focus

Your camera may also offer a choice of *when* to focus.

- **When you half press.** This option is available on every camera. It simply means: "I'll focus when you half press the shutter button." It also means: "At that point, I'll lock the focus at that distance—and keep it there as long as you're half pressing, even if you point the camera at something else." In other words, this is single-focus mode. One measurement of focus, one time.

- **Continuous autofocus.** This option is found in SLRs and advanced smaller cameras; it's sometimes called AI Servo. In this mode, the camera *continuously* recalculates focus, even if your camera moves or the subject moves, as long as you're half pressing the shutter button. As you can imagine, it's handy for action shots, racing cars, and anyone under five years old.

 Tip Then there's *predictive* continuous autofocus, available in nice SLRs. That's where the camera keeps tracking the subject even if it momentarily *leaves the frame,* by calculating its trajectory. Neat.

It's especially great for burst mode (usually on an SLR). Suppose, for example, that an ice cream truck has burst into flames and is now barreling directly toward you, out of control. You put the camera in burst mode, thinking that this will make a heck of a shot.

But if you just did the half-press trick, then the first shot would be in focus and subsequent shots would be increasingly out of focus as the truck closes in on you.

But if you put the camera in continuous mode, then every shot in your burst would be in focus as the truck approaches, right up until the moment when you get run over.

It's not foolproof—distance, lighting, subject speed, and other factors can affect its effectiveness—but it's great when it works.

Adjust the Light Sensitivity (ISO)?

Here's another setting you'll probably use often as a correction to a shot you've already taken: cranking the ISO up or down.

In the film days, ISO (also known as ASA) was a measurement of the light sensitivity of a particular kind of film. You'd buy ISO 100 or 200 film for bright outdoor shoots, and 400 or 800 for low-light situations. But now that you're digital, you don't have to fuss with swapping film rolls in and out; you can change the ISO setting of your camera with the push of a couple of buttons.

Lower ISO settings always produce better photo quality. So the only reason you'd ever want to crank it higher is to prevent *blur* in low-light shots. See Chapter 5 for a complete discussion.

Chapter 5:
The Anti-Blur Chapter

W hat separates a lousy photo from a great one? Well, there's the subject matter, the lighting, the composition—all that artsy stuff that depends on you, the photographer. But some of the greatness depends on the camera itself: namely, color and sharpness.

Ah, sharpness. It's the Holy Grail, isn't it? "Wow, this is such a nice, sharp photo!" someone might say, admiring your prints. Or: "Too bad it's a little blurry." (Software can help to sharpen up a picture *a little*. But if it's actually out of focus or blurry, then there's no hope.)

As you've probably noticed, blurry pictures are more likely to occur in these situations:

- **In low light.** Less light comes through the lens; the shutter stays open longer to compensate; there's more time for jiggles to happen; blur results.

- **When you're zoomed in.** Zooming in magnifies the scene—and amplifies your hand jitters, too.

- **When the camera is moving.** Of course, bouncing along in a car or on a bike is one sure recipe for blur, because the camera itself is moving while the shutter is open. But even if you're standing in one place, the ordinary, very tiny jitters of your hand can also be enough to introduce blur.

- **When the subject is moving.** Any movement in your scene can turn into blur if the shutter speed isn't fast enough to freeze it. (More on this in a moment.)

This is not to say, of course, that sharpness is *always* what you want. A little background blur is always a delicious feature of professional portraits, for example. And when you're trying to emphasize speed in a photo—bikers rounding a corner, traffic zooming through an intersection—some motion blur is precisely what you're after. (Chapter 6 tells you how to get those effects.)

But when you *want* your photo to be sharp, you should be able to get it. That's what this chapter is about.

It will also teach you about some of the most important technical aspects of photography: shutter speed, aperture size, and light sensitivity.

Shutter Speed and Aperture

Here it is, folks: the analogy of the year.

Suppose you have an empty wooden barrel standing in your back yard with a hole in the lid. It starts to rain. The question is, will the barrel fill up with water?

The answer is, "It depends."

First, it depends on the size of the hole. If it's the size of a quarter, then the barrel is less likely to fill up completely than if the entire lid is missing.

Second, it depends on how long it rains. If it stops 10 seconds from now, the barrel probably won't fill up, no matter how big the hole is.

Now then: Your camera is like that barrel. Except instead of filling it up to the top with rainwater, your job is to get enough light to shine on the sensor inside. But once again, there are two variables involved: how long the hole (the shutter) remains open, and how big the hole gets.

See, your camera is usually completely dark inside; it's a sealed-up box. But when you take a picture, the shutter briefly opens, creating a hole—an *aperture*—that lets in light.

Your camera can adjust the *size* of this aperture. It can be bigger or smaller, thereby controlling how much light gets in. (Inexpensive cameras make this decision automatically. Fancier cameras let you choose the aperture size before you take each shot.)

And, of course, the camera can also control how long that hole remains open. That's the *shutter speed*. This, too, can be either automatic or manual. On nice cameras, you can dial up speeds as quick as 1/500th of a second or as slow as—well, almost forever.

Clearly, shutter speed and aperture size are related. You can get away with a faster shutter speed if you make the hole larger. (That's what you want to do when, for example, you're trying to freeze an athlete in mid-jump.)

Or maybe you want to keep only a small area in focus and have the rest of the shot softly blurred, as in the shot on page 76. To get that effect, photographers deliberately dial up a *large* aperture. That means, of course, that the shutter speed will be nice and fast.

But here's the problem: The longer the shutter stays open, the greater the chance of a blurred picture. During that time, something might move—either your subject or your hand. Just the tiniest amount of motion is enough to make the picture blurry.

All right, that's the chalk talk. Now you have the technical background you need to appreciate the solutions. Basically, they boil down to these two approaches:

- **Let in more light.** That way, the shutter can fire fast, so there's less time for the camera (or the subject) to move.

- **Park the camera.** If the camera itself is steady, there won't be any camera-movement blur. So it doesn't make any difference how long the shutter stays open.

Use Stabilization

The biggest breakthrough in digital photography in the past few years was the invention of image stabilization. These systems work in several different ways, but the good ones—*mechanical* stabilizers—actually jiggle the sensor around, in real time, 4,000 times per second, to counteract the motion of the camera itself. Hard to believe, but it really works.

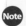 **Note** There's another kind of stabilization, found in cheap cameras, known as *fake* stabilization. (That's not what the camera companies call it, but you get the point.) In these cameras, nothing moves; instead, the cameras attempt to eliminate blur by goosing up the ISO, as described on page 82. It doesn't work very well.

In some SLRs, the stabilization is in the lens itself; the glass is actually vibrating, not the sensor in the camera. But here again, you get far fewer blurry shots. (Remember, though, that no camera stabilizer can do much about moving *subjects*.)

Speed Up the Shutter

Another obvious way to eliminate blur is to speed up the shutter (if your camera offers manual control over shutter speed, of course). If it opens and closes very quickly, then there's very little time for the camera (or the subject) to move. So the scene appears frozen.

And indeed, that's precisely how you *freeze action:* an athlete in mid-leap, water in mid-spray, and so on.

But remember that if the shutter is open only briefly, there's not much time for light to hit the sensor—so this technique works only when the light is good. In low light, like indoors, without the flash, a fast shutter speed produces a darkish photo.

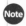 **Note** If you have a pocket camera, you've probably never even seen this problem, because your camera doesn't let it happen. It automatically fires the flash or makes the shutter stay open longer to make sure it gets enough light.

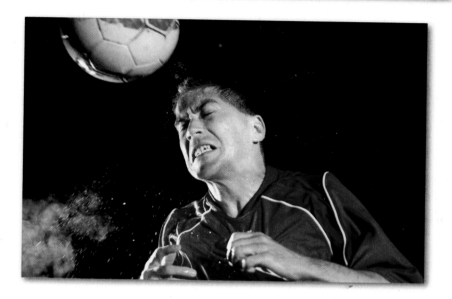

Where to Find It

Most SLRs have a special setting on the Mode dial just for *shutter-priority mode*. It's usually labeled either S or Tv (which stands for "time value"—there's no cable TV service on your camera). In this mode, turning the camera's little black thumbwheel adjusts the shutter speed.

Watch the screen to see the numbers go by. It's not especially easy to understand:

- **Numbers with quote marks** mean seconds. So if the screen says 2", for example, the shutter on your next photo will stay open for 2 seconds. That's a *very slow,* very long shutter speed, suitable only if your camera is on a wall or a tripod.

- **Numbers without quote marks** are meant to be the *bottom halves of fractions.* If it says 2, you'll get 1/2 second. If it says 500, that's 1/500th of a second—a very *fast* shutter speed, suitable for freezing action.

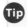 **Tip** If the result is too dark, slow down the shutter speed to the next notch; the camera is already opening the aperture as wide as it can.

On a pocket camera, if there's no S on the Mode dial, then you have to press the Menu button to find the shutter-speed settings. You then adjust the actual shutter-speed number by pressing the up- or down-arrow buttons on the back of the camera.

Open the Aperture

Remember, the shutter and the aperture are yin and yang. You can speed up the shutter without changing the amount of light—if you make the aperture larger. You can make the aperture smaller and keep the same amount of light—if you keep the shutter open longer.

Adjusting the aperture size does more than just admit more or less light, though. It also affects the *depth of field*—that is, how much of the scene is in focus, front to back. A larger aperture gives you a *shallow* depth of field; in this picture, for example, both the foreground and the background are blurry. Only the middle ground is sharply in focus.

You can read more about how the aperture controls the depth of field on page 113.

For now, it's enough to note that if your shutter offers modes for shutter speed and aperture, the camera handles the adjustment for you. That is, if you choose a faster shutter speed, the camera enlarges the aperture automatically

to compensate. And vice versa. In other words, the camera takes care of soaking in the amount of light it needs.

All bets are off when you choose the M mode, though. That's full automatic: You can fiddle with aperture and shutter speed yourself, with no help from the camera. Until you know what you're doing, you can wind up with a lot of too-dark and too-bright photos.

Where to Find It

On SLRs, look for an A or Av setting on the Mode dial. In this mode—called *aperture-priority mode*—you can turn the thumb wheel to adjust the aperture setting (watch the screen as you do that, to see what you're dialing up).

Aperture is measured in the same units they used to use for film cameras: in *f-stops.* A very small aperture might be f22; a fully open aperture might be f1.8.

 Yes, you're absolutely right: The numbers are backwards. You'd expect a higher number to mean a *larger* opening. You can thank those old-tyme film photographers for sticking us with this system.

Maybe this mnemonic helps: a smaller *f-stop number* gives you a smaller *depth of field*. (Or maybe not.)

Not many pocket cams offer an A setting right on the Mode dial. If it's not there, you'll have to delve through the menu system to find this option. In the end, you'll press the up- or down-arrow buttons on the back of the camera to adjust the f-stop.

Fire the Flash

As you can imagine, blurry shots are mostly a problem in low light, such as indoors or in the evening. After all, in bright light even a fast shutter speed, and even a smallish aperture, lets in enough light to make the sensor happy.

So here's one quick way to eliminate blur: Use the flash.

As long as your subject is close enough to be illuminated by your camera, the flash neatly solves the blur problem—by solving the shutter-speed problem. The flash provides enough light that the shutter can snap quickly; there's no time for the camera (or the subject) to move, and therefore there's no blur.

There's a huge problem with this approach, though: You wind up with a flash *photograph.* Often, that's a totally different beast, resembling nothing like what you were seeing with your eyes. For example:

- If you're too close to the subject, the flash blows out the picture, turning your best friend into a ghost face that looks like it was photographed during a nuclear test.

- If you're farther than about 10 feet away, the flash is too weak to do anything useful at all. (This means you, school-play parents.)

There are some ways to tailor the flash (see page 49). And sometimes, you have no choice; you have to use the flash. Other times, you *want* the flash to fire for certain special effects; all of this is described in Chapter 6.

In the meantime, though, when you're trying to take a picture in low light, and you *want* it to look like low light, avoid using the flash. Use one of the other techniques described here.

Set Up a Tripod

Built-in stabilization can take you only so far. It might permit you to choose a *slightly* lower shutter speed, or it might make the difference between a crisp shot and a blurry one in twilight.

The built-in stuff can't perform miracles, though. It can't give you a sharp shot of the constellations, or of city lights across the river at night. And it can't keep

the forest sharp but blur the babbling brook when you're using a very slow shutter speed on purpose (page 92).

In these situations, you need to bring in the big guns: a tripod.

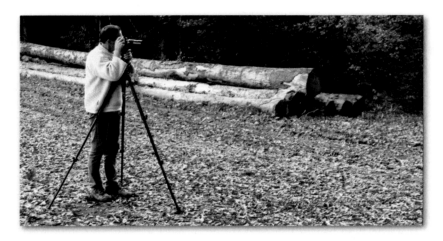

A tripod does wonders with some kinds of photography. It makes a camera stay perfectly still even for *very* long exposures, including those nighttime shots when the shutter stays open for seconds at a time. And even everyday shots often come out razor-sharp when the camera is tripod-mounted.

Every camera has a socket underneath where you can screw on a tripod mount (a little plate that snaps into the tripod itself). And while the nicest, smoothest, easiest-to-adjust tripods can be expensive, the simpler, occasional-use ones can be as cheap as $20.

 Tip A tripod is even more important if you also own a camcorder, by the way, or if you plan to record video with your still camera. Nothing screams "amateur" like unsteady video.

Now, there's not an advanced photographer on earth who would head out into the field without a tripod. But let's admit it: Realistically, you, the talented amateur, are probably not going to carry around a tripod, no matter how splendid the benefits. Even the proudest parents generally don't set up tripods at the school play, the wedding, or the soccer match. Tripods are bulky and heavy and pinchy and annoying.

And if you've bought a camera specifically because it's small enough to carry in your pocket, you're certainly not going to weigh yourself down with some huge, clacking piece of gear.

But you may be able to simulate the effects of a tripod. Read on.

Fake a Tripod

A tripod isn't the only steady structure on earth. If you're clever, you can find all kinds of ways to make your camera perfectly steady even without a tripod. Consider:

- **A monopod.** A *monopod* is basically a tripod with one foot instead of three. The advantage, of course, is that it's infinitely more compact than a tripod, cheaper, and much faster to set up. And you can use one in museums, gardens—wherever you're not allowed to set up a tripod.

 A monopod (below, left) doesn't steady the camera in all three dimensions. Still, it's a lot better than holding the camera by hand.

- **An inanimate object.** You can't believe how often there's a wall, a parked car, a bureau, or some other big, stationary object that you can use as a "table" for your camera (below, right).

 Tip Don't limit yourself to big, stationary, *horizontal* objects, either. A pillar, a door frame, or a tree makes a spectacular steadying surface for the side of your camera. Just press it tight from the other side.

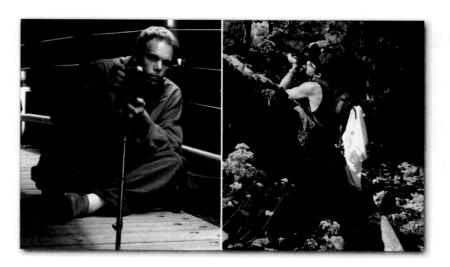

- **A table lamp.** The threads at the top of just about any *lamp*—the place where the lampshade screws on—are precisely the same diameter as a tripod mount! In a pinch, you can whip off the lampshade, screw on the camera, and presto: You've got a rock-steady indoor tripod (see page 281). People might think you're a nutcase, but never mind. It works.

- **A pocket tripod.** Camera catalogs sell all kinds of pocket gizmos that are meant to steady your camera: bean bags, fold-up micro-tripods, and so on. The point isn't to get your camera to the desired *height,* as a real tripod can, but to hold it at a desired *angle.* You still have to find a wall or a car roof, but at least the camera stays at some angle other than perfectly horizontal.

- **A string tripod.** Here's a photography hack that really works. Find a bolt that fits your tripod mount. Tie about five feet of non-stretchy string to it; tie a washer to the other end. When you need stability in a hurry, screw the bolt into the camera and step on the washer. Pull tight: instant tripod!

Use the Self-Timer

Every camera has a self-timer mode. You press the shutter button, but the camera beeps away for 2, 10, or 12 seconds before it takes the shot.

This feature was invented, of course, so that you, the photographer, can frame a group photo, squeeze the shutter button—and then, in those 20 seconds, run around to join the other people, thereby getting into the shot yourself.

But here's a trick that probably doesn't occur to many people: Use the self-timer even when you're not trying to be in the shot yourself.

That way, you avoid any risk of bumping the camera, even slightly, in the simple act of pressing the shutter button with your finger!

During long exposures (slow shutter), zoomed-in shots, and close-up shots, even that little movement can blur the shot. But not if you use the self-timer.

Goose the ISO

Finally, inside every modern camera is an anti-blur technique of last resort: Boost the ISO.

That awkward abbreviation stands for International Standards Organization. In the film-camera days, every roll of film had an ISO (or ASA) number like 100, 200, or 400. This number referred to the film's *light sensitivity.* If your film was more sensitive to light, your shutter speed could be faster.

If you were going to shoot some beach or skiing shots, where the scene would be flooded with glorious light, you'd buy ISO 100 film. For overcast days, you might go with 200. If you wanted to shoot indoors without the flash, you might load your camera with 400 or even 800 film.

Why didn't everyone want the most light sensitivity all the time? It had three downsides:

- Higher ISO film (known as *faster* film) cost more.

- There was such a thing as film that was *too* fast. In bright light, you might not even have a fast enough shutter speed to keep your shots from blowing out with brightness.

- Above all, higher-ISO film also increased *graininess* in the photos. And that, in general, was bad.

 Every year, cameras get better. Used to be, nothing over ISO 400 was usable; today, the best SLRs don't start showing bad noise until ISO 1600 or so. But you get the point: In general, ISO-boosting is not a free lunch.

Today, now that you've gone digital, ISO is still with you. Now it refers to the sensitivity of the *sensor,* not the film, but the basic idea is the same.

Fortunately, you don't have to worry about the first two drawbacks. You don't even have to deal with the inconvenience of committing to one ISO setting for an entire roll of film—now you can use a different ISO setting for every single camera shot. (Old-time photographers *love* that part.)

But you still have to worry about the third drawback: Setting a higher ISO on your digital camera increases the amount of *noise.*

And what is noise? It's random colored speckles. And when you reach the higher ISO settings—some cameras go all the way to 6400 today—it can look really terrible, as shown here.

It looks pretty bad when you use it in low-light situations. But what's really awful is changing your camera's ISO for the sake of a photo in a dim room—and then forgetting to change it back when you head out into sunlight! Digital noise in well-lit photos makes you look *really* clueless.

Even so, it's great to know about ISO, because it often means the difference between a slightly speckled shot and no shot at all. Goosing up the ISO means

that the sensor is more sensitive to light, so the shutter speed can be faster—
and you can get a sharp shot in low light without requiring the flash.

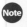 **Note** As noted earlier, some cheapo cameras with "digital anti-blur technology" actually do *nothing* but auto-goose the ISO! Yeah, you get less blur—but you also get much cruddier pictures.

And don't be *too* afraid of a little noise in your photos. Often, you can't even see it, even when printed out at typical sizes like 4 × 6 and 8 × 10 inches. (It becomes more noticeable in bigger enlargements.)

Furthermore, programs like Photoshop and Photoshop Elements can actually get *rid* of the noise; they have commands called things like Remove Noise that can help a lot.

Where to Find It

On an SLR, you probably have an ISO *button* right on the camera. Usually, you press it with one thumb and turn a thumbwheel to adjust the numbers, as shown here:

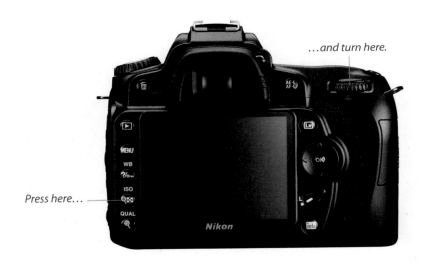

...and turn here.

Press here...

On pocket cameras, you generally have to dive into the menus to adjust the ISO.

Chapter 6:
How They Did That

There you sit, surveying your boxes of old photos. Snapshots of your family. Snapshots on vacation. Snapshots of tourist attractions. But they're all *snapshots*.

Then the professional photos in some magazine or newspaper hit you. There's the brilliant closeup of a ladybug on a leaf, with the bushes in the background gently out of focus. There's the amazing shot of a soccer player butting the ball with his head, frozen in action so completely that you can see individual flecks of sweat flying from his hair. There's the incredible shot of the city lights at night, with car taillights drawing colorful firefly tracks across the frame.

You can't help but wonder: "How do they *do* that?"

Some of these special shots require an SLR, but most of them involve nothing more than good technique—and knowing when to invoke your camera's special features. With a little practice, you can take pictures just as compelling, colorful, and intimate as the shots you see in magazines.

This chapter is dedicated to laying bare the secrets of professional photographers. May you never take another dull snapshot.

The Frozen Sports Shot

Everybody has seen those incredible high-speed action photos of athletes frozen in mid-leap. Without these shots (and the swimsuit photos), *Sports Illustrated* would be no thicker than a pamphlet.

The secrets are listed below. As a handy bonus, mastering the frozen-action sports picture also means you've mastered frozen-action water splashes, frozen-action bird-in-flight shots, and frozen-action kid moments.

> Don't get frustrated if, despite learning all of the following techniques, many of your pictures don't come out well. Sports photography produces lots of waste. Pros shoot dozens or *hundreds* of frames just to get one good picture.
>
> In short, a very low good-to-bad ratio is par for the course in this kind of shooting. But what the heck? It isn't costing you anything, and one great shot can make the entire effort worthwhile.

Get Close to the Action

It's no accident that the photographers at football games and gymnastics meets are always right down there in front, on the sidelines. If you're in the audience somewhere, you're generally too far from the players to get a shot where they fill the screen.

So: Get as close as you can. Zoom in as much as you can. (Unfortunately, a pocket cam with a 3X zoom just may not be good enough.)

Anticipate the action, too. Press the shutter button a hair *before* the player connects with the football.

Use a Fast Shutter Speed

Sometimes, sports shots come out just fine in full auto mode. But if the results are blurry because the motion is too fast, then you'll have to instruct the camera to use a faster shutter speed.

Try the Sports scene mode. It's on the Mode dial of most cameras.

If you have an SLR, you can also use *shutter-priority mode* (page 74). In this mode—a time-honored feature of traditional film cameras—you tell the camera that the *speed* of the shot is what matters. You want the "film" exposed for only 1/500th of a second, for example. (The camera responds by increasing the aperture to compensate for the shorter interval of light.)

On some cameras, you have to fiddle around with the menu system to control the shutter speed; on others, especially SLRs, you simply turn the mode dial to a position marked *S* or *Tv* (old-time photography lingo for *time value*).

Once you're in this mode, you adjust a dial or slider to indicate *how fast* you want the shutter to snap. Start with 1/500th or 1/1,000th of a second (indicated on the screen by "500" or "1000"; the fraction is implied) and take a series of shots. If the results are too dark, that's a sign that the camera is already opening the aperture as wide as it can. Slow down the shutter to the next speed setting and try again—or bump up the ISO (page 82).

Use Burst Mode

If ever there was a time to use burst mode—where the camera snaps a series of shots in rapid succession for as long as you hold down the shutter button—sports is it.

Even if you have a pocket cam that shoots only about two frames per second, that's still enough to improve the odds that one of your shots will be good.

Prefocus

Shutter lag (page 41) is a huge problem when you try to shoot action with a pocket camera. You'll miss the critical instant every time.

The solution, as noted in Chapter 3, is to *prefocus* by half-pressing the shutter button. So if you're trying to get a shot of the goalie in a soccer game, take advantage of the time when he's just standing there doing nothing. Frame the shot, focusing on him.

Then, as the opposing team comes barreling down the field toward him, half-press the shutter button. (Half-pressing makes the camera calculate the exposure and focus in advance.) Keep the button half-pressed until the moment of truth, when the goalie dives for the ball. *Now* squeeze the shutter button the rest of the way. This technique nearly eliminates shutter lag.

Light Metering

Ordinarily, your camera calculates the exposure for a shot by averaging all light from all areas of the frame (page 63). And ordinarily, that system works perfectly well.

In sports photography, however, the surrounding scene is usually substantially brighter or darker than the athletes. As a result, the one thing you really want—the action—winds up too bright or dark. If that's happening to you, use *spot metering* instead (page 63).

The Speeding Vehicle

You've seen this shot. It's a guy on a racing bike, colorful and crisp, rounding the corner of the track, leaning in at an incredible angle, the background and the crowd blurred into a rush of speed. Or it's a racing car, or a motorcyclist, or even a rollerblader rushing by.

You might wonder: How'd they get *that* shot? How come the *moving* element (the biker) is crisp and still, but the *stationary* element (the crowd behind him) has motion blur? What's up with that?

Answer: The photographer was *panning,* moving the camera sideways to keep the biker in the frame. And P.S.—it probably took the photographer a bunch of tries to get the one you saw published. Maybe one shot in 20 will have the crisp-against-blurry look you're after.

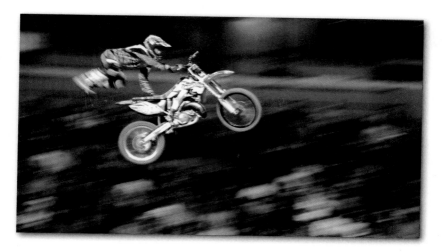

Anyway, here's how it works:

- **Shoot handheld.** No tripod.

- **Turn on burst mode** (page 57). You'll want as many stabs at getting this shot as possible.

- **Turn on continuous autofocus mode** (page 69), so that the camera will continuously refocus as the biker passes.

- **Prefocus.** If you're using autofocus, half-press the shutter button (or use manual focus) as you aim at the spot where the biker will be entering the frame. Use whatever's there now—a fence post, a pebble on the ground—as a standin, since the biker isn't there yet.

- **If your camera has a shutter-priority mode** (page 74), dial up a speed like 1/30th of a second. Yes, that's slow for a sports shot—but you *want* it slow, so you can get some good streaky blur of the background. The slower the shutter, the longer the streaks, but the more trouble you'll have keeping the biker in focus.

- **Dark backgrounds work best.** Bright ones can blur into a white cloud that may cause the biker to become a ghost.

Now you're ready. When the biker comes by, turn your upper body to move with him; once you've begun turning, press the shutter button and fire until he's out of range.

Review the results. Don't be depressed—the timing takes practice, and even professionals throw away most of the results.

 Tip And don't think that a razor-sharp biker is necessarily the only keeper. Even if the biker is a little blurred, it's still an exciting shot, implying action and motion.

The Panorama

Panoramas are more of a parlor trick than a photography standard; after all, the prints don't fit any standard picture frame, and they don't have much impact unless you get them printed at a big, juicy size. (When they appear any smaller—in a photography book, for example—panoramas just look like a slice from a standard-sized photo.)

Anyway, the point of a panorama is to capture a much, *much* wider slice of the landscape than you could with a single photo. And you do it by taking several successive side-by-side shots, turning the camera a bit each time. Later, either you or the camera stitches them together into a continuous, seamless, super-wide photo.

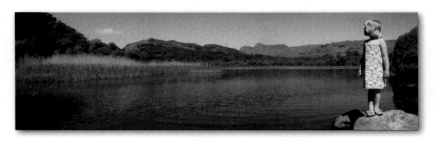

If your camera has a Panorama mode, great; use it. You'll see, on the screen, the ghosts of the photos as you take them, for ease in lining up the adjacent shots. And when you shoot the final one, the camera will combine all the component shots automatically. When you dump the photos to your computer, you'll get *one* very wide shot.

If you have an SLR or an advanced compact, you may not have a Panorama mode. And even if you do, you might want to build the panorama manually, to gain control and avoid problems.

What kind of problems? The kind where the exposure (brightness), focus, or white balance of the scene *changes* from shot to shot. Those unfortunate problems make the individual segments stand out in the finished panorama, and you can't fix it without a lot of tedious Photoshop work, if at all.

The trick, then, is to set your SLR's exposure (aperture/shutter speed), white balance, and focus *manually*. That way, these settings will remain consistent for every shot in the scene.

If you want the best panorama, you should also put the camera on a tripod. That arrangement ensures that the top edges of the panorama segments all line up. (You can shoot handheld, but you may wind up having to shave off some of the top or bottom edge of the finished panorama, evening up the shots—which makes the panorama *shorter* and saps some of its impact.)

> **Tip** Consider turning the camera 90 degrees, so that you're taking *portrait-orientation* shots. You'll get less lens distortion—a subtle warping that increases with distance from the center—and therefore your panorama will be easier to line up later. (The width of your photo, after all, is *not* going to be a problem.)

When you're ready to start shooting, make sure your consecutive shots over-lap—by at least 25 percent. That overlap will permit PhotoMerge, the auto-matic panorama-building command in Photoshop or Photoshop Elements, to recognize which photo goes where in the finished panorama.

> **Tip** Panoramas don't always have to be stitched together *horizontally*. Consider making *vertical* panoramas, too—a great way to create stunning shots of tall things like trees, skyscrapers, and cathedral interiors.

The Silky Brook

Nothing says "professional photographer" like the classic photo of sea waves, a waterfall, or a brook, in which the water seems to have been smoothed into a milky, silky continuum.

Shutter speed: 1/25th second

Shutter speed: 1/8th second

 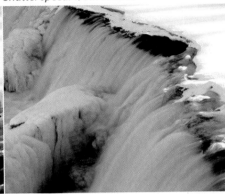

Actually, though, getting this shot is amazingly easy—if your camera has a shutter-priority mode (page 74). Usually, that means an SLR or an advanced compact. Alas, regular, inexpensive point-and-shoot models generally don't give you manual control of the shutter speed.

In any case, the trick is simply to dial up a slow shutter speed. While the shutter sits open, the water keeps running and soon blurs into a strip of white, ribbony magic.

So how come the rest of the scene isn't blurry? Because you've put the camera on a tripod, a rock, a tree stump, a fence post, or something else steady— just as you always do when you're using a slow shutter speed.

Put the camera into shutter-priority mode. Start with a shutter speed of half of a second (expressed on an SLR's screen as "2," meaning 1/2). Set it onto your stable platform and compose the shot. Turn on the self-timer, so your finger won't jiggle the camera pushing the shutter button.

 Tip If you have an SLR and you take a lot of nighttime or slow-shutter shots, consider a shutter-release cable (about $50). It's another way to trigger the shot without physically pressing the shutter button.

Take the shot.

See how much milky-water-ribbon you got. If you need more, slow down the shutter. If you're getting too much, speed it up a notch. Shoot a few so you'll have several candidates when you get the pictures onto your computer.

Trailing Car Lights

You've seen this shot on postcards and in magazines: neon bands of light streaking across the frame, with a nicely lit bridge or building in the background. The trick is to keep the shutter open long enough for the cars to pass all the way from one side of the frame to the other.

That may not be possible if you have a pocket cam. You really need a camera with shutter-priority mode (page 74)—an SLR or more advanced pocket camera. In this mode, you can tell the camera how many seconds to keep the shutter open—2 seconds or more for car-taillight photos, for example.

 Tip When preparing for nighttime shooting, pack a pocket flashlight so you can see the camera's controls in the dark.

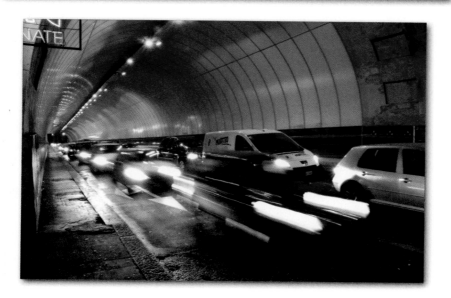

Try to find a vantage point high enough to provide a good overview of the scene. A nicely lit building, bridge, or monument in the background provides a great contrast to the erratic lights created by passing cars.

Put your camera on a tripod or some other steady surface and compose the shot. Set the shutter for 4 seconds. Use your remote control, if you have one, or self-timer mode, so your finger doesn't jiggle the camera.

When you see cars coming, trip the shutter. Review the results on the screen. If the streaks aren't long enough, add a couple of seconds to the shutter setting; if they're too long, subtract a second or two.

Then sell the best of your shots to a postcard company.

Fireworks

Q: What do fireworks shots have in common with milky waterfalls?

A: They both rely on slow shutter speeds; you're actually recording your subject's motion *over time.*

In the case of fireworks, you get the colorful, brilliant trails of fire against the black sky.

Arrive early to get a good spot. Beware setting up downwind of the smoke, which will interfere with both your shooting and your breathing.

The next steps vary slightly, depending on what kind of camera you have.

SLRs and Manual-Control Compacts

Use your M (full manual) mode. You'll be using a very slow shutter speed, so a tripod or another stable platform is essential. Now:

- **Turn off the flash.**

- **Dial up a long shutter speed**—maybe 4 to 8 seconds, to start. The longer the exposure, the more fireworks trails you'll capture.

- **Adjust the aperture.** Set it to something small, like f5.6 or f8. That small aperture will prevent "blooming" (bleeding) of light in the fireworks, which should help keep the images crisp.

- **Set a low ISO** (100 or 200, for example) to avoid "noise" (page 83).

- **Use manual focus.** Turn it to "infinity" (the ∞ symbol)—that is, focus on the most distant spot possible, to prevent the camera from futilely hunting for focus in the dark.

- **Use the self-timer,** remote control, or a shutter-release cable so you don't have to touch the camera.

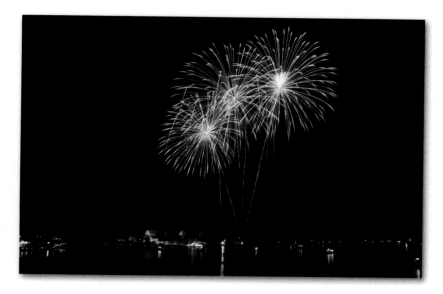

If the picture comes out too bright, make the aperture smaller—f11, for example. If it's too dark, open up the aperture—f4, say.

 Tip If your camera has a bulb mode (page 98), you can create even more dazzling shots by superimposing multiple fireworks into a single shot. That is, open the shutter; capture a few fireworks; block the lens with your hand or a lens cap until the next explosions begin; uncover the lens again; and so on. The multiple rounds of fireworks will appear in the same photo, looking extremely cool.

Pocket Cameras

If your camera doesn't have manual controls, you can still improve your odds of getting dramatic fireworks shots:

- **Choose Fireworks mode,** if there is one.

- **If not, choose Landscape mode,** which also focuses on infinity.

- **Turn off the flash.**

- **Put the camera on a tripod,** rock, fence post, trash can, or something else stable. Use the self-timer.

- **Specify long shutter speeds** if your camera allows it. On a Canon PowerShot, for example, in manual mode (M on the dial), you can call up shutter speeds as long as 15 seconds. Try 4 or 8 seconds; see what you like best.

Lightning

Catching lightning is tricky. It's not like a portrait, where you can say, "Hey, lemme take one more," or, "Could you move a little to your left?" Lightning tends to be fairly unresponsive to directions from the photographer.

Oh, and then there's that element of danger. Nothing makes you prouder of a shot than knowing you almost got killed taking it.

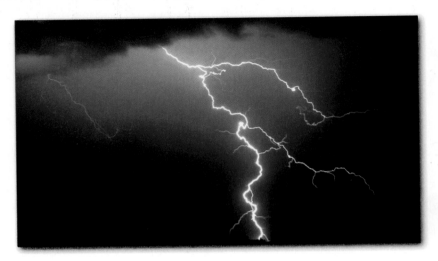

The first thing you're probably wondering is: "How do they know when the lightning is going to flash?" The answer: They don't. They open the shutter and just let it sit there until lightning happens. Because the sky is otherwise pretty much black, no harm is done; the lightning is the only light that registers on the exposure.

Lightning shots require a tripod and an SLR with a bulb mode, where the shutter can stay open for a long time, and a remote control or cable release (page 135). It also requires some thinking about where you want to set up so you won't be hit by lightning, which can ruin your whole day. For example, you should avoid standing in an open field, near power lines, next to water, atop a hill, and so on.

Use a low ISO. You'll have to experiment with the aperture; ambient light, and the presence of rain (which has a diffusing effect on the lightning's light). The lightning's distance and power also have an effect.

Use a very small aperture, too (a large f-stop number). If you hadn't noticed, lightning is very bright.

When you're ready, trigger the shutter. Wait for the lighting to happen; after it flashes, close the shutter again (relock the cable release, for example).

 Tip Consider setting up the tripod just outside. Trip the shutter, step inside to be safe, wait for the lightning, and then duck outside to close the shutter and see what you got.

The Star-Trails Shot

You've probably seen this amazing astronomy shot, where the stars in the night sky seem to swirl around in concentric circles.

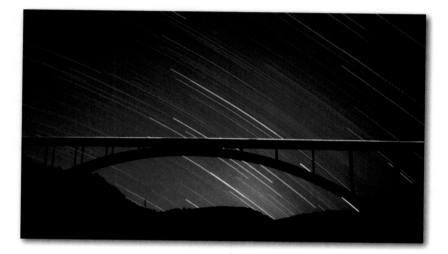

As you can probably guess, the swirling comes from the rotation of the *earth* relative to the stars. And it takes a long time to swirl that much; hours, in fact.

As a result, the star-trails shot is the exclusive domain of SLRs. (Pocket cameras don't offer a shutter speed that's slow enough.) So here's the drill:

- **Use a tripod.** (You were thinking handheld? Are you *kidding?*)

- **Compose the shot.** Very important: Include more than just the sky! Including some land, preferably something interesting in the foreground, gives the star trails a sense of scale and orientation. And the juxtaposition of elements—the streaking blurs in the sky, the super-sharp, steady ground features—makes the picture much more striking.

- **Use a cable release** (page 135), remote control, or the self-timer.

- **Start with a full battery charge!** Or run your camera plugged in, if it permits that arrangement.

- **Moonless nights work best.** Your shutter will be open for a *long* time, soaking in light. And too *much* light—from a full moon, for example—can overexpose the photo (make it too bright). Oh, and by the way: *Cloudless* nights are a good idea, too.

- **Sometimes the cool night air makes your lens fog up.** A skier's hand warmer wrapped around the lens might help, or socks held on with a rubber band. (The things we do to get that shot!)

- **Set the camera to its widest possible aperture,** like f1.8. You'll want the camera to soak in all the light it can.

- **Here's the tricky part:** You have to set the camera's shutter to stay open for a *long* time—hours. That requires something called *bulb* mode, sometimes designated by a B on the screen when you adjust the shutter-speed dial. Bulb mode means: "I'll leave the shutter open until you tell me to close it." If your camera doesn't offer bulb mode, then you're out of luck with star trails.

 Tip If you do have bulb mode, then don't worry about the cable release or self-timer. Instead, you can start and stop the exposure by unblocking and blocking the lens—with a folder, a hat, the lens cap, or something else that blocks tstarlight.

- **Trigger the shot—and go get dinner,** see a movie, or go to bed. Check back in an hour or three. The longer you wait, the longer the star trails—but the less visible they'll be against the sky, since the exposure lightens up the longer the shutter remains open.

Your first results might not be *National Geographic* material; they might be too bright or too dark, or maybe the camera got jiggled and therefore blurred.

Tip If your camera *does* have a bulb mode, another fantastic kind of photography awaits you: *light painting.* Go out on some dark night. Put the camera on a tripod, and point it at something interesting—crazy rocks, a big cactus, an old rusting tractor, whatever. Set it to bulb mode and click the shutter button.

While the shutter is open, "paint" the subject with your flashlight. The longer you dwell on a spot with the light, the brighter it will be. Keep in mind that the camera is "adding up" *all* the light that falls on different parts of the subject during the open-shutter interval. For samples of the amazing results, go to *www.flickr.com* and search for *light painting.*

The Stunning Landscape

In portraiture, *you* have to arrange the lights and the models. Landscape photography, however, demands a different discipline: patience. Nature calls the shots here. Your job is to be prepared and in position.

Shoot with Sweet Light

Hate to break it to you, but the best photographers don't get a lot of sleep. Show me an award-winning, breathtaking landscape—a pond shimmering in the woods, golden clouds surrounding a mountain peak—and I'll show you someone who got up at 4:40 a.m. to be ready with his tripod as the sun rose.

That hour before sunrise, and the hour after sunset, are known as the magic hours or the golden hours. The lower angle of the sun and the slightly denser atmosphere create rich, saturated tones, plus what photographers call *sweet* light. It's an amazing, golden glow that makes everybody look beautiful, every building look enchanted, and every landscape look breathtaking.

It's a far cry from the midday sun, which creates much harsher shadows and much more severe highlights. Landscape shooting is more difficult when the sun is high overhead on a bright, cloudless day.

 Tip The 20 minutes *before* the sun rises and *after* the sun sets can be pretty amazing, too.

Layer Your Lights and Darks

Ansel Adams, the most famous American landscape photographer, looked for scenes in sweet light that had alternating light and dark areas. As you view

one of these pictures from the bottom of the frame to the top, you might see light falling on the foreground, then a shadow cast by a tree, then a pool of light behind the tree, followed by more shadows from a hill, and finally an illuminated sky at the top of the composition.

A lighting situation like this creates more depth.

Layer Your Foregrounds and Backgrounds

Remember: One consistent element of great photos is that they're *interesting*—and one way to create interest is to give your viewers more stuff to look at. Here's a great trick: Compose the shot with elements in the foreground, the middle ground, *and* the background.

Don't just shoot the sunset; shoot the sunset, the water, and a lonely sun umbrella in the foreground. Don't just shoot the mountain; shoot a 6-year-old leaning over the railing to look at the mountain.

If your camera has an aperture-priority mode (page 77), use it, and specify a large f-stop (a small aperture); that will keep everything, near and far, in focus. If not, just switch the camera to Landscape mode on the dial, which accomplishes the same thing.

 Tip Sometimes you can lend nature a helping hand by turning on your flash to illuminate the foreground subject. The effect can be stunning.

The Classic Sunset

Your camera usually does a good job of exposing the sky during sunset, even in auto mode. Turn off the flash and shoot at will.

 Tip Keep an eye on your shutter speed (if your camera shows it). If it goes slower than about 1/30th of a second, you may need a tripod or some other steady surface to prevent camera shake. Activate the self-timer or remote control to avoid jiggling the camera when you press the shutter button.

The biggest mistake people make when shooting sunsets has nothing to do with the sky—it's the *ground* that ruins the shots. Your eyes can make out much more detail in the shadowy ground than your camera will. Therefore, it's not worth trying to split the frame in half, composing it with the sky above and the ground below. The bottom half of your photo will just be a murky black blob in the final image.

Instead, fill your composition with 90 percent sky and 10 percent ground or water. This arrangement may feel funny—at least until you look at your prints and see how much more dynamic they are with this composition.

 Tip Many photographers make the mistake of going home right after the sun dips below the horizon. Hang around for another 10 minutes or so; sometimes there's a truly amazing after-burst of light.

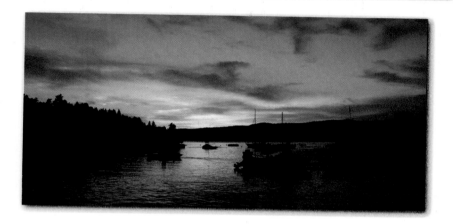

The Prize-Winning Kid Shot

Children are like flash floods: fast, low to the ground, and unpredictable. In other words, they're challenging for any kind of photographer.

Here are some tips:

- **Be prepared.** Rule number one is to have your camera handy at all times, charged, and with memory card space to spare. Great kid shots come and go in the blink of an eye. Parents don't have the luxury of keeping their equipment stowed away in a camera bag in the closet.

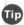 **Tip** When you're shooting kids, or action, or natural disasters with an SLR, don't get hung up on replacing the lens cap all the time. The front glass is a lot more durable than you think, and the fussing might lead you to miss the shot.

- **Get down there.** The best kid shots are generally photographed at kid level, and that means getting low. (Flip screens are especially useful for

kid shots, because they let you position the camera down low without actually having to lie on the ground.)

- **Get close.** Kid shots have much more impact if the subject fills the frame.

- **Prefocus.** Shutter lag will make you miss the shot every time. In many cases, you can defeat it by using the half-press trick (page 41) when the kid's not doing anything special. Keep your finger on the button until the magical smile appears, then press fully to snap the shot.

- **Burst away.** Use your camera's burst mode to fire off several shots in quick succession. Given the fleeting nature of many kids' grins, this trick

improves your odds for catching just the right moment.

- **Force the flash.** If you're still getting motion blur, the flash, despite all its downsides, does help freeze the action.

- **Make it bright.** See page 50 for a discussion of redeye, but don't bother using the redeye reduction flash on your camera. By the time it has finished strobing and stuttering, your kid will be in the next ZIP code.

 If redeye is a problem in your flash photos of kids, make the room as bright as possible, shoot from an angle that isn't dead-on into the eyes, and touch up the redeye later on the computer, if necessary.

- **Fire at will.** Child photography is like shooting a sports event—you'll take lots of bad shots in order to get a few gems. Again, who cares? The duds don't cost you anything. And once you've captured the image of a lifetime, you'll forget about all the outtakes you deleted.

Theater Shots

This one's really tricky; capturing stage performances is a tough job even for professionals. The chief problem is that the bright main light on the actors often shares the frame with a subdued or even darkened background. If you shoot in auto mode, then the camera brightens up the image enough to bring out details in the dominant dim background—and turns the spot-lighted actors into white-hot, irradiated ghosts.

Furthermore, the built-in flash is useless; in the audience, you're just too far away for it to do any good (unless you climb right up onto the stage, which is generally frowned upon). So for God's sake, **turn your flash off** at theater performances—because it's annoying to the rest of the audience, because it's worthless, and because it's usually forbidden. Crank up the ISO, if necessary.

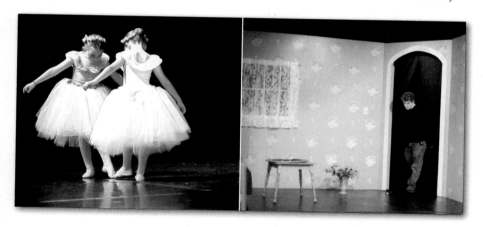

If you have a *spot-metering mode* (page 63), you have a fighting chance. Instead of averaging the light in the entire scene, the camera measures the brightness of one particular spot—in this case, the brightly lit actors.

Not all cameras have a spot-metering mode. But even basic cameras generally offer some kind of *exposure compensation,* an overall brightness control (page 63). Try lowering the exposure to −1 or −1.5, for example. That darkens the entire scene. The background will be *too* dark, of course, but at least the actors won't be "blown out."

The Undersea Stunner

Digital cameras are fantastic for underwater photography. The screen lets you preview your shot precisely, which is essential in the murk of the water. You also don't have the *parallax* problems you'd have with a film camera. (That's where the eyepiece viewfinder, which is offset from the lens, misleads you into taking a slightly off-to-the-side shot.)

Ordinarily, water is the mortal enemy of digital cameras. But you can buy a waterproof case for many camera models, both compacts and SLRs. They open up whole new worlds of photographic possibilities.

The good news: These enclosures protect the camera down to about 100 feet, while still providing access to the camera's controls. The bad news: The underwater case can cost more than the camera! Sometimes the camera manufacturer makes these enclosures; sometimes they're made by other companies; see *www.ikelite.com* or *www.uwimaging.com*.

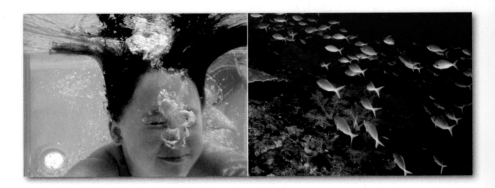

And now, some tips:

- **When shooting underwater,** force the flash (page 48); it's dark down there. Unfortunately, the built-in flash may make all the little floating specks reflect right back at you, creating "marine snow." The only way to avoid it is to use an external underwater flash—not something the average vacationgoer is likely to carry in the old backpack, to be sure.

- **Sunlight becomes more diffuse** the deeper you go, and different colors of the spectrum drop out at different rates. Red is the first to go. So adjusting the camera's white-balance controls is essential (page 58). Use the Cloudy setting for deep dives, the Daylight setting close to the surface. If all else fails, you can adjust the color later in a program like Photoshop. (Some compact cameras include an Underwater scene mode that improves the color balance and exposure under the sea.)

- **Underwater camera cases are ingenious.** All the key controls of the camera have corresponding, gasket-sealed pushbuttons on the outside of the case. But they're still not immune to the laws of physics. Even a hair or a grain of sand is enough to admit water on deeper dives. You're supposed to spend a great deal of time before and after each dive taking care of it, removing, and inspecting the rubber O-ring seal, rubbing it with the supplied grease, and so on.

- **As the temperature inside the case rises,** the camera's own moisture evaporates, which fogs up the inside of the case. You can either rub your case with anti-fog solution beforehand, or—talk about low-tech!—wedge one of those little silica gel packs inside (of the sort that you sometimes find in shoeboxes).

Tip You can minimize the fogging problem if you put the camera into its case in an air-conditioned room, where the air is dry.

- **Fish are, well, fish.** They move quickly, and they're easily frightened. Hold the camera at arm's length to avoid scaring the little guys. If you're scuba diving, approach from underneath.

- **Don't try to change the batteries** while you're down there.

Tip There's an excellent guide to underwater digital photography on the Japanese Canon Web site (don't panic—it's in English): *www.canon.co.jp/Imaging/uwphoto/index-e.html*.

The Not-Boring Vacation Shot

Getting out to see the world is highly recommended, both because you'll exercise your skills as a photographer and because it helps you get a life.

But as you stand there in front of the Grand Canyon, the Eiffel Tower, or Cinderella's Castle, the thought may flit through your brain: *I'm about to take exactly the same photo that's been taken about 472 million times before.*

So how do you capture the moment so you'll remember it in your declining years—without turning into a tourist cliché?

Packing Up

First of all, make sure you'll be ready to take any pictures at all. You'll need some supplies:

- **Batteries.** A typical compact-camera battery has enough juice for about 300 photos. If you have an adorable 4-year-old, that's about half a day at Disney World. Consider buying a second battery (or set of batteries), and make sure it's charged every night.

- **Camera bag.** Not only will it protect your camera, but it also will keep your batteries, cards, and cables together.

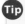 **Tip** If you can find a camera bag that doesn't *look* like a camera bag, it's less likely to be ripped off. An insulated beverage bag does nicely, for example.

- **Memory cards.** Nobody has ever said, "Oh, I wish I'd bought a smaller memory card." Pack a big one, especially if you plan to capture movies on

the same excursion. Or a couple; it's generally cheaper to buy two 1 GB cards than one 2 GB card, but shop around to get the best deal possible (*www.shopper.com*, for example).

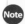

- **Tripod.** Nobody likes to lug a tripod across Europe—or across town, for that matter. But if you're a serious photographer, or aspire to be one, you'll occasionally need a way to steady your camera.

 A miniature tabletop, flexi-leg tripod like the Gorillapod is an ideal compromise. It weighs only a few ounces, costs less than $25, and supports your camera in a variety of situations. A quick search at *www.google.com* should help you find a mail-order company that carries it.

- **Weatherproofing.** Tuck a couple of plastic bags in your carrying case for use in bad weather. Digital cameras hate water, but some of nature's most dramatic shows occur at the beginning and end of storms.

- **Lens cloth.** Fingerprints happen. Microfiber lens cloths are light, inexpensive (about $5), and easy to pack—and they're the best way to keep your optics sparkling clean. These soft cloths have thousands of microfibers that grab smudges off your lens.

Get Creative

Digital cameras encourage playfulness. You can try something wacky, and if you play it back and it looks ridiculous, you can erase it before anyone else discovers just *how* amateur an amateur you really are. Meanwhile, you'll have a lot of fun experimenting, and you'll be less likely to come home with the same lame shots taken by masses of tourists before you.

Consider, for example, tips like these:

- **Get in the picture.** Set up in front of an interesting background, trip the self-timer, and get in the shot. It's really fun if you're with a group, too.

- **Try the close-up mode.** When you're away from home, everything is a potentially great *macro* (super-close-up) shot, from local currency to flower petals.

- **Vary the shots.** The so-called "little shots," such as your kid staring out the train window, or your friend buying flowers from a street vendor, are often more compelling than the typical "stand in front of a building and smile" photos.

- **City lights + sunset.** There's a magic moment every day at twilight when the city lights come on right before the sun sets. Grab your camera, park it on a wall or windowsill for stability, and take a few shots.

- **Shoot from the passenger-side window.** Let someone else drive. Roll down the window and look for interesting pictures. Don't worry about the background blurring and other little glitches; those are often what make the pictures compelling.

- **Signs and placards.** Museums, monuments, and national parks are all loaded with informative signs and placards. Shoot them as you go. That way, you don't have to take notes—and later, these shots will make great introductory shots for segments of your slideshow.

- **Shoot through shop windows.** Storefront displays say so much about the local culture.

 Tip Reflections can make shop windows tricky. The trick is to zoom out, and then get the front of the lens barrel as close to the window as possible. The closer you are, the fewer reflections you'll get.

The Museum Challenge

Many museums permit photography, provided you keep the flash off and don't use a tripod. Once you're in, here are some techniques to consider:

- Without the flash, you'll probably want to goose the ISO to handle the dim lighting (page 82).

- Museums often use halogen lights to illuminate the artwork, which can lend a red or yellow cast to your photos. Your camera is supposed to adjust the white balance automatically, but if your sample shots look too reddish or yellowish, switch the white-balance control to Incandescent.

- How do you take a picture of what's in a glass display case without getting nasty reflections? Put the front of your lens barrel right against the glass and zoom out, as described in the previous tip. Or shoot at 45 degrees, so that the flash bounces away instead of back at you.

- Because of the low lighting, your camera will choose a slow shutter speed, which raises the likelihood of getting blur. The steadier you hold your camera, the sharper your shots will be. Chapter 5 offers solutions.

Vacation Portraits

How do you take a "We were there" photo—when the "there" is something huge, like a skyscraper, monument, canyon, or pyramid?

If you back up far enough to get the whole landmark into the background, then your companions will be little more than tiny, unrecognizable dots in the scene. But if you frame the shot as you would a standard headshot, you'll be so close you can't see the landmark.

Sometimes, you just have to take two shots.

The Wedding Shot

Weddings dominate special-event photography. And they're the primary income source for a huge percentage of professional photographers.

If you can shoot an entire wedding, then you can shoot any other event that comes your way. After all, graduations are just weddings without the reception. Birthday parties are just weddings without the spouse.

If you're a guest, by the way, don't interfere with the *hired* photographer's posed shots. Introduce yourself and ask if it's OK to take a couple of shots right after the pro has finished each setup. You'll generally receive permission— and the opportunity to capture the highlights of the day.

 Tip As a digital photographer, you can bring a new dimension to the celebration that most pros don't even offer: immediacy. You can hook up your camera to a TV to play the pictures back while the reception is still going on.

Shots to Look For

In part, your success at shooting a wedding depends on your ability to antici-pate the action. If you've been to any weddings recently, you probably know that you can expect classic photo ops like these:

- **Before the wedding.** Bride making final dress adjustments, alone in dress, with mother, with maid of honor, with bridesmaids, and so on. Groom with his best man, with his ushers, with his family.

- **During the ceremony.** Groom waiting at the altar, his parents being seated, the bride's mother being seated, the processional, the bride coming down the aisle, the vows, the ring ceremony, the kiss, the bride and groom coming back down the aisle. Oh, and of course the obligatory adorable shots of the flower girl and ring bearer walking down the aisle looking dazed.

- **Directly after the ceremony.** The wedding party at the altar, the bride and groom with family, the bride and groom with the officiant, a closeup of the bride's and groom's hands on the ring pillow.

- **During the reception.** Guests signing the guest book, the bride dancing with groom/father/father-in-law, the groom dancing with mother/mother-in-law, the cake table, the cake cutting, the cake feeding, the toasts, the bouquet tossing, the decorated getaway car.

 Tip You have a key advantage over the hired photographer: You *know* people at the wedding. In theory, at least, you therefore have the opportunity to take candid, relaxed pictures of the guests—a sure bride-and-groom pleaser.

That's the checklist for a professional, of course. If you're one of the guests, use that list only for inspiration. If you get only a fraction of those classic photo ops, you'll still have plenty to share at the end of the day.

The Ultra-Closeup

Most people usually photograph people and places. Every now and then, however, you'll need to photograph *things:* flowers, butterflies, and bees, for example, not to mention stuff you plan to sell on eBay, illustrations for a report, your personal belongings for insurance purposes, and so on.

Every camera, cheap or fancy, has a *Macro* (close-up) mode. It's always marked on the Mode dial by, for some reason, a tulip.

In any case, macro photography is really fun, because seeing a tiny object blown up huge gives it an automatic impact that inevitably wows your audience. There's not much to it—but do beware:

- Not all cameras let you get equally close to the subject, even in Macro mode. Some cameras can get so close the lens is practically touching the subject (Nikon compacts are famous for this feature). Others have to be at least a couple of feet away. The only way to find out what your camera can manage is to experiment (or just read the specs in the back of the manual, if you can find it).

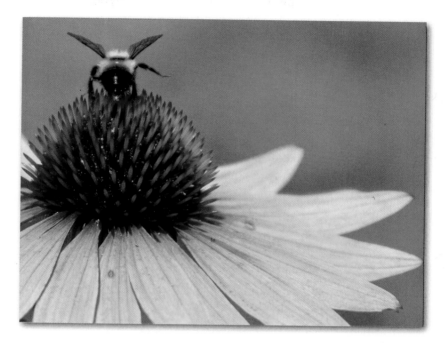

- The half-pressing trick is extremely important when you're shooting close-up. If you half-press and you don't hear the little beep (and see the "OK, we're focused" indicator on the screen), then the close-up shot will be slightly out of focus. If you don't hear the beep, back up a little and half-press again. Repeat until you find the minimum focusing distance.

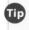 **Tip** If you don't follow this advice, you might wind up with close-up shots that look fine on the camera's screen—but turn out to be slightly, heartbreakingly out of focus when you see them on the computer.

- If you have an SLR, of course, you can buy or rent a macro *lens,* which is a real kick; it lets you take truly jaw-dropping, *National Geographic*-type shots of bugs, flowers, grass, snowflakes, and so on.

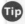 **Tip** Actually, you can get fantastic macro shots using only a *zoom* lens. Not only are you saved the expense of a macro lens, but you can get an even nicer blurry-background effect. And if you're shooting bugs, and they're still alive, you minimize the risk of startling them off their perches, because you can shoot from farther away.

- Many cameras insist on firing the flash in Macro mode—and offer no way to turn it off. If that's not what you want, then choose a different mode and just zoom in as close as you can.

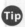 **Tip** In a pinch, you can turn *any* SLR lens into a rudimentary macro lens. Put the camera in Manual mode; *take off* the lens you have; then *turn it around*. Gently but firmly, hold it against the lens opening on the camera. Now look through the viewfinder: super macro! Adjust focus by inching closer or farther from the subject. You'll have to estimate exposure; the camera won't give you any readings, since it doesn't think it has a lens. But with some experimentation, you can get some imperfect but very cool ultra-close up shots, even with your $100 starter lens.

Disclaimers: Don't bang either end of the lens against anything. And be aware that the inside part of the lens is now exposed, so it can catch dust.

The Flying-Bug Shot

Photographing a bee, butterfly, hummingbird, or dragonfly in flight is nearly impossible. You'll spend your whole time chasing, aiming, half-pressing, and generally feeling like an idiot.

Your best bet is to pick a spot where the critter is likely to land or hover, pre-focus on that spot, and just *wait*. Patience is the primary tool of the wildlife photographer. (A fast shutter speed also helps.)

The Flower Shot

Shooting flowers is much easier than shooting bugs, because the darned things are much less likely to fly away spontaneously. Pop into Macro mode, read the previous discussion, survey the scene, and then obey these guidelines:

- **Get down low.** A flower's-eye-view is much more interesting than the usual person angle.

- **Look for diffuse light.** An overcast day is perfect; the sky becomes one gigantic light-diffuser, casting an even, soft light. (Professionals often supplement the light with their own photographic lights.)

- **Consider the background.** One stunningly sharp flower, with all of its friends and family blurrily fading away into the distance, makes a great shot. So does a single gorgeous flower against the sky or the grass.

The Blurry-Background Portrait

In most professional photos of people, animals, or objects, the background is softly out of focus. In fact, that's one of the first things you might say when explaining the difference between an SLR and a pocket cam: "SLRs can keep the person sharp but the background a little blurred."

In technical terms, what you're looking at is a shallow *depth of field.* That's a geek-shutterbug term meaning "which part of the scene is in focus, front-to-back."

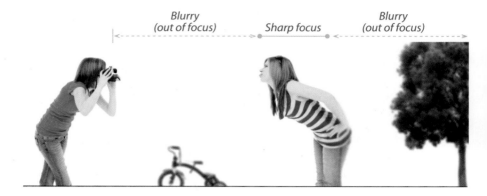

Blurry (out of focus) — Sharp focus — Blurry (out of focus)

When you shoot with a pocket cam, pretty much the entire scene is in focus: the people, the ski lodge behind them, and the mountains behind *everything.* When you shoot with an SLR, though, you can keep the people in sharp focus, but blur the ski lodge a bit, and blur out the mountain into a mere suggestion. You can, in other words, set up a *shallow* depth of field.

(Of course, you can create a deep depth of field with an SLR, if you like. And it doesn't always have to be a blurred *background;* blurring the foreground is very effective, too, if it's not the subject of the shot. Or, what the heck—blur both the foreground *and* the background.)

Why is the blurry background so effective? First, because it's cool-looking; it's associated with professional photography in *Sports Illustrated, National Geographic,* and so on. Second, it's a great compositional tool; it isolates the subject and eliminates clutter in the frame.

So how do you get this effect? It's easy on an SLR, slightly harder otherwise.

- **Use Portrait mode.** Most cameras under $2,000 have a Portrait mode right on the Mode dial (look for an icon that looks like a person's head in silhouette). It's supposed to introduce the blurred-background effect automatically—because, behind the scenes, it calls up a wide aperture (read on).

- **Choose a wide aperture.** For more manual control, put the camera in aperture-priority mode, if it has one (it's marked with A or Av on the Mode dial); it's a feature you're more likely to find on SLRs and advanced smaller cameras.

 Once you've turned on this mode, you adjust the aperture by turning a knob or pressing the up/down buttons. On the screen, you'll see the changing *f-stop* numbers, which represent different-sized apertures.

 To get the crisp foreground/blurred background effect, choose a small f-stop number. This table shows you the general idea:

f-stop	diameter of aperture	depth of field	background looks
f2	very large	very shallow	very soft
f2.8	large	shallow	soft
f4	medium	moderate	a little out of focus
f5.6	medium	moderate	a little out of focus
f8	small	moderately deep	mostly in focus
f11	small	deep	sharp
f16	very small	very deep	very sharp

- **Back up and zoom in.** Even with a pocket camera, you'll greatly improve your odds of getting a blurry background by using the *back-up-and-zoom-in* trick—and it's one of the best tricks in the book.

That is, back up from your subjects—the farther, the better—and then use the camera's zoom to "bring you" back up close. Thanks to a quirk of optics, zooming in helps to create a shallow depth of field.

You may look like a weirdo, backing way up like that. But the more you back up and zoom in, the greater you'll blur the background. It really works.

Tip Here's a tip on that tip. Move your *subjects* away from the background, too. The farther they are—say, 20 feet or more from the wall or forest behind them—the blurrier the background will be.

The Outdoor Portrait

The first consideration is blurring the background, as described above. And while you're considering the background, check for telephone poles or anything else that may appear to pierce the model's head.

The second consideration is light. Believe it or not, bright sunshine is *not* what you want for photographing people. Direct midday sunlight makes people squint, which is not such a flattering look, as you can see below at left. It also casts dark shadows and brings out wrinkles, which isn't so flattering either.

Tip 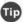 If your model *is* looking right into the sun, ask her to look away until you reach the count of three. That way, when she does turn to face you, she won't be squinting; in fact, she'll probably be smiling naturally as a result of this peculiar request.

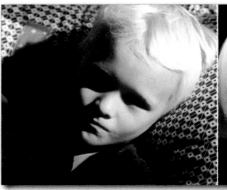 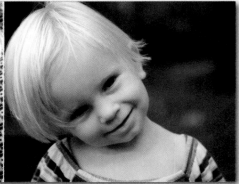

What you really want is *diffuse* (softened) light, as shown above at right. Clouds, as it turns out, are top-notch diffusers; portrait photographers love overcast days, because the light comes out of the sky pre-softened and pre-evened. Early morning and late afternoon are terrific, too, because, once again, the sun's light is softer and more flattering.

Or consider one of these two time-honored portrait professionals' tricks:

Rim Lighting (Back Lighting)

Once you've experimented with fill flash, try this pros' trick for striking portraits: *rim lighting.*

Position the subject with her back to the sun (preferably when it's high in the sky and not shining directly into your camera lens). Force the flash.

If the sun is shining into the lens, block it with your hand, a hat, a magazine, or whatever.

Now check it out: The sun creates a **rim light** or **back light** around the subject's hair. You'll also notice that her eyes are more relaxed and open. In one swift move, you've made your subject more comfortable and improved your chances for a dramatic portrait.

When it works, rim lighting creates portraits that you'll be very proud of. It can sometimes produce jaw-dropping results.

 Tip If your camera accepts filters, try a *softening filter* for your rim-lighting shots. It can reduce facial wrinkles and create a nice glow around the subject's head.

Open Shade

Alternatively, ask your subject to stand in "open shade," like under a tree. Look for a subtle background without distracting elements. There's plenty of light from the world at large—just not from directly overhead. (Light bounced from something big and white, like the wall of a house or even a white car, works wonders.)

The open shade eliminates harsh shadows around the face and keeps the subject from squinting. Remember, once again, to force the flash to fire (page 48). This *fill flash* not only eliminates the silhouette effect when your subject is in front of a bright background, but frontal light is very flattering. It softens smile lines and wrinkles, and it puts a nice twinkle in the subject's eyes.

The result: an evenly lit, relaxed subject with a perfectly exposed background. You won't even notice that it was shot in the shade.

 Tip If you own an external flash, use it for the fill flash. It gives you a choice of angle, you can control its power, and it's also the only way to go if your subject wears glasses. If the flash is on a dedicated cord, you can raise it a couple of feet above the camera to minimize the reflection of the flash.

Composition

No matter what your lighting setup, the last step is to frame the shot (including the upper body is generally a nice composition). Hold your camera at different angles to see if some are more flattering; a slightly angled portrait can make your subject look a little more casual and pleasant.

Above all, *focus on the eyes*. No matter what else is going on in the frame, the life and soul of any portrait of a human or animal comes from the eyes.

 Tip Shooting a group shot? Tell them, "OK, on three!" Then count "One, two…" —and snap the shot on *two*, not on three. For some reason, you wind up with fewer blinks with this sneaky trick.

Existing-Light Portraits

Cameras love light, that's for sure. And you may need the flash for indoor shots.

But not always. Some of the best interior photos use nothing more than light streaming in from a window. Pictures that use only ambient light without adding flash are called *existing-light, natural-light,* or *ambient-light* photos. They have numerous advantages over flash photography:

- **More depth.** The problem with the flash is that it illuminates only about the first 10 feet of the scene. Everything beyond that fades to black.

 In existing-light photography, on the other hand, your camera reads the lighting for the entire room. Not only is your primary subject exposed properly, but the surrounding setting is too, giving the picture more depth.

- **Less harsh.** The light in an existing-light photo generally comes from a variety of sources: overhead lights, windows, lamps, and reflections off walls and ceilings. All of this adds up to softer, more balanced light than what you get from the laser beam generated by your built-in flash.

- **More expressive.** Too often, flash pictures produce the "deer in the headlights" look from your subjects—if the close-range flash doesn't whitewash them completely. Existing-light pictures tend to be more natural and expressive, and the people you're shooting are more relaxed when they're not being pelted by bursts of light.

An existing-light indoor portrait has a classic feel, because it's reminiscent of those timeless paintings by great artists like Rembrandt.

Keep it Steady

Of course, the key to natural-light portraits is turning off the flash. And without the flash, the camera will want to keep its shutter open long enough to admit enough light.

In other words, keep the camera very steady. Use a tripod, even a tabletop tripod, or a table, doorway, or wall (page 80).

Now you face another challenge: taking the picture without jiggling the camera when you push the shutter button. Even a little camera shake will blur the photo.

If a remote control came with the camera, or if you've bought a shutter-release cable for your SLR, use it. If not, use the camera's self-timer feature (page 81).

 Tip If your camera has a burst mode, here's another way to use it. Your finger pressing the shutter button is likely to ruin your first shot by introducing camera shake—but because it will thereafter remain down without moving, the second or third shot of the burst will look much steadier.

Do what you can to persuade the *subject* to keep still, too; during a long exposure like this, fidgety people mean blurry portraits. (Of course, you can use this effect to your advantage, too, if you want to create a moody interior picture with ghostlike subjects.)

The Camera Setup

If you can adjust the camera's ISO setting—its light sensitivity (page 82)—use the lowest setting you can. Try 100, then review your test shot. (Zoom in to the LCD screen, magnifying the photo, to inspect it more closely.) If it's too dark or has motion blur, increase the ISO to 200. Take another test shot. If things are still looking dark, try one more time at 400 speed. And open the drapes all the way.

Also consider turning on spot metering (page 63), so the camera can worry about the light on the subject regardless of the lighting in the surrounding background.

 Tip Great painters of the past preferred the light coming through a *north* window for their portraits, especially in the early hours of the day. Try this setting for your existing-light portraits.

The Lighting

Now look at the lighting—not the way you would normally view it, but the way the camera would see the scene. If there's a noticeable difference between the brightest area of the model's face and the darkest area, then you may want to add a little *fill light*.

If you were a serious photographer with actual photographic gear lying around—and maybe you are—you could use a low-power flash as a fill light. Of course, then it would no longer be an *existing*-light portrait.

It's a better idea to find a reflector and position it so that light bounces off it onto the dark side of the model's face. A reflector is a common piece of photographic gear; it's essentially a big white shiny surface on its own pole. If you don't have lighting equipment sitting around the house, but you really want this portrait to look good, just rig a big piece of white cardboard or white foam board to serve as a reflecting surface.

 Tip In fact, a white umbrella, a bed sheet, or even a white pillowcase, held nearby by an accommodating friend, can make all the difference in the photo. (Hint: For best results, keep this reflecting object out of the shot.)

When you think you've balanced the tones, take a picture and review your results. Chances are that the shadow areas look darker to the camera than they do to your eyes. In that case, move the reflector closer to brighten the shadows.

Taking the Picture

With time and practice, you'll be able to "calibrate" your eyes so that they see shadows the same way your camera does. You'll spend less and less time testing before the shoot, and more time creating your classic image.

As you've figured out by now, creating a great natural-light portrait means learning to work with light as though it's a paintbrush. It takes time and practice to become proficient at this, but even your first efforts will probably surprise you with their expressiveness.

 Tip Don't be too quick to delete shots from the camera before viewing them on the computer screen. Existing-light shots sometimes contain subtleties that don't appear on tiny LCD screens. You'll be pleasantly surprised by many of the images that may have looked uninteresting when viewed on your camera's two-inch display.

The Self-Portrait

The portrait discussions on the previous pages apply to pictures you take of yourself, too, of course. But there are a few other considerations.

Find a stool or a low-back chair without arms, and position it about five feet in front of the background you've chosen. If possible, it should face the brightest window in the room.

Next, you'll need a way to position your camera. A standard tripod is best, but you can use a pocket tripod on top of a table, or even a pile of books, if necessary. Either way, position the camera about five feet from your stool.

Turn on the flash. The ambient room lighting is often bright enough to provide overall even illumination, but the flash will provide a little burst of front light to smooth out facial blemishes and put a twinkle in your eyes.

This job is easiest, of course, if your camera has a flip screen and a remote control. If yours doesn't, use the camera's self-timer. To help you frame the shot while you're not actually on the stool, use a table lamp as a standin.

Check your hair and clothes, press the shutter button to trigger the self-timer countdown, and then sit on the stool (preferably *after* removing the table lamp).

Once the camera fires, inspect the photo on the camera. Did you zoom in close enough? Are you in focus and framed correctly? How's the lighting?

If you need to add a little light to one side of your face or the other because it's appearing too shadowy, you can construct a homemade reflector out of white cardboard or similar material. Position your reflector as close to you as possible (not, of course, actually in the shot) and angle it so it bounces light off the brightest light source onto the area requiring illumination to help lighten up the dark areas.

 Tip Remember the lampshade-as-tripod trick described on page 81! Or buy a QuikPod ($25, *www.quikpod.com*), a very lightweight, collapsible extend-o-stick for taking self-portraits. The camera screws onto the far end (models are available for both compacts and SLRs); you hold onto the handle at the near end. The camera winds up four feet away, and the self-timer takes the shot.

Shoot another round. Once you get the basic setup looking good, experiment with different angles and facial expressions. One advantage of taking your own portraits is that you can be more creative. Remember, you can always erase the embarrassing frames—or all of them. Remember, too, that self-portraits don't have to be dull headshots; they can be every bit as interesting as any other photo.

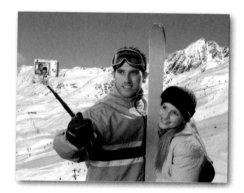

The Indoor-Flash Portrait

OK, and what if there *is* no northern-exposure window casting gorgeous, even light over your patiently posed subject? What if it's, you know, *nighttime?*

Well, then you'll have to use the flash.

Unfortunately, you know perfectly well what's wrong with that. You've probably seen plenty of indoor flash pictures where there's a pitch-black background and overexposed subjects that look like they're witnessing a nuclear blast.

If you must use the flash, you can make certain adjustments to preserve the ambiance of the room.

If your camera lets you adjust the aperture (f-stop) and shutter speed (page 74), you can easily overcome these problems. Once in manual mode, try this combination as a starting point for flash photography indoors:

- **Set your ISO** (light sensitivity) speed to 100 (page 82).

- **Set the aperture** (f-stop) to f5.6.

- **Set the shutter speed** to 1/15th of a second.

- **Stand back 5 to 7 feet** for best flash range.

- **Use the forced-flash mode.** (*Don't* use the redeye reduction feature.)

At these slow shutter speeds, your shots are more vulnerable to camera shake, and therefore to blurriness. The flash will freeze the subject, so he'll be sharp (and following the flash, he'll be so dark he won't even register). But the lights of the background, not illuminated by the flash, may blur if the camera isn't steady.

If your camera doesn't have a manual mode, all is not lost. Almost every pocket cam offers a flash setting called *Night Portrait* or *Slow Synchro* mode, often indicated by a star-over-human-silhouette icon.

This mode was designed for shooting portraits at twilight, as described in the next section. But you can also use Nighttime mode to "open up" the background indoors.

The Nighttime Portrait

Nighttime portraits can be extremely interesting, especially when your subject is in front of a lit-up building or other landmark.

You can probably guess the first step at this point: Put the camera on a tripod or steady surface.

The next step is critical: You want to open the aperture very wide to admit as much light as possible. You can do this in one of two ways:

Aperture-Priority Mode

If your camera offers an aperture-priority mode (page 77), set the aperture to f2.8 or f4.

Take a shot of just the background; check how it came out. If it looks good, force the flash and position your subject within 7 feet of the camera. Ask her to stand still until you say it's OK to move.

When you take the picture, the flash fires very briefly, but the shutter stays open for another second or two to soak in enough light to pick up the background.

Review the results. If your subject is too bright, move the camera farther away. Move closer if the subject is too dark.

Nighttime Flash Mode

If your camera doesn't have an aperture-priority mode, it probably has a Nighttime Portrait mode (the icon looks like a person beneath a moon or star).

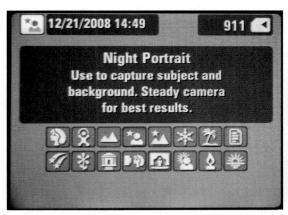
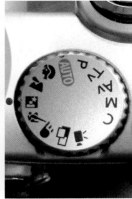

The camera opens the aperture wide to soak up light. It flashes to illuminate your subject, and then the shutter remains open long enough to soak in whatever light is provided by the background: city lights, partygoers, whatever. (You can see a sample on page 53.)

Try it. If your model is too bright or too dark, move closer or farther.

The Exploding Zoom

You've probably seen this classic special-effect shot. It's a cool, artsy, abstract sort of photography—not what you'd want to illustrate your eBay goodies, but a lot of fun to make.

Oh—it's for SLRs only.

Steady the camera as best you can. Frame the shot with the widest zoom setting on your lens. Select a slow shutter speed—maybe 1 or 2 seconds.

The goal is to zoom in while the shutter is open. Be quick but steady. You may need to try multiple times to get the center reasonably sharp (if that's something you want).

The resulting picture looks as if it's exploding from the center, or as though you're flying at Warp 9 toward the subject.

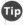 **Tip** There are hundreds more classic photo types that aren't covered by this chapter—or, indeed, by any one book. Snow shots. Tennis shots. Animal photography. Experimental shots. Virtual-reality shots. Infrared shots. High-dynamic-range shots. Architectural shots.

Subscribe to *Popular Photography,* a terrific magazine written in plain English. Each month, its How To articles tackle another one of these specialized photo ops.

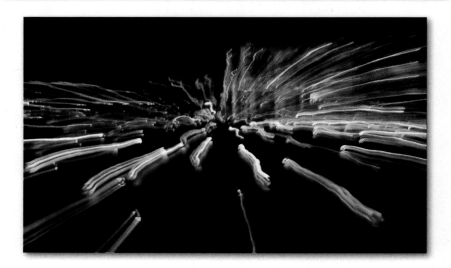

Chapter 7:
The SLR Chapter

Most of the advice in this book applies to any kind of camera: the tiny, sleek compacts; the midrange superzooms; and the big, black SLRs. But some glorious features—and some irksome pitfalls—are unique to SLR ownership. This chapter steers you through them.

Lenses

Just taking pictures with an SLR gives your photography an *enormous* boost. Without learning anything new, you get all of this:

- **Less "noise" in low-light photos** without the flash, thanks to the huge sensor inside.

- **Much better sharpness and detail,** thanks to the extremely high-quality lens.

- **No shutter lag and high burst rates,** thanks to highly tuned circuitry inside.

- **That delicious blurry-background look** in your portraits.

- **Manual controls** that make possible all kinds of shots that you simply can't get with a compact camera (see Chapter 6).

- **Battery life** that blows away pocket cams.

But for serious photographers, the biggest perk of all might be the fact that you can *swap lenses.*

True, many people start out using only the "kit lens"—the one that came with the camera. It's usually a basic 18 to 55 mm zoom (that is, about 3X zoom) that works beautifully with the camera body.

And that's fine. It's even fine if you never get a second lens. But the point is that you *can* if, someday, you decide it's time to grow as a photographer.

Unfortunately, there's no such thing as a single lens that covers the whole range, from wide angle to telephoto. Instead, you'll have to shop for lenses by focal range. They tend to fall into these categories:

- **Wide angle.** You might consider, first, a wide-angle lens (say, a 12 to 24 mm lens). Ever wonder why the photos in travel magazines seem to be more stunning than your own? Or why the photos in architecture magazines and real-estate catalogs manage to show an entire huge room in a single shot—and you just can't seem to back up far enough for your camera to do that?

 That's because the pros used a wide-angle lens. It grabs a much taller and wider view of the scene than a regular lens, like the 18-55 lens that comes with many SLRs. It's absolutely fantastic to have when you travel; wide-angle photos resemble what your own eyes see much more than regular-lens photos do.

12 mm (wide angle) 18 mm

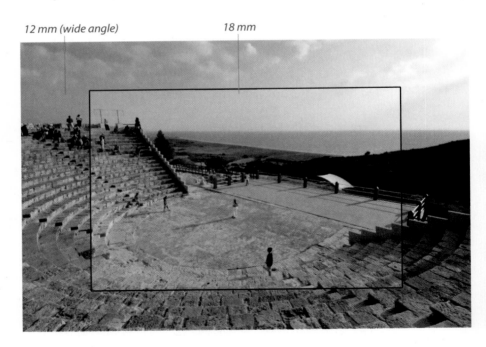

They are not, however, great for portraits; they tend to distort faces that aren't dead-center, which is rarely appreciated by your subjects.

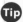 **Tip** Here's a great article about the art of using ultra-wide-angle lenses: *http://tinyurl.com/6pw33y.*

- **Standard.** The kit lens is a standard lens, a nice, middle-of-the-road lens, great for portraits and just about anything else, although you won't get a particularly wide angle or an especially powerful zoom.

- **Prime.** A *prime* lens is one with no zoom at all. Yes, that's right: Photographers routinely pay hundreds of dollars for fixed-zoom lenses.

 Why? Because the optics in a prime lens have no compromises. You get the best possible flow of light, undistorted and bright. A 50 mm prime lens, for example, takes astonishingly high-quality portraits.

- **Telephoto.** Telephoto means "zoom." These lenses put you very close to the action (especially if you get one of those enormous, telescope-like *superzoom* lenses that you see on the sidelines at pro sports games). They compress distances, though; there's not as much three-dimensionality with a telephoto shot.

 You can also buy a midrange-to-telephoto lens—say, one that goes from 18 to 200 millimeters. That's an 11X zoom that puts you in in close when you're shooting sports, school plays, airplanes and helicopters, and so on—and yet behaves as a good, everyday lens the rest of the time, since the 18 mm end is wide enough for group shots and walk-around shots.

Lenses aren't cheap; you may be appalled to discover that one lens might cost more than the camera. (Buying used might help.) And nobody's expecting you to haul around a suitcase full of lenses, like the professionals do.

But even if you own only two lenses—a wide-angle and a normal-to-telephoto lens—you'll be ready for just about anything and yet keep your camera bag light.

 Note On the box, and in the ad, for any lens, you'll see an f-number, like f/2.8. That's a measurement of how *fast* the lens is—a photographer's term that specifies how light-sensitive it is. (It's a reference to the fact that you can use faster shutter speeds and maintain the same light.)

Lower f-numbers are better, because they admit more light. If there's a range, like f/3.5 to f/5.6, then it means that the lens grows dimmer as you zoom in. (Faster lenses usually cost more, however.)

Changing Lenses

Despite all the power and flexibility you get from interchangeable lenses, you also get one potential pitfall: When you *remove* a lens (to put on a different one), you can't help leaving the camera itself exposed to the air for a moment. During that time, dust can drift into the yawning cavity of the camera. If a fleck of dust lands on the sensor itself—a shiny rectangle, dead center, clearly visible whenever you remove the lens—you wind up with a shadowy spot on every single picture you take. Forever, or until you remove that dust, whichever comes first.

Dust shadows

Clearly, dust specks on the sensor do not make people happy.

They're not the end of the world, though:

- Almost all SLRs built since 2007 contain anti-dust features. All those Canon Rebels and Nikon D-whatevers perform a tiny sensor dance each time you power them up—a little shudder that's intended to knock dust right off the sensor and onto a waiting, nearby adhesive strip. As a result, you hardly ever hear about dust-on-sensor problems with these models.

- When you change lenses, of course, you have only two hands. So it can be a little awkward to hold the camera, the outgoing lens, and the new lens all at the same time.

 For best results, then, worry most about the camera itself during the change; keep its opening pointed downward, so dust won't drift in. If it's possible, change lenses when it's not windy (or, needless to say, dusty).

Minimize the amount of time the camera spends exposed to the air. That is, put the new lens onto the camera and *then* put the end caps on the outgoing lens.

- If you do wind up with dust spots on photos, all is not lost. Those shadows are quick and easy to fix in a program like Photoshop Elements, Picasa, or iPhoto (see page 201).

 Tip Of course, that doesn't solve the problem of *removing* the dust once it's on the sensor. If it comes down to that, you can find all sorts of cleaning kits—blowers, swabs, fluids—available on the Web or in camera stores.

But you generally don't have to go to those extremes. Just prowl through your SLR's menus until you find sensor cleaning mode, which opens the shutter and locks the mirror up out of the way. Now blow the sensor clean using an ear syringe (one of those rubber bulbs from the drugstore). Don't touch anything with the bulb tip—just blow. In general, that's all you need to blast the dust off of the sensor.

Every photographer has a different way of changing lenses, but here's one sequence. You'll note that it's designed to minimize the amount of time that your camera's sensor is exposed to the dusty air:

- With the strap around your neck, let the camera hang, pointing downward as much of the time as possible. Put the lens cap on the camera's current lens. Press the lens-removal button on the camera, right next to the lens, and twist slightly, counterclockwise, to loosen the lens—but don't take it off yet.

- Pull the new lens out of your bag. Remove the smaller end cap (on the camera end). Hold the new lens in one hand.

- Remove the current lens with the other hand, and pop the new lens on without lollygagging. (Align the little white dot of the new lens with the same dot on the camera body. Push the new lens into the socket and twist clockwise to lock it.)

- Put the endcap onto the lens you've just removed, and put it back into your bag.

 Managing the endcaps of your lenses (the smaller ones, opposite the regular lens caps) is a lot easier if you *glue them together.* That's right: glue them back to back, so the camera company's logos are kissing each other.

One lens is usually on your camera. So when you want to swap, you pop off that lens; screw it into the double-sided endcap; unscrew the new lens from the endcap; and pop it right onto the camera. This trick minimizes the time that your lenses' more sensitive (smaller) ends are exposed, reduces the likelihood that you'll drop or lose an end cap, and makes the whole job easier for people who have only two hands.

Film Equivalents

Whenever people write about SLR lenses—on the Web, in reviews, in magazines—they always give you this weird little parenthetical: "The Nikon D60 comes with an 18 to 55 mm lens (27 to 82.5 film equivalent)."

You might have wondered what the deal is with that. And you wouldn't be alone.

Truth is, the number of people who *care* about the film-camera equivalent, or even understand what it means, is rapidly dwindling. Sorry to depress the old-timers, but film is just about dead.

The intention, of course, is good. If you're used to using a film camera, and you know how big the scene looks through a 50 mm lens, then you might be startled to find out that on a digital SLR, a 50 mm lens gives you a much smaller field of vision.

This all comes about because a digital camera's light sensor is not the same size as a frame of film (except on the most expensive digital SLRs—called *full-frame* SLRs—which require no multiplier).

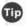 For lots of good detail on the multiplier problem, visit *www.lonestardigital.com* and click the article "Multiplier Effect."

To make matters worse, there's no standard multiplier. A 24 mm lens on a Nikon digital camera does not give you the same wide angle as a 24 mm Canon lens. (You'd multiply the Nikon by 1.5 to get the film equivalent, the Canon by 1.6.) Then came the Panasonic/Olympus SLR format called Four Thirds, which has a 2X multiplier (a 40 mm lens is the equivalent of an 80 mm film lens). Some Kodak models have yet *another* multiplier.

The world still waits for some *consistent* measurement unit for lens focal lengths in the digital era—a new system that's consistent across all lenses, all cameras. Not even millimeters—something more useful, more recognizable. (You can't just say "3X" or "4X," as you do with pocket cameras. Think about it: A 15 to 45 mm lens and a 50 to 150 mm lens are both 3X zoom lenses. But they have very different starting points, and that matters.)

Maybe degrees, measuring the maximum field of view provided by a certain lens. That would work.

That would end two problematic traditions: first, having to grapple with a different multiplier for every camera brand—and second, having to measure it against a standard from a dying technology.

JPEG Compression

As you fool around with your SLR's menus, you'll eventually stumble on an option that governs the file format of the photos you're about to take. Here, for example, is where you can opt to shoot RAW files or JPEG+RAW (page 60).

But if you're taking regular JPEG files, you're also offered a *choice* of JPEG types: superfine, fine, standard, and so on.

As you move down the scale, you're telling the camera to take lower-quality photos—the resulting JPEG files are compressed so that less information is used to describe each pixel. The result is that the photos take up less memory-card space.

It's hard to imagine anyone, these days, who'd buy an SLR and then voluntarily degrade the picture quality, especially when memory cards are so cheap they practically fall out of boxes of Cracker Jack. Leave your camera on fine or superfine.

Ten Accessories Worth the Weight

One blessing/curse of SLR ownership is that you can add to your camera. You can screw on, snap on, and slide on all kinds of accessories.

The photography magazines and Web sites are seething with possibilities, all of which seem attractive and useful when you read about them. Here, though, are some of the most popular (and useful).

Camera Bag

Camera bags come in all shapes and sizes: backpacks, belt packs, tummy packs, side-sling packs. (Some of them scream, "There's an expensive camera in here. Steal me!")

The point, though, is that you need a bag to contain your camera and lenses, shield it all from little bumps, and keep it all dry.

Lens Cloths

The lens on your SLR isn't actually that risky. If fingerprints or dust get on the outer lens (the part usually covered by a lens cap), it may not even be visible in your photos.

Still, if it does get gunked up, you need a lens cloth—a soft little cloth that leaves no lint behind (as a Kleenex would do). Or you can get lens-cleaning tissues, which come all together in a little stapled packet.

Lens Cap Leash

Whatever genius came up with the fundamental design of an SLR must have run out of steam when it came time to design the lens cap. It's just way too easy to drop, to lose, and to forget. When you want to use the camera, what are you supposed to do with the lens cap? Just carry it around.

A lens cap leash is a $2 elastic band that goes around the lens barrel; a thread connects to the lens cap itself. Now when you want to shoot, you can just yank off the lens cap and let it drop; it stays with the lens, because it's basically tied on. Great idea.

Tripod

You've read it enough times now that you've probably got it by heart: If you're going to shoot indoors or in low light without the flash, you pretty much need a tripod.

Consider carrying a tabletop tripod (or at least a beanbag). Or a Gorillapod, which you can wrap around tree branches, poles, or other oddball surfaces when a tabletop isn't available. (You can see one on page 107.)

Monopod

As noted in Chapter 5, a tripod may be the most important single antiblur, antishake accessory you can buy. Unfortunately, it's a huge pain to pack, carry, and set up, and it's not even permitted inside museums, arenas, theaters, and other places where you might like to take low-light photos.

A monopod is another story. It folds down compactly, it's legal in many more places, and it does a decent job of steadying the camera (although not, of course, as good a job as a tripod).

Cable Shutter Release

Here's another way to get steadier, sharper shots: Avoid touching the shutter button. A cable release lets you snap the shot without risking jiggling the camera. Sure, you can always use the self-timer for the same purpose—but a cable release eliminates the wait.

Use Google (or *www.bhphotovideo.com,* a huge, highly regarded photo-gear mail-order outfit) to find one that fits your camera. Prices start at $25 or so.

External Flash

An external flash is photographically superior to a built-in flash in a million different ways. It has more power. It has more control. Above all, it lets you control the angle of the light on your subject. For example, you can bounce the flash off of a wall or ceiling, which creates infinitely softer, more diffuse, more flattering light than a direct blast from the built-in flash. An external flash also means no more redeye, since the light is coming in from the side.

Of course, an external flash is like a tripod: a worthwhile investment only if you're getting really serious about your art—and otherwise, a huge hassle to buy, pack, set up, and carry.

 Note You can estimate a flash's maximum distance by checking its guide number (GN), which appears in the manual or in the marketing materials. But a little math is involved. For example, if the GN is 80 feet, you have to divide by the f-stop number you'd want to use (for example, f4) to find out its real-world range (in this example, 20 feet). The same flash would reach 40 feet if you opened the aperture up to f8.

Lightscoop

The Lightscoop is a $30 mirror attachment that slides onto your SLR's flash (at *www.lightscoop.com*, you order the model that corresponds to your camera brand). When you take a flash picture, the mirror bounces the light off the ceiling. The result: Your subject is illuminated by diffuse, even light, just as though you'd used one of those reflector umbrellas or an external flash. The Lightscoop also eliminates both redeye and the "cave effect," where the room background comes out looking black.

The Lightscoop requires a ceiling or light-colored wall, so it's useless outdoors. And you have to crank your SLR's flash brightness to its full strength. But indoors, it produces nuanced, natural, flattering light on your subject; the before-after difference is incredible.

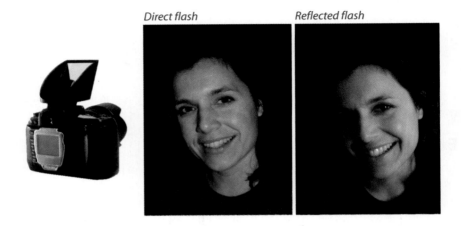

Direct flash *Reflected flash*

Filters

A *polarizing filter* is a thin disc made of special glass. It screws onto the end of your regular lens (you have to buy it by brand and lens, so it will fit)—and it does some real magic for landscape photos. Specifically, it turns the sky a beautiful, rich blue. It also brings out lush greens in trees and plants, and gets rid of glare and reflections from water and other shiny things. In short, it's sunglasses for your camera, and it's great to have ($30 and up).

An **ND (neutral-density)** filter is another standard photographer's cheat. It's essentially a circle of gray glass that you screw onto your lens, cutting down on light of all wavelengths.

After reading several chapters full of tips on getting **more** light into your camera, you might be surprised to hear about an accessory that **cuts down** on the light. But suppose you were trying to use a slow shutter speed on a very bright day—to get the "silky waterfall" effect described on page 92, for example. You might find that every shot winds up overexposed (too bright), because too much light is entering the camera for too long, even with a small aperture.

A *graduated* ND filter may be even more useful. It's a square piece of glass that you mount or hold in front of your lens, and it has a gradual *lessening* of the ND effect from top to bottom of the glass—at the bottom, it's completely clear. This filter is perfect when part of the shot is very bright (usually the sky)

and the rest is not (usually the ground); it prevents the shot from winding up "blown out" above or too dark below. It evens out the contrast.

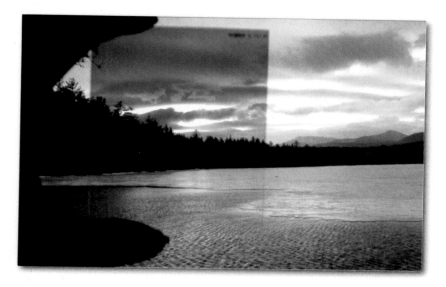

Both kinds of filters usually increase the amount of exposure time, since the shutter has to stay open longer. So the usual suggestions to keep the camera steady apply here as well.

Battery Grip

For the high-volume shooter (read: somebody who gets **paid** to take pictures—or would like to), a battery grip is a particularly useful accessory. It's a big black battery block, designed for your particular SLR model, that attaches to the camera and becomes a beefy hand grip. Inside are either rechargeable batteries or AA batteries that at least double the shooting life of your camera.

Battery grips add some serious weight to your camera, but they dramatically increase its shooting life (and offer the possibility of picking up more power at the drugstore when you're out on a shoot).

If you do a lot of portrait-orientation shooting, a grip can also lower your chiropractor bill. It adds a handle to the bottom of the camera, so that when you turn it 90 degrees, it becomes a new right-side handle, complete with vertically oriented shutter button, AE lock, AF point selector, and aperture controls. Vertical shooting is now much more comfortable; you don't have to hunt or twist to reach the shutter button and other controls.

Chapter 8:
Camera Meets Computer

O K, the Ansel Adams part of your job is over. Your camera's memory card is stuffed with photos and videos. You've snapped the perfect graduation portrait, captured that jaw-dropping sunset over the Pacific, or compiled an unforgettable photo essay of your 2-year-old attempting to eat a bowl of spaghetti. Now comes the payoff: dumping them all onto your Mac or PC so that you can organize, edit, and share them with the rest of the world.

And sharing doesn't just mean printing or emailing. You're *electronic* now, baby. Your photos can become slideshows, posters, movies, Web pages, desktop pictures, screensavers, bound books, blankets, mugs, t-shirts, calendars, and just about anything else you can think of.

But before you start organizing and publishing those pictures, they have to find their way from your camera to the computer. This chapter explains how to get pictures from camera to computer and introduces you to the software you'll need.

Picasa and iPhoto

For the rest of this book, you'll be hearing almost exclusively about Picasa (for Windows) and iPhoto (for the Macintosh). These are digital shoebox programs. They let you organize, touch up, and then send or present your pictures, so that your adoring fans can enjoy them.

Why Picasa and iPhoto? There are plenty of digital-shoebox and photo-editing programs. Why not Photoshop ($600 online), Photoshop Elements ($80), Aperture ($160), Lightroom ($272), or another big-guns program?

Well, listen: Those are great programs. If you're going to go professional, for example, you'll pretty much need a copy of Photoshop.

But including instructions in this book for every one of those programs would have pushed it past that 1,500-page threshold that the bookstores are so fussy about.

Meanwhile, Picasa and iPhoto have three huge advantages:

- They're very easy to use.
- They have every conceivable feature for touching up, organizing, and sharing photos.
- They're free.

Picasa is a free program from Google, and iPhoto comes preinstalled on every Mac. They're both excellent. And once you've learned their fundamental concepts, graduating to one of the expensive programs will be much easier.

In fact, these programs are so similar, you could describe them both in the same book, with only a few wording changes to differentiate the steps.

Guess what? This is the book.

Where to Get Them

Picasa is a free download from *www.picasa.com.* Follow the installation instructions; the whole thing is over in 5 minutes. You'll find Picasa listed in your Start menu's Programs list, and its icon on your desktop.

iPhoto comes preinstalled on every Mac. It's in your Applications folder. (In the Finder, choose Go→Applications or press Shift-⌘-A to open this folder.) You'll also find the iPhoto icon—the little camera superimposed on the palm tree—preinstalled in your Dock, so you'll be able to open it more conveniently from now on.

This book covers Picasa 3 and iPhoto '08, but earlier and later versions work pretty much the same way.

Transferring the Photos by USB Cable

Now it's time for you to import your pictures to your computer—a remarkably easy process.

Connecting with a USB Camera

Every digital camera comes with a USB cable, usually black. The computer end of the cable has a flat, rectangular, standard USB plug. Connect it to one of your computer's USB jacks.

The other end—the part you plug into your camera—has a small, flat-bottomed plug whose shape varies by manufacturer. Connect it to the corresponding jack on the camera, which is often hiding behind a rubber or plastic door. Now you're ready to proceed.

Step 1: Turn on the Camera

What happens now differs only slightly depending on your program:

- **Mac:** If iPhoto isn't already running when you make this connection, the program opens and springs into action as soon as you switch on the camera.

- **PC:** Open Picasa. Click the Import button shown here. On the next screen, from the Select Device pop-up menu at the top left, choose your camera's model name (you can see it in the illustration on the next page).

After a moment, you get to see thumbnails—miniature images—of all the photos on your camera's memory card. If for some reason the software doesn't "see" your camera after you connect it, try turning the camera off, then on again.

In any case, your screen should look something like this:

iPhoto

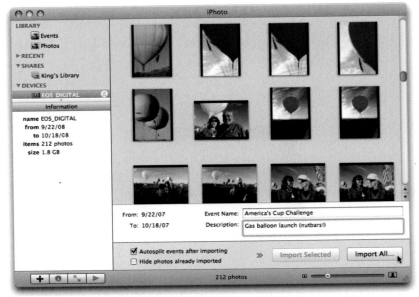

Picasa

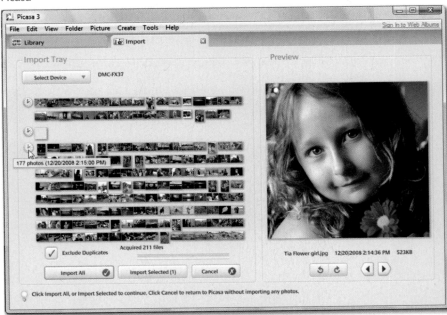

How is this wonderful? Let us count the ways. First, you can see right away what's on the card. You don't have to sit through the time-consuming importing process just to discover, when it's all over, that you grabbed the wrong card or the wrong camera.

Second, you can choose to import only *some* of the pictures, using any of the thumbnail-selection tricks described on page 163.

- **iPhoto notes:** Drag the size slider at the bottom-right of the window to change the size of the thumbnails. If you like, type in an *Event name* and description for the pictures you're about to import. An Event, in iPhoto's little head, is "something you photographed within a certain time period" (for example, on a certain day or during a certain week). It could be *Disney Trip, Casey's Birthday,* or *Baby Meets Lasagna,* for example— anything that helps you organize and find your pictures later.

- **Picasa notes:** You can click the arrow buttons to step through larger versions of the photos. Note how nicely Picasa groups the thumbnails by *batch*—that is, in groups of photos that were all taken at about the same time.

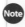 **Note** Both programs let you avoid importing pictures from the camera that are already on the computer. In Picasa, the option is called Exclude Duplicates; in iPhoto, it's "Hide photos already imported." It's hard to imagine when you *wouldn't* want this option turned on.

Step 2: Import

If you selected just *some* of the photos in step 1, then the Import Selected button springs to life. Clicking it brings only the highlighted photos onto your computer, ignoring the rest of the camera's photos.

If you click Import All, well, you'll get all the photos on the card, even if only some are selected.

- **iPhoto notes:** As soon as you click an Import button, iPhoto swings into action, copying each photo from your camera to your hard drive. You see them flash by so you can watch the parade.

- **Picasa notes:** You arrive at a Finish Importing screen. Behind the scenes, Picasa intends to store all the new pictures in a new folder on your hard drive; at this moment, you're asked to type a name for this folder. Here, too, you can specify where the pictures were taken, when, and what they're about (in the Description box).

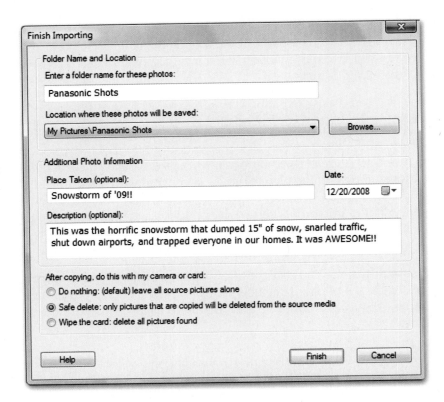

Make a decision about erasing the pictures from the camera (see below), and then click Finish.

Step 3: Erase Them from the Camera, or Not

Now you have an important question to answer: When the process is complete, and the photos are safe on your hard drive, do you want to delete the transferred pictures from the memory card? (Picasa asks you *before* importing them; iPhoto asks you after the job is done.)

If you click Delete Originals (iPhoto) or "Safe delete" (Picasa), then the computer deletes the transferred photos from the memory card. The memory card will have that much more free space for another exciting photo safari.

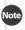 The "Wipe the card" option in Picasa erases *all* pictures from the card, even ones you haven't just imported. Be careful, will you?

If you click Keep Originals (iPhoto) or "Do nothing" (Picasa), then the memory card is left untouched. (You can always use the camera's own menus to erase its memory card.)

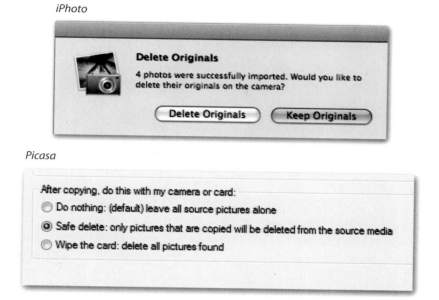

iPhoto

Picasa

Step 4: "Eject" the Camera's Card

In other words, get it off the screen so you can safely turn off the camera.

- **iPhoto:** Click the ⏏ button next to the camera's name in the Source list (that column at the far left of the screen). Or, if the ⏏ button doesn't appear, just drag the camera's icon directly onto the Trash icon in the Source list. You're not actually throwing the camera away, of course, or even the photos on it—you're just saying, "Eject this." Even if the camera's still attached to your Mac, its icon disappears from the Source list.

- **Picasa:** Just unplug the USB cable from the camera. It's OK.

Either way, your freshly imported photos appear in the main window, awaiting your organizational talents.

Transferring Photos with a Card Reader

A *memory card reader* offers an incredibly convenient way to transfer photos to your computer. Plenty of PCs, for example, have memory-card slots built

right in; and even if yours doesn't, or if you have a Mac, you can buy an external USB card reader for about $10. They look like tiny plastic disk drives. Some can read more than one kind of memory card.

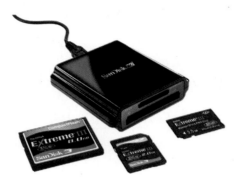

If your computer is equipped with card slots or a USB card reader, then instead of connecting the camera to the machine, just remove the camera's card and insert it into the slot or card reader. From here, the steps are exactly as described above. Picasa or iPhoto recognizes the card as though it's still in the camera and offers to import the photos, all of them or some of them, just as described on the previous pages.

This method offers two big advantages over the camera-connection method. First, it eliminates the battery drain involved in pumping the photos straight off the camera. Second, it's less hassle to pull a memory card out of your camera and slip it into your card reader (which is always plugged in) than it is to hunt for the camera's USB cable and connect both ends every time you want to dump photos.

> **Tip** Of course, if your compact camera has a stash of *built-in* memory, as most do these days, then a USB cable is the only option. It's not very practical to try to jam the entire camera into a memory-card reader.

Two More Cute Tricks

Actually, there *are* ways to travel even lighter. Depending on the memory card you buy, you may be able to travel without packing either a USB cable *or* a card reader.

First, you can buy a SanDisk Ultra II SD card. It's a *folding* card, believe it or not.

In your camera, it works just like any ordinary SD card. But when you're ready to transfer your pictures, you just fold the thing in half on its tiny hinges, revealing a hidden set of USB contacts. You can now insert that exposed portion of the card itself directly into a computer's USB jack—no cables, no reader required.

It shows up on your Mac or PC just as though it were inserted into a card reader.

Second, you can buy another rather unusual SD card called the Eye-Fi card. Once again, it looks and works just like a regular SD card—except that, incredibly, it has Wi-Fi wireless networking circuitry built into it. (How'd they get it so small?) The point is that whenever your camera and your computer are on the same wireless network—when you get home each day, for example—the card sends all of your pictures back to the computer, wirelessly and automatically.

It can also upload them to your choice of dozens of online photo galleries—Flickr, KodakGallery.com, Snapfish, and so on—wirelessly and, once again, automatically. That's quite a slick trick.

 In fact, the Eye-Fi Explore card, which costs a little more, actually has a sort of GPS on it. Every time you take a picture, the photo is stamped with your physical coordinates. Later, in Picasa or on Flickr.com, you can see an aerial photo or a map that reveals exactly where you were standing when you took the picture. (Welcome to *geotagging*.)

Importing Pictures on Your Hard Drive

If you've been taking pictures for some time, you probably have a lot of photo files already on your hard drive. You might want to use your new digital-shoebox program to organize them, too.

- **iPhoto:** To add photo folders to iPhoto, find them on the Mac's hard drive. Now drag them either into the main photo area or into the Source list (the column on the left side).

 Or, if you prefer, choose File→Import to Library (or press Shift-⌘-I) in iPhoto; select a file or folder to import in the Open dialog box, and then click Import.

- **Picasa:** All photo files on your hard drive show up in Picasa automatically, the very first day you install the program. You'll find their corresponding folders listed at the left side of the window, exactly as they're named on your hard drive.

By the way, Picasa and iPhoto take radically different approaches to storing your photos:

- **iPhoto:** When you import pictures into iPhoto, the program makes *copies* of your photos, always leaving your original files untouched.

 Where do they all go? Behind the scenes, iPhoto stores your pictures in a special folder called iPhoto Library, which you can find in your Home→Pictures folder.

 Don't move, rename, delete, or open this iPhoto Library file yourself! You should do all your photo organizing within the iPhoto program, not behind its back in the Library. Making changes in the Finder will confuse iPhoto in very unpleasant ways.

- **Picasa:** The program doesn't actually store *anything.* It just lists whatever folders of pictures it finds on your hard drive, and it creates new folders full of pictures each time you import from your camera.

 In other words, you can move or delete photos from within Picasa, or right there in Windows Explorer windows. It makes no difference to Picasa. It's just a mirror of whatever's on your hard drive.

The File Format Factor

iPhoto and Picasa can't import digital pictures unless they understand the photos' file formats, but that rarely poses a problem. Every digital camera on earth can save its photos as JPEG, TIFF, or RAW files; both photo programs handle these formats beautifully. (JPEG is the world's most popular file format for photos, because even though it's compressed to occupy a lot less disk space, the visual quality is still very high. The terms JPEG, JFIF, JPEG JFIF, and JPEG 2000 all mean the same thing.)

In fact, they can handle other graphics formats, too, like BMP, Photoshop, PNG, and GIF. Good to know if you want iPhoto and Picasa to manage a bunch of other graphic stuff from your hard drive.

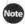 **Note** Not every camera offers an option to save your files in RAW format (page 60). And among those that do, not all are iPhoto/Picasa compatible. Why are only some cameras compatible? Because RAW is a concept, not a file format. Each camera company stores its photo data in a different way, so in fact there are dozens of different file formats in the RAW world. Programs like iPhoto and Picasa must be upgraded periodically to accommodate new camera models' emerging flavors of RAW.

Movies

In addition to still photos, compact cameras (and even a few SLRs) can also capture digital movies. These are no longer jittery, silent affairs the size of a Wheat Thin; modern cameras capture full-blown, 30-frames-per-second, fill-your-screen movies—even high-definition movies.

Movies eat up a memory card fast, but you can't beat the convenience, and the quality comes breathtakingly close to camcorder quality.

Fortunately, iPhoto and Picasa can import and organize them, too:

- **iPhoto** imports any format that QuickTime Player (the program on your Mac that actually *plays* these movies) recognizes, which is a very long list indeed. It includes MOV, AVI, MPG, and many other video formats.

- **Picasa** can recognize AVI, MPG, ASF, and WMV video files. (Check your camera's manual to see what kind of movie files it produces.)

You don't have to do anything special to import movies; they get slurped in automatically. To play one of these movies once they're in, just double-click its thumbnail (which represents the *first frame* of the video).

- **iPhoto** opens the video into a separate program on your Mac called QuickTime Player. It offers a lot of different playback options—and if you spring $30 to upgrade it to QuickTime Player Pro, you gain menu commands and features for *editing* your videos (instead of just watching them).

- **Picasa** plays the video immediately, right in place. Next to the video, you even get buttons like Upload to YouTube and Export Clip.

The Post-Import Inspection

Once you've imported a batch of pictures, what's the first thing you want to do? If you're like most people, you want to look at them. This is the first opportunity you have to see, at full-screen size, the masterpieces you and your camera created. After all, until this moment, the only sight you've had of your photos is on the little screen on the back of the camera.

Step 1: Click the "Container"

To begin inspecting photos, you first have to tell the program *which* photos you want to inspect.

- **iPhoto:** Click the Last Import icon in the Source list.

- **Picasa:** Click the name of the folder that contains your newly imported pictures. It should be easy to remember, since you just typed it a few minutes ago. (It's in the Folder list.)

iPhoto

Picasa

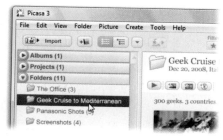

Either way, in the main window, you're now treated to a soon-to-be-familiar display: a grid of thumbnails. In this case, they represent the pictures you just imported.

Tip You can adjust the size of these thumbnails by dragging the size slider at the lower-right edge of the window.

To inspect a photo, double-click it. If all goes well, it swells to fill the main part of the window.

Note iPhoto Note: If double-clicking the photo did not open it up into a window like what you see below, it's likely that you or somebody else has changed the iPhoto preferences so that double-clicking a thumbnail does not magnify a photo for inspection. Choose iPhoto→Preferences, click General, and where it says "Double-clicking a photo," select "Magnifies photo." Close the Preferences window.

After the shock of seeing the giant-sized version of your first photo has worn off, press the → key on your keyboard to bring the second one into view. Press it again to continue walking through your new photos, checking them out.

This is the perfect opportunity to throw away lousy shots, flag the winners, fix the rotation, and linger on certain photos for more study. Here's the full list of things you can do as you walk through the magnified pictures:

- Press the ← or → keys on your keyboard to browse back and forth through your photos.

- Click the Rotate button(s) to turn a photo, 90 degrees at a time.

Tip iPhoto Tip: iPhoto has only a single Rotate button. Option-click it to rotate the photo the opposite direction.

iPhoto

Picasa

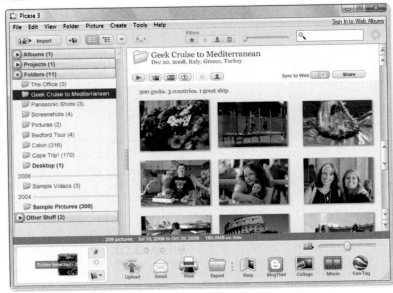

- In iPhoto, you can give each photo a rating in stars, from 1 (terrible) to 5 (terrific). To do that, press ⌘-1 through ⌘-5 (or press ⌘-0 to remove the rating). Or, during a slideshow, use the number keys at the top of the keyboard or on the numeric keypad; press 3 (without the ⌘ key) to give a picture three stars, for example.

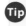

- Press the Delete key on your keyboard to delete a photo.

- *Hide* a photo. You return to the thumbnails view, the photo you were looking at fades away, and the remaining thumbnails slide over to close the gap. Hiding a photo isn't the same as deleting it; the photo's out of your way, but it's still in your Library, and you can always bring it back. In iPhoto, click the Hide button beneath the picture; in Picasa, choose Picture→Hide. Details on hiding photos appear on page 165.

- *Flag* a photo. Flagging means whatever you want it to mean. It could mean, "This one's a winner,""Edit me,""Send this one to Uncle Morty," or whatever you decide. In iPhoto, click the Flag button beneath the picture (or press ⌘-period); in Picasa, click the Star button beneath the picture (or press the space bar).

- Take care of jobs like cropping, color-correcting, or adjusting the expo-sure of a picture. In Picasa, these controls appear to the left of every photo; in iPhoto, click the Edit button beneath the photo. Details on edit-ing are in Chapter 10.

The other buttons on the toolbar offer ways to share your photos, and you can what appears there using the View→Show in Toolbar commands.

When you're finished walking through your pictures, you can return to your thumbnails:

- **iPhoto:** Click inside the photo.

- **Picasa:** Click the Back to Library button (top left).

Instant Slideshow

The slideshow feature offers one of the world's best ways to show off your digital photos. Slideshows are easy to set up, they're free, and they make your photos look fantastic. Your images fill every inch of the monitor—no windows, no menus, no borders. Professional transitions take you from one picture to the next, producing a smooth, cinematic effect. If you want, you can add a musical soundtrack to accompany the presentation.

You begin by selecting the pictures you want—by clicking a container (album, folder, whatever) in the left-side list.

Now all you have to do is look for the Play button (▶), which is pointed out by the arrow cursors in the illustrations below:

- **iPhoto:** *Option*-click the ▶ button, which is just below the photos.
- **Picasa:** Click the ▶ button, which is just above the photos.

iPhoto

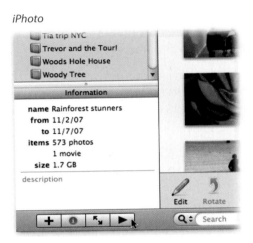

Picasa

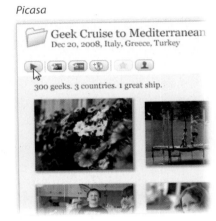

In any case, the slideshow begins immediately. It shows all photos in that album or folder, 3 seconds at a time, with a dissolve effect between.

You can exit the slideshow by pressing the Esc key (upper left of your keyboard).

Music Options

What's a slideshow without music? Boring, that's what. Time to dig into your music-file collection and add a little emotional impact to your photos.

- **iPhoto:** If you click the ▶ button *without* the Option key, you get a dialog box where you can choose the music for the slideshow, adjust its speed, and make other settings. Only when you dismiss the dialog box by clicking the Play button does the show begin.

- **Picasa:** Choose Tools→Options. Click the Slideshow button. In the result-ing dialog box, click Browse to choose a folder full of music files (in MP3 or WMA format) that you want to use as the musical background. Click

OK when you're finished. *Now* when you start the slideshow, you'll hear the music.

iPhoto

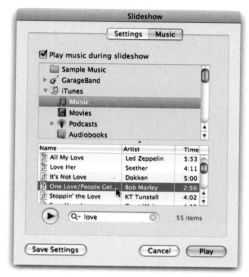

Picasa

Controlling the Show

The slideshow is a terrific feature for reviewing photos you've just dumped in from the camera. To pause the slideshow, press the Space bar; to resume, press it again.

Once the slideshow begins, wiggle your mouse to call forth the slideshow control bar.

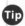 **Tip** When the show is paused, press the right or left arrow keys to walk through the slides manually. This is a great technique when you're narrating the slideshow in person.

The control bar has all the buttons you need for throwing away lousy shots, flagging the winners, fixing the rotation, and lingering on certain photos for more study—all without interrupting the slideshow.

Here's the full list of things you can do when the onscreen control bar is visible:

- Click the left and right arrow buttons to browse back and forth through your photos. The ← and → arrow keys on your keyboard work, too.

- Click the rotation icons to turn photos clockwise or counterclockwise, 90 degrees at a time.

- Press the Esc key (upper-left of your keyboard) to end the show. (Or click Exit on Picasa's toolbar, or click the mouse in iPhoto.)

iPhoto

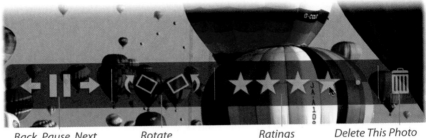

Back, Pause, Next Rotate Ratings Delete This Photo

Picasa

Back, Pause, Next Transition Effect

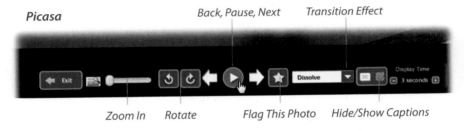

Zoom In Rotate Flag This Photo Hide/Show Captions

Each program's control bar also offers a few toolbar goodies of its own. For example:

iPhoto

- Click one of the five dots to apply a rating in stars, from one at the left to five all the way at the right. Or use your number keys; press 3 to give a picture three stars, for example.

- Press the ↑ or ↓ keys on your keyboard to make the slides appear faster or slower.

- Delete a photo by pressing the Delete key while the picture is on the screen. (Unless you have very understanding family and friends, you may want to do this before you show the pictures to others for the first time.)

The deleted photo goes into the iPhoto Trash—an icon at the left side of the main window—where your photos sit in a safety net until you finally choose iPhoto→Empty Trash.

> **Tip** iPhoto Tip: iPhoto offers *saved* slideshows—a memorized set of photos, music, and settings—each of which appears as an icon in your Source list. You can tweak a slideshow to death—you can even set up different transition and speed settings for each individual slide—and then save all your work as an independent clickable icon, ready for playback whenever you've got company.
>
> Select the photos you want, click the Slideshow button at the bottom of the screen, choose a playback order (drag thumbnails horizontally), choose your music, walk through the slides and set up their timings and transitions (if you like), and then click the big Play button.

Picasa

- Flag a photo as a winner by clicking the star button.

- Zoom in to inspect the details of a photo by dragging the Zoom slider and then dragging the photo on the screen with the hand tool that appears.

- Change the speed of the slideshow by clicking the + and – buttons beneath the words "Display Time."

- Change the transition style using the pop-up menu (which starts out saying Dissolve).

- Click the trash can icon to delete a photo from the album you're viewing (but not from the Photo Library). Or simply hit Delete on your keyboard.

Chapter 9:
The Digital Shoebox

I f you've imported photos into iPhoto or Picasa, as described in the previous chapter, your journey out of chaos has begun. You're not really organized yet, but at least all your photos are in one place. From here, you can sort your photos, give them titles, group them into smaller sub-collections (called *albums*), and tag them with keywords so you can find them quickly. This chapter helps you tackle each of those organizing tasks as painlessly as possible.

The Source List

Even before you start naming your photos, assigning them keywords, or organizing them into albums, your digital shoebox software imposes an order of its own.

The key to understanding it is the *Source list* (folder list) at the left side of the window. This list grows as you import more pictures and organize them. But right off the bat, you'll find certain icons that get you started:

- **iPhoto:** The icons include Events (thumbnails for *clumps* of photos that were taken around the same time—on someone's birthday or wedding weekend, for example), Photos (all the photos, not clumped, on a massive, scrolling display), Last 12 Months, and Last Import.

- **Picasa:** The list displays every folder on your PC that contains photos or graphics of any kind.

 Picasa Tip: Sometimes, you'll find folders in the list that contain graphics you don't really want to work with (say, a folder that contains a bunch of clip art) or that you'd prefer that other people not be able to view (for example—well, you know). To get them out of your hair (and out of the Folders list), click the offending folder, then choose Folders→Hide. You're offered the chance to make up a password for the viewing of all hidden folders.

The folder doesn't actually disappear; it just moves to a category called Hidden Folders, farther down the Source list. You can always restore it to the main Folders list by clicking its name and choosing Folders→Unhide.

In any case, when you click an icon in the Source list, the main part of the screen displays everything inside it.

iPhoto

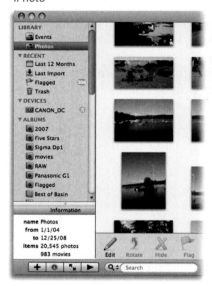

Picasa

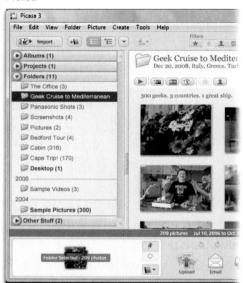

Pretty soon, you'll add icons of your own to this Source list. For example, it's where the program will list the following:

- **Albums.** Later in this chapter, you'll find out how to create your own arbitrary subsets of pictures, called *albums*. They're all listed in the Source list.

- **Projects.** Under this heading, you'll find the icons for any creative photo presentation goodies that you've assembled. In iPhoto, that means photo books, photo calendars, or photo greeting cards; in Picasa, it means movie slideshows, slideshows, and collages.

- **Web albums.** Both iPhoto and Picasa can post photo albums on the Web, for all your adoring fans to see. You also can subscribe to *other* people's albums, so you can see them. Those albums, too, appear in the Source list.

As the Source list grows longer, you may be increasingly grateful for the flippy triangles beside each category name (Projects, Albums, and so on). Click one to collapse that category of list items, making the whole list that much shorter and easier to manage.

 Picasa Tip: If you feel light-headed from the simple list of folders, choose View→Folder View→Tree View. Now Picasa displays the folder list in a much more Windowsy way: as a hierarchy of nested, collapsible folders, which makes it much easier to figure out what *other* folders yours is inside of.

Working with Thumbnails

To see what's in one of these folders or albums, click it. The right side of the screen fills with the thumbnails of its contents. At this point, you can have all kinds of fun:

- **Scroll through them** either by using the vertical scroll bar or by pressing the Page Up or Page Down keys. Press Home to jump to the very top of the photo collection, or End to leap to the bottom.

- **Make them all bigger or smaller** by dragging the size slider at the lower-right corner of the window.

- **Rotate one** by clicking it, or selecting several, and then pressing ⌘-R (iPhoto) or Ctrl+R (Picasa).

 Those keystrokes rotate the selected photos clockwise. To rotate them the opposite direction, press Option-⌘-R (iPhoto) or Shift+Ctrl+R (Picasa).

- **Delete one** by clicking it and then pressing the Delete key.

 It's not actually gone for good. It goes into the iPhoto Trash (iPhoto) or the Recycle Bin (Picasa). It's not fully deleted until you choose iPhoto→Empty Trash or right-click the Recycle Bin and, from the shortcut menu, choose Empty Recycle Bin.

- **Open one for viewing** by double-clicking.

- **Sort the photo thumbnails** by date, name, size, and so on. In iPhoto, these options are in the View→Sort Photos submenu; in Picasa, they're in the View→Folder View submenu.

 Note: You can also drag thumbnails around into a new sequence using the mouse. In iPhoto, though, this works only in an *album* (described later in this chapter).

- **Export some photos to the hard drive** by selecting them (see the selection tricks described on page 163), and then choosing File→Export (iPhoto) or File→Export to Folder (Picasa). A dialog box appears, where you can name the exported photos, choose a folder location for them, scale them down to a smaller size, and so on. In iPhoto, you're also offered the chance to change the photos' file format; in Picasa, you can add a watermark to the exported pictures (a faint, superimposed copyright notice, for example, to prevent marauding bands of photo thieves from depriving you of your livelihood.)

- **Batch rename the pictures.** Select a whole bunch of thumbnails. Then, in iPhoto, choose Photos→Batch Change; in Picasa, it's Picture→Batch Edit→Rename. Either way, you're now given the chance to give all the selected photos a new name (Disney Trip 1, Disney Trip 2…).

- **Rename the photos individually.** In iPhoto, choose View→Titles. Now each photo's name appears. Unfortunately, at the outset, they're something like P10149931DSC.JPG. Click a title and type something more descriptive, like *Casey Meets Spaghetti Bowl*.

 Tip: iPhoto Tip: Press ⌘-] (right bracket) to highlight the *next* thumbnail's name, ready for editing that one.

In Picasa, choose View→Thumbnail Caption→Caption to make the titles appear. (At the outset, there aren't any.) Double-click a thumbnail to open it for editing; at the bottom of the screen, click where it says "Make a caption!" and type a better description for the photo.

To edit captions more efficiently—that is, all from the keyboard—press Enter to close the caption box. Hit the right arrow key to bring up the next photo; press Tab to jump to its "Make a caption" box. Lather, rinse, repeat.

Selecting Photos

You probably know how to select one photo—for opening, printing, rotating, or whatever: Just click it once with the mouse. But many first-timers have no idea how to manipulate *more* than one icon at a time, in preparation for deleting, moving, duplicating, printing, and so on. Here's how.

- **To select all photos in the window.** Select all the pictures in the set you're viewing by pressing ⌘-A (iPhoto) or Ctrl+A (Picasa). That's the equivalent of the Edit→Select All command.

- **To select several photos by dragging.** You can drag diagonally to highlight a group of nearby photos. You don't even have to enclose the thumbnails completely; your cursor can touch any part of any icon to highlight it. In fact, if you keep dragging past the edge of the window, the window scrolls automatically.

 Tip If you include a particular thumbnail in your dragged group by mistake, you can remove it from the selected cluster with a ⌘-click (Mac) or a Ctrl-click (Windows).

- **To select consecutive photos.** Click the first thumbnail, and then Shift-click the last one. All the files in between are automatically selected.

- **To select random photos.** If you want to highlight, for example, only the second, fourth, and eighth photos in a window, start by clicking photo icon number two. Then click each of the others while pressing ⌘ (iPhoto) or Ctrl (Picasa).

- **To deselect a photo.** If you're highlighting a long string of photos and then click one by mistake, you don't have to start over. Instead, just ⌘-click/Ctrl-click it again; the dark highlighting disappears. (If you do want to start over from the beginning, however, deselect all the selected photos by clicking any empty part of the window.)

That trick is especially handy if you want to select *almost* all the photos in a window. Press ⌘-A/Ctrl+A to select everything in the folder, then

⌘-click/Ctrl-click any unwanted photos to deselect them. You'll save a lot of time and clicking.

Tip You can combine the ⌘-clicking/Ctrl-clicking business with the Shift-clicking trick. For instance, you could click the first photo, then Shift-click the 10th, to highlight the first 10. Next, you could ⌘-click/Ctrl-click photos 2, 5, and 9 to remove them from the selection.

Click here...

...then Shift-click here. Everything in between is selected.

Or Ctrl+click (⌘-click) here...

...and here... *and here, to select only these three.*

Once you've highlighted multiple photos, you can manipulate them all at once. For example, you can drag them en masse into an album at the left side of the iPhoto window. Just drag any one of the highlighted photos; all the other highlighted thumbnails go along for the ride. Furthermore, when multiple photos are selected, the commands in various menus (Print, Rotate, Export, and so on) apply to all of them.

Tip You can't select Picasa thumbnails from different *albums* unless you click the Hold button after each batch. That's the thumbtack icon in the lower-left Photo Tray.

Hiding Photos

Most people think they have only two choices when confronting a so-so photo: Keep it or delete it.

Keeping it isn't a satisfying solution, because it's not one of your best, but you're still stuck with it. You have to look at it every time you open iPhoto/Picasa, you have to skip over it every time you're making a photo book or slideshow, and so on. But deleting it isn't such a great solution, either. You just never know when you might need *exactly* that photo again, years later.

Fortunately, there's a happy solution: You can *hide* a photo. It's there behind the scenes, and you can always bring it back into view should the need arise. In the meantime, you can pare your *visible* collection down to the really good shots, without being burdened by the ghosts of your less impressive work.

To hide some photos, select them (page 163). Then choose Photos→Hide Photos (iPhoto) or Pictures→Hide (Picasa). The selected photos vanish. Of course, they're still on your hard drive. But they no longer bog you down when you're scrolling, and they no longer depress you when they stare out at you every day.

Seeing Photos While They're Hidden

To bring all your hidden photos back into view for a moment, choose View→Hidden Photos (iPhoto) or View→Hidden Pictures (Picasa).

All of the hidden photos now reappear, but you'll still know which ones they are; in iPhoto, they bear big red Xs on their corners, and in Picasa, they're ghostly and transparent. This is your chance to reconsider—either to delete them for good, or to welcome them back into society.

iPhoto

Picasa

Of course, you can rehide the hidden photos whenever it's convenient, just by choosing View→Hidden Photos (or View→Hidden Pictures) again.

Unhiding Photos

Just marking a photo as hidden doesn't mean you can't change your mind. At any time, you can unhide it, turning it back into a full-fledged photographic citizen.

To do that, first make your hidden photos visible, as described above. Then select the photo(s) you want to unhide, and reverse whatever step you took to hide it in the first place. For example, choose Photos→Unhide Photos or Picture→Unhide.

Albums

In the olden days of film cameras and drugstore prints, most people kept pictures in their original paper envelopes. You might have used that photo in an album or mailed it to somebody—but then the photo was no longer in the envelope, and it couldn't be used for anything else.

But you're digital now, baby. You can use a single photo in a million different ways, without ever removing it from its original "envelope" (your hard drive).

In iPhoto/Picasa terminology, an *album* is a subset of your pictures—drawn from a single Event or folder, or many different ones—that you group together for easy access and viewing. An album can consist of any photos that you select. It's represented by a little album-book icon in the list at the left side of the screen. (You can see a bunch of them on the facing page.)

While your photo collection as a whole might contain thousands of photos from a hodgepodge of unrelated family events, trips, and time periods, a photo album has a focus: Steve & Sarah's Wedding, Herb's Knee Surgery, and so on.

As you probably know, mounting snapshots in a *real* photo album is a pain—that's why so many people still have stacks of Kodak prints stuffed in envelopes and shoeboxes. But with iPhoto/Picasa, you don't need mounting corners, double-sided tape, or scissors to create an album. In the digital world, there's no excuse for leaving your photos in hopeless disarray.

The single most important point is this: Putting photos in an album doesn't *move* or *copy* them. You're just creating *references,* or pointers, back to the photos in your master photo collection. This feature works a lot like Macintosh aliases or Windows icon shortcuts.

In other words, you don't have to commit a picture to just one album when organizing. One photo can appear in as many different albums as you want. So if you've got a killer shot of Grandma surfing in Hawaii and you can't decide whether to drop the photo into the Hawaiian Vacation album or the Grandma & Grandpa album, the answer is easy: Put it in both. iPhoto and Picasa just create two references to the same original photo.

Of course, you're not *required* to group your digital photos in albums, but consider the advantages of doing so:

- **You can find specific photos faster.** By opening only the relevant album, you can avoid scrolling through thousands of thumbnails to find a picture you want—a factor that takes on added importance as your collection expands.

- **Albums offer a perfect way** to round up the photos you want to use in a slideshow, collage, book, or whatever.

- **In iPhoto, only in an album** can you drag your photos into a different order.

Creating an Empty Album

Here's how to create a new, empty photo album:

- **iPhoto:** Choose File→New Album (⌘-N), or click the + button below the Source list.

- **Picasa:** Click the Create New Album button above the folder list. (It's a tiny blue book marked by a + sign.)

iPhoto

Picasa

A dialog box appears, prompting you to name the new album. Type in a descriptive name (*Summer in Aruba, Yellowstone 2009, Edna in Paris,* or whatever), click OK, and watch as a new photo album icon appears in the Source/folder list.

Now you can add photos to your newly spawned album by dragging in thumbnails, as shown below. There's no limit to the number of albums you can add, so make as many as you need to satisfactorily organize all the photos in your collection. And remember: A photo can appear in as many different albums as you like.

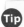 **iPhoto Tip:** You can create a new album *and* fill it with photos in a single move. Just select some thumbnails (page 163) and then drag them directly into an empty portion of the Source list. In a flash—well, in about 2 seconds—iPhoto creates a new album for you, named "untitled album." The photos you dragged are automatically dumped inside.

Viewing an Album

To view the contents of an album, click its name or icon in the Source list. All the photos included in the selected album appear in the photo-viewing area.

Removing Photos from an Album

If you change your mind about the way you've organized your photos and want to remove a photo from an album, open the album, select the photo, and then press the Delete key.

The thumbnail disappears from the album, but of course it's not really gone from your computer. Remember, it's still in your Library (iPhoto) or its original hard drive folder (Picasa).

Deleting an Album

To delete an album, select its icon in the Source/folder list, and then press the Delete key. You can also right-click an album and then choose Delete Album from the shortcut menu. Either way, you're asked to confirm your intention.

Deleting an album doesn't delete any photos—just the references to those photos. Even if you delete *all* your albums, your collection remains intact.

Smart Albums

Albums, as you now know, are a primary organizational tool in your shoebox program. But you have to create regular albums yourself, one at a time, and then fill them up yourself.

A *smart album,* though, is a self-updating folder that always displays pictures according to certain criteria that you set up.

- **Picasa.** The smart album always contains the photos to which you've assigned a certain tag (keyword), as described on page 177. Every time you assign the tag *travel* to a photo, Picasa pops it automatically into the Travel smart album.

 To create the smart album, choose Tools→Experimental→ "Show tag as album." In the dialog box, type the tag whose photos you want rounded up into this smart album, and then click OK.

 Note: When you're creating the smart album, you must type the tag name in lowercase letters. (It doesn't matter if the actual tag name contains capital letters—what matters is how you type it as you create the smart album.)

- **iPhoto.** Smart albums are very smart indeed. They can round up all pictures with "Aunt Edna" in the comments, for example, or all photos that you've rated four stars or higher—or *both*. (If you've ever used smart playlists in iTunes, you'll recognize the idea immediately.)

 To create a smart album, choose File→New Smart Album, or Option-click the + button below the Source list. Either way, the Smart Album sheet slides down from the top of the window. The controls here are designed to set up a search of your photo Library. In this illustration, you'll create

a smart album containing pictures that you took in the first month of 2009—but only those that have four- or five-star ratings and mention your Aunt Edna in the title or comments.

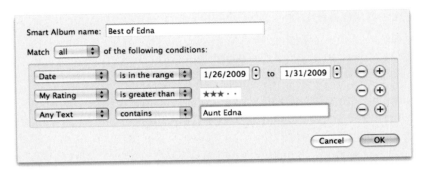

Click the + button to add a new criterion row to be even more specific about which photos you want iPhoto to include in the smart album. You can have the album round up photos by *Description, Filename* (as it appears on your hard drive), *Keyword* (page 177), *Title* (the name you've typed for it in iPhoto), *Event, Album, Date, Rating*, and so on. You can also round up photos by photographic setting: by *Aperture, Camera Model, Flash, Focal Length, ISO,* or *Shutter Speed.*

Any Text searches your Library for words or letters that appear in the title, comments, or keywords that you've assigned to your photos.

And *Photo* lets you include (or exclude) photos according to whether they're hidden, flagged, or edited. Its pop-up menu also lets you pinpoint RAW-format photos or digital movies. These are very useful options; everyone should have a smart folder just for movies, at the very least.

Click the – button next to a criterion to take it out of the running. For example, if you decide that the date shouldn't be a factor, delete any criterion row that tells iPhoto to look for certain dates.

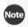 **iPhoto Note:** Choose File→New Folder to create a new folder icon in the Source list called "untitled folder." (Type a name for it and then press Return or Enter.) Its sole purpose in life is to contain *other* Source-list icons—albums, smart albums, saved slideshows, book layouts, and so on. (A folder can even contain *other* folders.)

In other words, iPhoto is capable of more than a two-level hierarchy. That's great if your list of albums has become unwieldy.

When you click OK, your smart album is ready to show off. When you click its name in the Source list, the main window displays the thumbnails of the photos that match your criteria. The best part is that iPhoto/Picasa keeps this album updated whenever your collection changes—as you apply new tags, change your ratings, take new photos, and so on.

Photo Info

Behind the scenes, iPhoto and Picasa maintain a complete dossier of details about every photo: the model of camera, for example, and exposure details like the f-stop, shutter speed, and flash settings. It can be useful when you're trying to study why a photo came out especially badly (or especially well).

- **iPhoto.** Select a thumbnail, and then choose Photos→Show Photo Info (or press ⌘-I). The resulting Photo Info panel is expandable. Click enough flippy triangles, and you'll wind up with four sections of details. The Exposure panel shows all the camera's settings at the instant the photo was taken: shutter speed, aperture size, exposure settings, zoom amount, whether the flash went off, ISO setting, and more.

iPhoto

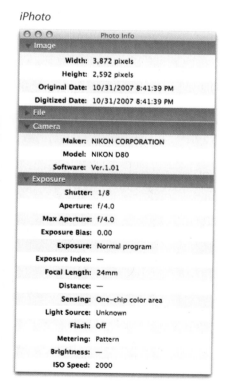

Picasa

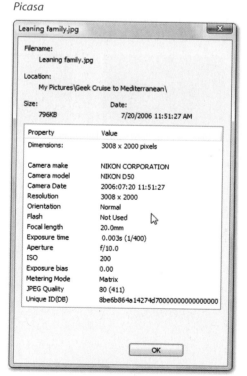

- **Picasa.** Select a thumbnail, and then choose Picture→Properties (or press Alt+Enter). The resulting dialog box shows all the details in a single, scrolling table.

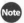 How on earth do iPhoto and Picasa know so much about how your photos were taken? Most digital cameras embed a wealth of image, camera, lens, and exposure information in the photo files they create, using a standard data format called *EXIF* (Exchangeable Image Format). With that in mind, iPhoto and Picasa automatically scan photos for EXIF data as they import them.

Keywords, Titles, and Event Info

The thumbnails don't have to speak for themselves. You can opt to have helpful text appear beneath each one: its name, its rating, its tags, and so on.

- **iPhoto.** From the View menu, choose Ratings, Titles, or Keywords to make these text bits appear.

- **Picasa.** From the View→Thumbnail Caption submenu, specify what you want to appear beneath each thumbnail: Filename, Caption, Tags, or Resolution (the photo's size, in pixels).

iPhoto

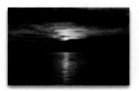 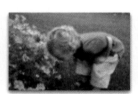

Sunset on da Lake
Vacation, Scenic

Stop and Smell
Kids, Li'l Jeff

Shufflebored
Kids, Family, Vacation,...

Picasa

Leapin' Lizards!

THUNDERBIRDS!!

Dive to the Finish

Flagging Photos

In both iPhoto and Picasa, you can *flag,* or *star,* any photo. That marking can mean anything you want it to mean; it's open to a multitude of personal inter-pretations. The bottom line, though, is that you'll find this marker extremely useful for temporary organizational tasks.

For example, you might want to cull only the most appropriate images from a photo album for use in a printed book or slideshow. As you browse through the images, use the Flag button to flag each shot you want. Later, you can round up all the images you flagged so that you can drag them all into a new album en masse.

Here's how you flag a selected photo, or a bunch of selected photos:

- **iPhoto.** Press ⌘-period, or choose Photos→Flag Photo, or click the Flag button on the toolbar. A tiny, waving-pennant logo appears on the upper-left corner of the photo's thumbnail.

- **Picasa.** Click the Star button in the toolbar (at the bottom of the screen). A tiny yellow star appears on the lower-right corner of the photo's thumbnail.

iPhoto

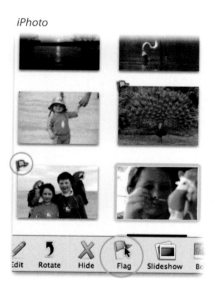

Picasa

You remove flags and stars the same way you applied them. (That is, click the Flag or the Star button a second time.)

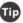
How to Use Flagged or Starred Photos

Now suppose you've worked through all your photos for some project, carefully flagging them as you go. Here's the payoff: rounding them up, so that you can delete them all, hide them all, incorporate them into a slideshow, export them as a batch, or whatever.

- **iPhoto.** Click the Flagged icon in the Source list; you see all the flagged photos in your entire library.

- **Picasa.** Click the Find Starred Photos filter button (next to the Search box, top right) to round up the starred photos, as indicated by the cursor in this illustration.

iPhoto

Picasa

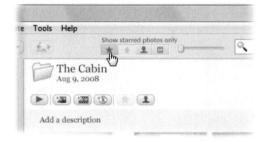
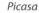

In both cases, you see only the flagged/starred photos. (All other photos are temporarily hidden.) You can now drag them en masse into a *regular* album, if you like, in readiness for making a slideshow, Web album, or anything else where you'd like the freedom to rearrange their sequence.

Searching for Photos by Text

The flagging/starring mechanism described above is an adequate way to tag photos, but there are other ways. The name you give a picture might be significant; its original filename on the hard drive might be important; and maybe you've typed some important clues into its Title/Caption box.

That's the purpose of the Search box. (In iPhoto, it's below the thumbnails; in Picasa, it's on the top right.) Start by selecting the container you want to search—folder, album, or whatever. Then type into the Search box.

iPhoto

Picasa

The program instantly shows you only the thumbnails of the photos whose text matches what you typed. "Text," in this case, means filenames, captions, tags, folder names, album names, date, camera model, and so on.

> **Picasa Tip:** As you type, a pop-up menu appears, showing matching bits of text, which can save you some typing—just the way it does when you use Google on the Web! Coincidence? You decide.

As you type, all pictures are hidden except the ones that have your typed phrase somewhere in their text. In iPhoto, "text" means names, keywords, descriptions, filenames, and Event titles. In Picasa, it means filenames, captions, tags, folder names, album names, camera maker, and date.

> **Picasa Tip:** You can also search for photos that contain *faces.* Yep, that's right: Face recognition software has come to the PC. Just click the Find Faces button next to the Search box.

Searching by Calendar or Timeline

iPhoto and Picasa offer long lists of ways to find certain photos: visually, by album, by text, and so on. But they also offer what seems like an obvious and very natural method of finding specific pictures: by consulting a calendar or timeline.

After all, you might not know the filenames of the pictures you took during your August 2008 trip to Canada. You might not have filed them away into an album. But one thing's for sure: You know you took that trip in August of 2008. The calendar and timeline will help you find those pictures fast.

iPhoto Calendar

Start by indicating what container you want the calendar to search: an album or folder, for example, or one of the Library or Recent icons.

Now make the calendar appear by clicking the tiny button at the left edge of the Search box. From the pop-up menu, choose Date.

The little calendar may look small and simple, but it contains a lot of power—and, if you look closely, a lot of different places to click the mouse.

For example, the calendar offers both a Year view (showing 12 month buttons) and a Month view (showing 28 to 31 date squares). Click the tiny ◀ or ▶ button in the upper-left corner to switch between these two views. You can also double-click a month's name (in Year view) to open the month, or double-click the month title in Month view ("March 2009") to return to Year view.

iPhoto

Picasa

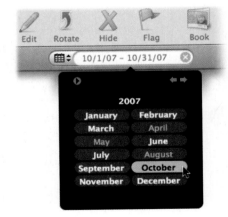

You can find photos taken in a certain month by clicking a month's name in the tiny calendar; on a certain date by clicking a date within that month; within a certain week by double-clicking a week row; and so on. In any case, you can close the calendar and return to seeing *all* your pictures by clicking the ❸ at the right end of the Search box.

Picasa Timeline

When you choose View→Timeline, Picasa treats you to a wild, animated, interactive view of your photo collection, organized by time.

The timeline appears at the bottom. Scrub your mouse to the stacked dots, which show roughly how many photos were taken on each occasion. As you do, the carousel of albums rotates. (You can also spin the carousel by hand, using an "album cover" as a handle.) Double-click an album to see a slideshow. Hit the Esc key to return to the regularly scheduled Picasa.

Keywords/Tags

Keywords, or tags, are descriptive words—like *family, vacation,* or *kids*—that you can use to label and categorize your photos, regardless of which album or Event/folder they're in.

The beauty of keywords is that they're searchable. Want to comb through all the photos in your library to find every closeup taken of your children during summer vacation? Instead of browsing through multiple photo albums, just perform a search for photos containing the keywords *kids, vacation, closeup,* and *summer.* You'll have the results in seconds.

It may take some time to develop a really good master set of keywords. The idea is to assign labels that are general enough to apply across your entire photo collection, but specific enough to be meaningful when conducting searches.

Here's a general rule of thumb: Use *albums* to group pictures for specific projects—a book, a slideshow, or a Web page, for example. Use *keywords* to focus on general characteristics that are likely to appear through your entire photo collection—words like Mom, Dad, Casey, Robin, Family, Friends, Travel, and Vacation.

It also might be useful to apply keywords that describe attributes of the photos themselves, such as Closeup, Landscape, Portrait, and Scenic—or even the names of the people *in* the photos, like Harold, Chris, and Uncle Bert.

You can apply as many keywords/tags to an individual photo as you like. A picture of your cousin Rachel at a hot dog-eating contest in London might bear all these keywords: *Relatives, Travel, Food, Humor,* and *Medical Crises.* Later, you'll be able to find that photo no matter which of these categories you're hunting for.

Keywords (iPhoto)

Start by choosing Window→Show Keywords (⌘-K). The Keywords window (facing page, left) shows a few canned keyword suggestions like Family and Kids. To modify the list of keywords, click Edit Keywords. You'll see the + button for adding a keyword and the – button for deleting one (facing page, right).

iPhoto offers several ways to apply keywords:

- **With the Keywords window.** Open the Keywords window by pressing ⌘-K. Highlight the photo(s) you want to bless with a keyword. Then click the appropriate button on the Keywords window (or press the keyboard shortcut letter for the keyword you want to apply—V for vacation, for example).

- **From the keyboard.** Choose View→Keywords. Now you can see the keyword assignments for every single thumbnail in your collection. Click in the keyword spot. Type a new keyword to create it, or type a couple of letters of an existing one to apply it.

Tags (Picasa)

Start by selecting the photos you want to tag. Then choose View→Select Tags (Ctrl+T). The Tags dialog box appears.

In the Add Tag box, type a tag name; you're creating and applying it simultaneously. (If you've previously applied tags to the selected photos, you'll see those tags listed here.) Click Add after each tag name, and Done when you're ready to move on to other thumbnails.

Using Keywords/Tags

After you've tagged your photos, the big payoff for your diligence arrives when you need to get your hands on a specific set of photos, because you can *isolate* them with one quick click.

- **iPhoto.** Start by clicking the tiny icon at the left side of the Search box (◉). A little palette of all your keywords appears, and here's where the fun begins. When you click one of the keyword buttons, iPhoto immediately rounds up all photos labeled with that keyword, displays them in the photo-viewing area, and hides all others.

 Tip If you point to one of these buttons without clicking, a pop-up balloon tells you *how many* photos have been assigned that keyword.

To find photos that match multiple keywords, click additional keyword buttons. For example, if you click Travel and then click Holidays, iPhoto reveals all the pictures that have *both* of those keywords. Every button stays "clicked" until you click it a second time.

Click ❽ to restore the view to whatever you had visible before you performed the search.

- **Picasa.** Type a tag's name into the Search box. Picasa displays the matching photos instantaneously. (Picasa is, after all, a product of Google.)

Backing Up Your Photos

Bad things can happen to photos. They can be deleted with a slip of your pinkie. They can become mysteriously corrupted and subsequently unopenable. They can get mangled by a crashed hard disk and be lost forever.

Any kind of computer file loss is heartbreaking. But losing one-of-a-kind family photos can be totally devastating, and in some documented cases, even marriage-threatening. So if you value your digital photos, you should back them up regularly—perhaps after each major batch of new photos joins your collection.

If you've already got an automated, up-to-date, whole-computer backup system in place, then never mind; you're covered.

You're also about 4 percent of the population.

iPhoto Backups

Backing up your whole iPhoto library to another hard drive is exceptionally simple, since the program stores *everything*—photos, movies, keywords, albums, and so on—in a single file in your hard drive. Open your Home→Pictures folder, and there it is: the iPhoto Library icon. Drag it to another hard drive, and that's it; you're safely backed up.

If you prefer to back up onto CDs or DVDs, you can do that, too. Note, however, that what iPhoto can make on its own is something called *iPhoto discs*. These contain not just your photos, but a clone of your iPhoto Library as well. In other words, an iPhoto disc includes all the thumbnails, keywords, comments, ratings, photo album information—even the unedited original versions of your photos that iPhoto keeps secretly tucked away.

 Note These are a perfect backup of your iPhoto library. They are *not*, however, any good for distributing photos to your friends. An iPhoto disc is designed exclusively for transferring pictures into another copy of iPhoto. If you try to insert it into, say, a Windows PC, it will show up as a lot of cryptically named gobbledygook. The photos are there somewhere, but in a buried folder that will trigger a lot of cursing.

All right, then, here's how you do the backup to disc:

❶ Select the photos that you want to include on the disc.

You can hand-select some photos (page 163), click a Source list icon (Event, album, book, or slideshow), or click either Events or Photos to burn your whole photo collection.

❷ Choose Share→Burn.

A dialog box appears, prompting you to insert a blank disc. Pop in the disc; the dialog box vanishes after a few moments.

The Info panel at the bottom of the iPhoto window shows a little graph, indicating how much of the disc will be filled up. If the set of photos you want to burn will fit on a single disc, great.

If not, a message informs you that you'll have to split your backup operation across multiple discs, selecting only a portion of your photos at a time. For example, you might decide to copy the 2007 folder onto one

disk, the 2008 folder onto another, and so on, using the calendar feature to round up your photos by year.

❸ Click the Burn button.

You get either get a "not enough space" message or a "Burn Disc" message. If you get the latter, you're ready to proceed.

❹ Click Burn.

When the process is complete, your Mac spits out the finished CD or DVD, ready to use, bearing whatever name you gave it.

Picasa

Backing up with Picasa is much more straightforward. It backs up only your picture folders; it makes no attempt to back up your album structure, Projects, and so on.

❶ Choose Tools→Backup Pictures.

At the bottom of the screen, you see graphics representing the three steps, as shown here at top.

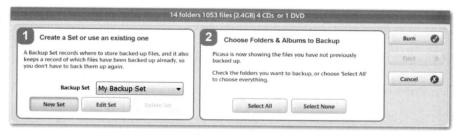

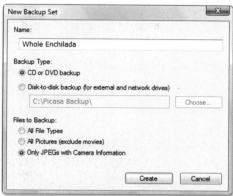

❷ Click New Set.

A backup *set* is a set of backup parameters that remembers which photos to back up, and onto what backup disk (DVD or hard drive, for example). Each set remembers which photos you've already backed up, so subsequent backups go faster.

At this point, the New Backup Set dialog box appears.

❸ Type a name for the set, specify where you want the backup to go (CD or DVD, or to another hard drive), and which kinds of files you want backed up.

You can have everything backed up ("All File Types"), only photos (no movies, to save space on your CD or DVD), or only JPEG photo files that were taken with a camera (so you don't wind up backing up every last graphic on your hard drive, including thousands that aren't photos at all).

❹ Click Create.

In big step 2 at the bottom of the screen, you can click Select All to choose *all* folders and albums for backing up. Or just turn in the individual checkboxes in the Source list.

As you go, the blue bar above the *Burn* button lets you know how many discs you'll need to complete the backup.

❺ **If you're backing up to another hard drive, click Backup. Otherwise, insert the first blank CD or DVD, wait until its icon appears, and then click Burn.**

Picasa will let you know when it needs the next blank disc.

When it's all over, you'll wind up with a set of discs that, in case of disaster, you can insert into a new PC. At that point, you'll be offered the chance to copy the photos back into precisely the same folders as they were on your first, ill-fated machine.

 Home-burned discs don't last forever. The "gold archival" blanks are supposed to last 100 years, and early testing supports that claim—but will computers in 100 years even be able to play DVDs?

Storage technologies are changing faster than ever. (Just ask the punch card, the floppy disk, and the Zip cartridge.) Nobody's invented a single storage format that will last forever.

If you care about your descendants' ability to see your photos, then, print the most important ones on archival paper; frame them under glass. Keep the rest of your collection on more than one hard drive—and every 10 years, check back to see how technology has marched on. Migrate your photo collection to whatever newfangled storage technology is in vogue at the time. And harangue your children and grandchildren to carry on this little hobby when you can't.

Chapter 10:
Fixing Your Photos

Straight from the camera, digital photos often need a little bit of help. A picture may be too dark or too light. The colors may be too bluish or too yellowish. The focus may be a little blurry, the camera may have been tilted slightly, or the composition may be off.

Fortunately, you're digital now. You can fine-tune images in ways that, in the world of traditional photography, required a fully equipped darkroom, several bottles of smelly chemicals, and an X-Acto knife.

OK, iPhoto and Picasa aren't full-blown photo-editing programs like Photoshop. You can't paint in additional elements, mask out unwanted backgrounds, or apply 50 different special effects filters in iPhoto and Picasa. Nonetheless, these programs are well equipped to handle most basic photo fix-up tasks: rotating, cropping, straightening, fixing redeye, color correction, special effects (like black-and-white or sepia-tone), and tweaking brightness, contrast, saturation, color tint, exposure, shadows, highlights, and sharpness.

Opening a Photo for Editing

The first challenge, then, is opening up a photo to get it ready for editing.

The Picasa Editor

You can open a photo in either of these ways:

• Double-click the photo.

• Choose Picture→View and Edit (Ctrl+3).

Either way, the photo opens up nice and big. The tools you need to edit it appear in three tabs to its left. The following pages guide you through all of these controls.

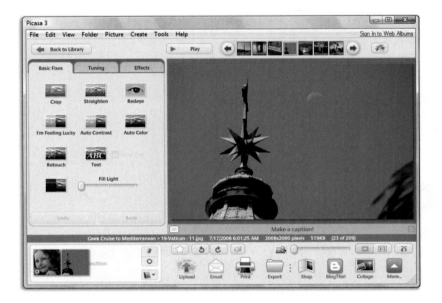

The iPhoto Editor

Over the years, in hopes of accommodating every conceivable working style, Apple has designed iPhoto to offer access to the editing tools in four different ways. Here are all the places where you can open the editing screen:

- **Right in the iPhoto window.** *Pros:* You don't lose your bearings; all of the familiar landmarks, including the Source list, remain visible. *Cons:* The picture isn't very big, since it has to fit inside the main iPhoto window.

- **In a window of its own.** *Pros:* You can make the window big. You can open more than one photo at once, and still see the main iPhoto window in the background. *Cons:* There's still some Mac OS X clutter (menus, windows) at the periphery, and more windows mean more complexity.

- **In full-screen mode.** *Pros:* The photo fills your entire monitor, as big and dramatic as you can possibly see it (at least without upgrading to a bigger screen). Elements like the menu bar, Source list, and thumbnails display are temporarily hidden. *Cons:* You've left the familiar iPhoto world behind; it's almost like you're working in a different program.

- **In another program.** It's one of iPhoto's slickest tricks: You can set things up so that double-clicking a photo in iPhoto opens it up in a totally different program, like Photoshop Elements. You edit, you save your changes, you return to iPhoto—and presto, the changes you made in Photoshop, apparently behind iPhoto's back, are reflected right there in the iPhoto original. You can even use the Revert to Original command (page 191) to bring back the original copy, if necessary.

 Pros: Other programs have a lot more editing power. For example, the Auto Levels command (in Photoshop and Photoshop Elements) is a better color-fixer than iPhoto's Enhance button. Photoshop-type programs are also necessary if you want to scale a photo up or down to specific pixel dimensions, combine several photos into one (a collage or montage), apply special-effect filters like Stained Glass or Watercolor, or adjust the colors in just a portion of the photo.

 Cons: Well, you're using two programs instead of one, which can be a little disorienting.

To specify which editing mode you prefer, choose iPhoto→Preferences. From the "Edit photo" pop-up menu, specify which of the four editing modes you prefer, as shown here.

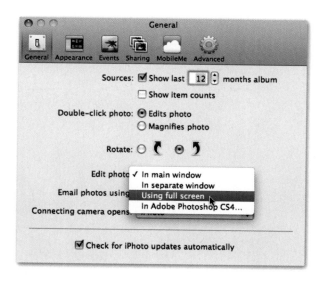

(If you choose "In application" from this pop-up menu, a standard Open dialog box appears. You're being asked to specify which external program you want to use for your editing—Photoshop, for example. Choose the program you

want, and then click Open. After that, the pop-up menu reflects the name of the program you've chosen.)

You've just specified what happens when you open any photo for editing. To try it, click a thumbnail, and then click Edit at the bottom of the window.

> **Tip** iPhoto Tip: Ordinarily, double-clicking just opens a photo to fill the iPhoto window, so you can get a closer look at it. (No editing tools are available.) But while you're in the Preferences dialog box, you can establish an alternative meaning for the double-click: opening a photo directly into your chosen editing mode.

Even though you've now told iPhoto which editing window you want to use most of the time, you can still choose a different one *now and then* without having to haul yourself back to Preferences to change the setting. At any time, right out in the thumbnails view, you can Control-click (or right-click) a thumbnail or a photo in its own window; from the shortcut menu, choose "Edit," "Edit in separate window," "Edit using full screen," or "Edit in external editor," depending on your preference. (The full-screen editor looks like this:)

The Toolbar and Thumbnails Browser

In iPhoto/Picasa's editing mode, you have at your disposal a *thumbnails browser* at the top of the screen (so you can choose a different photo to work on) and an editing toolbar or panel (so you can fix up what you're seeing).

 iPhoto Note: When you're in full-screen mode, both the toolbar and the thumbnails browser are *self-hiding*. They don't appear unless you push your cursor to the top or bottom of the screen for a moment.

When you're finished with one of the pictures, you can use the thumbnail scroller at the top to move on to another photo, without having to close the editing screen. (Click the arrows to scroll; click a thumbnail to open it for editing.)

Or just press the right or left arrow keys on your keyboard.

 Picasa Tip: You can also move through your photos by turning the wheel on the top of your mouse.

iPhoto

Picasa

Notes on Zooming and Scrolling

Before you get deeply immersed in the editing process, it's well worth knowing how to zoom and scroll around, since chances are you'll be doing quite a bit of it.

To magnify the photo you're working on, use the size slider at the lower-right corner of the editing window.

 iPhoto Tip: You can also press the number keys on your keyboard to zoom. Hit 1 to zoom in so far that you're viewing every single pixel. Hit 2 to double that magnification level. Now each pixel of the original picture consumes *four* pixels of your screen, a handy superzoom level when you're trying to edit individual skin cells. Finally, when you've had quite enough of superzooming, tap your 0 key to zoom out again so the whole photo fits in the window.

iPhoto

Picasa

Once you've zoomed in, you can scroll the photo in any direction:

- **iPhoto:** Press the space bar as you drag the mouse. That's more direct than fussing with two independent scroll bars.

 Better yet, if your mouse has a scroll wheel on the top (or a scroll pea, like the Mighty Mouse), you can scroll images up and down while zoomed in on them by turning that wheel. To scroll the zoomed area *horizontally,* press Shift while turning.

- **Picasa.** Just drag the mouse anywhere on the magnified photo.

Both programs also offer a tiny navigation window—a "map" of the entire photo, with a little rectangular lens that shows you how much of it you're seeing at the moment. Instead of scrolling, you can drag that little tiny lens within the map, or just click somewhere in the map.

 iPhoto Note: In iPhoto, this map appears only when you're in Full-Screen Editing mode.

iPhoto *Picasa*

Backing Out, Undoing, and Restoring

Before you go to town, tweaking your photos to perfection (or into unrecognizability), it's good to know that iPhoto and Picasa are incredibly forgiving.

Undo

After any change, you can change your mind:

- **iPhoto.** To undo a change, choose Edit→Undo (⌘-Z). The wording changes to reflect what you've just done: Undo Crop, Undo Rotate Photo, or whatever.

 iPhoto Tip: After making any kind of edit, it's incredibly useful to compare the "before" and "after" versions of your photo. So useful, in fact, that Apple has dedicated one whole key to that function: the Shift key on your keyboard. Hold it down to see your unenhanced "before" photo; release it to see the "after" image. By pressing and releasing Shift, you can toggle between the two versions of the photo to assess the results of the enhancement.

- **Picasa.** On the left-side editing panel, the lower-left button always says Undo. It might say Undo Crop, or Undo Straighten, or Undo whatever-it-is-you-just-did.

In fact, using Undo, you can back out of your changes no matter how many of them you've made. The only catch is that you must back out of the changes one at a time. In other words, if you rotate a photo, crop it, and then change its contrast, you must use the Undo command or button three times—first to undo the contrast change, then to uncrop, and finally to unrotate. (In iPhoto, you must do this Undoing while you're still in Edit mode. Picasa's Undo button, on the other hand, still works even if you return three weeks later.)

Reverting to the Original

iPhoto and Picasa include built-in protection against overzealous editing—a feature that can save you much grief. If you end up cropping a photo too much, cranking up the brightness of a picture until it seems washed out, or accidentally turning someone's lips black with the Redeye tool, you can undo all your edits at once with a command called Revert to Original (iPhoto) or Undo All Edits (Picasa). This powerful command strips away *every change you've ever made* since the picture arrived from the camera. It leaves you with your original, unedited photo.

Consequently, you can freely edit any photo for any purpose, remaining secure in the knowledge that in a pinch, you can always restore it to the state it was in when you first imported it. This is an amazing, powerful feature.

To restore an original photo like this, select its thumbnail in the main window. Then:

- **iPhoto.** Choose Photos→Revert to Original.

- **Picasa.** Choose Picture→Undo All Edits.

Now the program swaps in the original version of the photo—and you're back to where you started.

 Note The result is the same in both programs, but the workings are very different.

Whenever you edit a photo for the first time, iPhoto, behind the scenes, actually *duplicates the original* and sets it aside for safekeeping. When you use Revert to Original, it throws away your edited copy and replaces it with the stashed original. The system works beautifully, but of course it eats up a lot of hard drive space.

Picasa, on the other hand, simply records the changes you make to your photos in tiny text files called *picasa.ini*. Ordinarily, it never touches the original photos. (Hint: Don't delete those .ini files.)

There are three exceptions, though. Redeye editing does change the file; in that case, Picasa makes a safety copy of the untouched original in a folder called Originals. The Save to Disk button (above the thumbnails) also applies your edits to the actual photos—and also stashes the untouched originals in Originals. Finally, when you send a picture *out* of Picasa—upload it, email it, export it—Picasa applies those changes to the outgoing copy of the picture.

All right then. Now that you know just how safe you'll be as you edit, here's how you make the actual changes.

Open a photo for editing, and then read on.

Rotate

Unless your digital camera has a built-in orientation sensor, all photos arrive on your computer in landscape orientation (wider than they are tall). The program has no way of knowing if you turned the camera 90 degrees when you took your pictures. Once you've imported the photos, just select the sideways ones and rotate them into position.

You don't actually have to be in Edit mode to rotate photos. A Rotate button or two appears right there in the main thumbnails view. You can also use the keyboard shortcuts or menu commands:

- **iPhoto.** Use ⌘-R to rotate selected photos counterclockwise, or Option-⌘-R to rotate them clockwise. (Those are the shortcuts for Photos→Rotate Photos Clockwise and Photos→Rotate Photos Counter Clockwise.)

- **Picasa.** Use Ctrl+R to rotate selected photos clockwise, or Shift+Ctrl+R to rotate them counterclockwise. (Those are the shortcuts for Picture→Batch Edit→Rotate Clockwise and Picture→Batch Edit→Rotate Counterclockwise.)

 Picasa Tip: You can also flip a photo horizontally (press Ctrl+Shift+H) or vertically (Ctrl+Shift+V). These commands do not appear in any menu, and are not sold in any store.

The Rotate commands are also in the shortcut menu that appears when you right-click a thumbnail.

Cropping

Think of the cropping tool as a digital paper cutter. It neatly shaves off unnecessary portions of a photo, leaving behind only the part of the picture you really want.

You'd be surprised at how many photographs can benefit from selective cropping. For example:

- **Eliminate parts of a photo you just don't want.** This is a great way to chop your brother's ex-girlfriend out of an otherwise perfect family portrait, for example (provided she was standing at the end of the lineup).

- **Improve a photo's composition.** Trimming a photo allows you to adjust where your subject matter appears within the frame of the picture. If you inspect the professionally shot photos in magazines or books, for example, you'll discover that many pros get more impact from a picture by cropping tightly around the subject, especially in portraits. Even a photo of a child's face may wind up looking more powerful if you crop in closely. Even lose the top of the hair; it's OK. (See page 34 for an example.)

- **Get rid of wasted space.** Huge expanses of background sky that add nothing to a photo can be eliminated, keeping the focus on your subject.

- **Fit a photo to specific proportions.** If you're going to place your photos in a book layout or turn them into standard-size prints, you may need to adjust their proportions. That's because there's a substantial discrepancy between the *aspect ratio* (length-to-width proportions) of your digital camera's photos and those of film cameras—a difference that will come back to haunt you if you order prints.

Cropping, in other words, is one of the most important improvements you can make to a photo. If you want your photos to have emotional impact, *crop that frame!*

How to Crop a Photo

Begin by opening the photo for editing. Then:

iPhoto

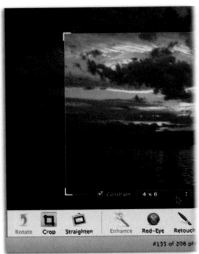

Picasa

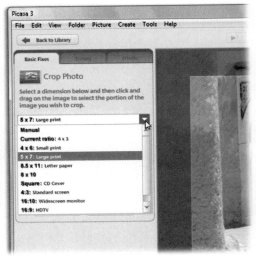

❶ Click the Crop button on the toolbar/tool panel.

When you do so, a pop-up menu magically appears. In iPhoto, it's labeled Constrain; it has no label in Picasa, but it does the same thing: it controls *how* you crop. What you do with it has to do with *why* you're cropping.

❷ Make a selection from the Constrain pop-up menu, if you like.

When this pop-up menu is set to None or Manual, you can draw a cropping rectangle of any size and proportion, in essence going freehand.

But when you choose one of the other options in the pop-up menu, the program constrains the rectangle you draw to certain preset proportions. It prevents you from coloring outside the lines, so to speak.

This feature is especially important if you plan to order prints of your photos. Prints come only in standard photo sizes: 4 × 6, 5 × 7, 8 × 10, and so on. You may recall, however, that most digital cameras produce photos whose proportions are 4:3 (width to height). This size is ideal for DVDs and books, because standard television and book layouts use 4:3 dimensions, too—but it doesn't divide evenly into standard print photograph sizes.

That's why the Constrain pop-up menu offers you canned choices like 4 × 6, 5 × 7, and so on. Limiting your cropping to one of these preset sizes guarantees that your cropped photos will fit perfectly into standard prints. (If you don't constrain your cropping this way, the printing company—not you—will decide how to crop them to fit.)

You'll also find an Original or "Current ratio" option here, which maintains the proportions of the original photo even as you make it smaller, and a Square option.

> **Tip** iPhoto Tip: Here's a bonus feature: the item in the Constrain pop-up menu called Custom. Inside the two text boxes that appear, you can type any proportions you want: 4 × 7, 15 × 32, or whatever your eccentric design needs call for.

At last, you're ready to draw a new rectangle to show how you want the picture cropped. (iPhoto, in fact, draws a starter rectangle *for* you, but you can ignore it.)

❸ Drag diagonally across the portion of the picture that you want to keep.

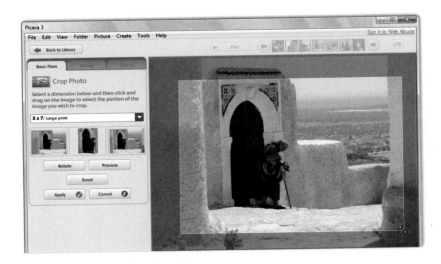

As you drag across your photo, the part of the photo that will eventually be trimmed away is dimmed out, as shown on the next page in Picasa.

Don't worry about getting your selection perfect. Nothing will actually be trimmed from the photo until you click the Apply button.

 Picasa Tip: Just below the pop-up menu, Picasa displays three thumbnails of the photo. It's actually *suggesting* three ways to crop the photo, based on face recognition, the Rule of Thirds, and other factors, and it often does an amazingly good job.

If you like its artistic sensibility, click one of those thumbnails to place the cropping rectangle in that place on your photo.

❹ **Adjust the cropping, if necessary.**

If the shape and size of your selection area are OK but you want to adjust which part of the image is selected, you can move the selection area without redrawing it. Position your mouse inside the selection so that the pointer turns into a hand icon. Then drag the existing rectangle where you want it.

You can also change the rectangle's size. Move your cursor close to any edge or corner so that it changes shape—to a double-headed arrow, for example. Now you can drag the edge or corner to reshape the rectangle.

If you get cold feet, you can cancel the operation by clicking Cancel or tapping the Esc key.

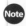

⑤ When the cropping rectangle is just the way you want, click the Apply button, or just press Enter.

If you realize immediately that you've made a cropping mistake, you can use the Undo command (Edit→Undo Crop Photo) or click the Undo Crop button to restore your original.

If you have regrets *weeks* later, on the other hand, you can always select the photo and choose the Revert to Original or Undo All Edits button.

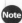

Straightening

Many a photographer has remarked that it's harder to keep the horizon straight when composing images on a digital camera's screen than when looking through an optical viewfinder. Whether that's true or not, off-axis, tilted photos are a fact of photography, and especially of scanning—and fixing them is incredibly easy.

Open the photo for editing, and then click the Straighten button on the toolbar/tool panel.

The minute you click Straighten, a grid appears, superimposed on your picture, and a slider appears near the bottom of the photo. By dragging the slider's handle in either direction, you rotate the image. Use the grid lines to help you align the horizontal or vertical lines in the photo.

Now, if you think about it, you can't rotate a rectangular photo without introducing skinny empty triangles at the corners of its "frame." Fortunately, iPhoto and Picasa sneakily eliminate that problem by very slightly *magnifying* the photo as you straighten it. Now you're *losing* skinny triangles at the corners, but at least you don't see empty triangular gaps when the straightening is over.

iPhoto

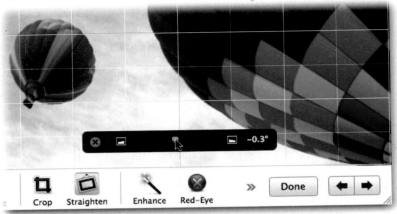

Picasa

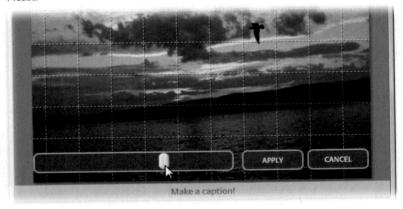

In other words, the straightening tool isn't a free lunch. Straightening an image decreases the picture quality slightly (by blowing up the picture, thus lowering the resolution) and clips off tiny scraps at the corners. You would have to view the before and after pictures side by side at high magnification to see the difference, but it's there.

So, as cool as the Straighten slider is, it's not a substitute for careful composition with your camera. However, it can help you salvage an otherwise wonderful image that's skewed. (And besides—if you lose a tiny bit of clarity in the straightening process, you can always apply a little sharpening afterward. Read on.)

Fixing Color

iPhoto and Picasa come complete with a simple button that improves the appearance of less-than-perfect photos. This one button will make colors brighter, skin tones warmer, and details sharper. In iPhoto, it's called Enhance. In Picasa, which is brought to you by Google, the button is called I'm Feeling Lucky (a witty reference to the same button on the Google home page).

This function analyzes the relative brightness of all the pixels in your photo and attempts to "balance" the image by dialing the brightness or contrast up or down and intensifying dull or grayish-looking color. In addition to this overall adjustment of brightness, contrast, and color, the program makes a particular effort to identify and bring out the subject of the photo. Usually, this approach makes pictures look at least somewhat richer and more vivid.

To enhance a photo, just click the Enhance button or the I'm Feeling Lucky button. That's it—there's nothing to select first, and no controls to adjust.

> **Tip** **Picasa Tip:** You can also break up the I'm Feeling Lucky button's functions into separate passes. You can click Auto Contrast to balance only the bright and dark levels of your photo, or you can click Auto Color to balance the colors themselves.

Remember that these image-correcting algorithms are just guesses at what your photo is supposed to look like. It has no way of knowing whether you've shot an overexposed, washed-out picture of a vividly colored sailboat, or a perfectly exposed picture of a pale-colored sailboat on an overcast day.

Consequently, you may find that Enhance and I'm Feeling Lucky have no visible effect on some photos and only minimally improve others. Remember, too, that you can't enhance just one part of a photo—only the entire picture at once.

In some cases, you'll need to do more than just click the Enhance button to coax the best possible results from your digital photos. You may have to tweak away with the Brightness and Contrast sliders, as explained later in this chapter.

Redeye

Redeye is a sinister quirk of flash photography. It's when the flash's light reflects from the blood-red tissue at the back of your subject's eyes, creating red discs where the pupils should be.

Page 51 offers advice on avoiding redeye to begin with. But if it's too late for that, and people's eyes are already glowing demonically, then there's always

the iPhoto/Picasa Redeye tool. It lets you alleviate redeye problems by digitally removing the offending red pixels.

Start by opening your photo for editing. Change the zoom setting, if necessary, so that you have a close-up view of the eye with the redeye problem. Now then:

- **iPhoto.** Click the Redeye button. Use the crosshair pointer to click inside each red-tinted eye; with each click, iPhoto neutralizes the red pixels, painting the pupils solid black.

- **Picasa.** Click the Redeye button. Drag diagonally across the eyeball, thereby enclosing the pupil with a yellow box. Picasa computes for a moment and then fixes the redeye. (If you don't like what it did, you can click inside the box to reverse the change. Then try again.) Click Apply to make the change stick.

 Picasa Note: You can't scroll your zoomed-in image just by dragging at this point—because dragging tells Picasa where the redeye is! So you have to scroll around using the tiny navigation window—the floating panel that shows a miniature of the entire photo. Click in a new place on this panel, or drag the tiny "what I'm seeing now" rectangle.

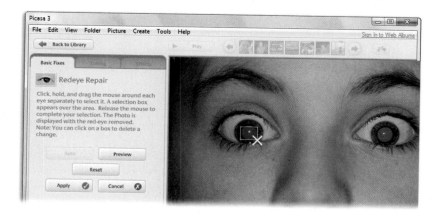

Of course, these Redeye tools wind up giving everybody black pupils instead of red ones—but at least they look a little less like the walking undead.

Retouching Scratches and Hairs

Sometimes an otherwise perfect portrait is spoiled by the tiniest of imperfections—a stray hair or an unsightly blemish, for example. Professional photographers, whether working digitally or in a traditional darkroom, routinely remove such minor imperfections from their final prints—a process known as *retouching,* for clients known as *self-conscious.*

The Retouch brush lets you do the same thing with your own digital photos. You can paint away scratches, spots, hairs, or any other small flaws in your photos with a few quick strokes.

The operative word here is *small.* The Retouch brush can't wipe out a big blob of spaghetti sauce on your son's white shirt or completely erase somebody's mustache. It's intended for tiny touch-ups that don't involve repainting whole sections of a photo. (For that kind of photo overhaul, you need a dedicated photo-editing program.)

 Tip The Retouch brush is particularly useful on traditional photographs that you've scanned in. You can use it to wipe away the dust specks and scratches that often appear on film negatives and prints, or those that are introduced when you scan the photos.

To use Retouch, click the Retouch button on the toolbar/tool panel.

Once you've selected the Retouch brush, your pointer turns into a round brush. (Use the slider to change the size of the brush cursor.)

Now you're ready to enter the air-brushing studio.

- **iPhoto.** Find the imperfection and "paint" over it, using short dabs to blend it with the surrounding portion of the picture. Don't overdo it: If you apply too much retouching, the area you're working on starts to look noticeably blurry and unnatural, as if someone smeared Vaseline on it.

 Note iPhoto Note: On high-resolution photos, it can take a moment or two for iPhoto to process each individual stroke of the Retouch brush. If you don't see any results, wait a second for iPhoto to catch up with you.

The Retouch brush works by blending together the colors in the tiny area that you're fixing. It doesn't cover the imperfections you're trying to remove, but *blurs* them out by softly blending them into a small radius of surrounding pixels.

- **Picasa.** You're going to click twice on the photo. The first time, click right on the imperfection; you've just told Picasa what you want to *fix*.

Now move the cursor around the nearby area, looking for a texture that matches the original area pretty closely—minus the spot or zit. As you move the cursor, watch the original spot; Picasa changes what you see there to reflect what's under the cursor. When you find a tone that would smoothly fill in the blemish, click a second time.

 Picasa Note: Because clicking has a specific effect in the Retouch mode, you can't use the mouse to scroll as you usually can—at least not unless you press the Ctrl key as you drag.

Click Reset to start completely over, Undo Patch to take back just your last click, or Apply to commit to the changes and return to the main editing panel.

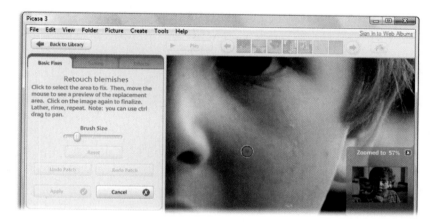

Fine-Tuning Exposure

The best time to adjust the exposure (brightness) of a photo is when you take it. But software can sometimes help after the fact.

Both iPhoto and Picasa have an Exposure slider:

- **iPhoto.** Open a photo for editing. Click the Adjust button on the toolbar (or press the letter A key) to make the Adjust panel appear. Drag the Exposure slider to adjust the overall brightness of the photo.

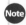 **iPhoto Note:** iPhoto's Levels controls offer a more accurate, more nuanced way to adjust the exposure. See page 215.

- **Picasa.** Open a photo for editing. On the Basic Fixes tab, drag the Fill Light slider to make the photo brighter or darker overall. (This same slider also appears on the Tuning tab.)

When you're editing JPEG graphics (that is, most photos from most cameras), the Exposure slider primarily affects the middle tones of a photo (as opposed to the brightest highlights and darkest shadows). If you're used to

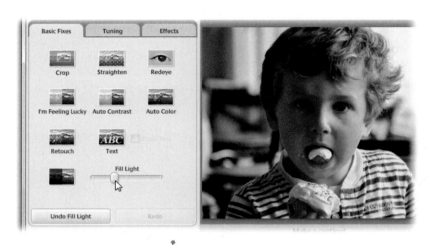

advanced programs like Photoshop, you may recognize this effect as a relative of Photoshop's *gamma* controls. (Gamma refers to the middle tones in a picture.)

When you're working with RAW files, however (page 60), this slider is even more interesting. It actually changes the way the program *interprets* the dark and light information that your camera recorded when it took the picture. A photographer might say that it's like changing the ISO setting before snapping the picture—except that now you can make the change long *after* you've snapped the shutter.

In other words, the Exposure/Fill Light slider demonstrates one of the advantages of the RAW format. In a RAW file, iPhoto/Picasa has a lot more image information to work with than in a JPEG file. As a result, you can make exposure adjustments without sacrificing the overall quality of the photograph.

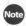
Boosting Contrast

Contrast is the difference between the darkest and lightest tones in your picture. If you could see the photo's histogram (page 65), you'd see that increasing the contrast stretches out the histogram's shape, creating darker blacks and brighter whites. When you decrease the contrast, you scrunch the histogram inward, shortening the distance between the dark and light endpoints. Since the image data now resides in the middle area of the graph, the overall tones in the picture are duller. Photographers might call this look "flat" or "muddy."

- **iPhoto.** Open a photo for editing. Click the Adjust button on the toolbar (or press the letter A key) to make the Adjust panel appear. Drag the Contrast slider and watch the effect on the photo.

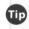
- **Picasa.** Open a photo for editing. Click the Tuning tab on the Editing panel.

In this case, you can adjust both sides of the contrast equation independently: The Highlights slider makes the bright parts brighter, and the Shadow slider makes the dark parts darker.

Color Correction

Truth is, digital cameras don't always capture color accurately. Digital photos sometimes have a slightly bluish or greenish tinge, producing dull colors, lower contrast, and sickly looking skin tones. Other times, the color looks OK, but you want to tweak it to create a specific mood.

Fortunately, both iPhoto and Picasa offer color-adjustment sliders that achieve just these effects. Start by opening a photo for editing.

Color Correction in iPhoto

Click the Adjust button on the toolbar, or press the letter A key, to open the Adjust panel.

The three sliders in the middle provide plenty of color adjustment power. In particular, the Tint and Temperature sliders govern the *white balance* of your photo. (Different kinds of light—fluorescent lighting, overcast skies, and so on—lend different color casts to photographs. White balance is a setting that eliminates or adjusts the color cast according to the lighting.)

- **Tint** adjusts the photo's overall tint along the red-green spectrum—great for correcting skin tones and compensating for difficult lighting situations, like pictures you took under fluorescent lighting.

- **Temperature** adjusts the photo along the blue-orange spectrum. That's a particular handy technique for breathing life back into subjects that have been bleached white with a flash. A few notches to the right on the Temperature slider, and their skin tones look healthy once again!

Color Correction in Picasa

Open the photo for editing, and then click the Tuning tab. Drag the Color Temperature slider left or right to tilt the photo more toward blue or orange.

Tip Picasa Tip: Click the tiny magic wand next to the Neutral Color picker if you'd rather have Picasa fix the color balance automatically.

Automatic White-Balance Correction

Dragging the color-correction sliders by hand is one way to address color imbalances in a picture. But there's an easier, more automatic way.

It relies on your ability to find, somewhere in your photo, an area of what *should* appear as medium gray or white. You can use either. Once you find the gray or white point, iPhoto/Picasa can take it from there—it can adjust all of the other colors in the photo accordingly, shifting color temperature, tint, and saturation, all with a single click. This trick works amazingly well on some photos.

Before you use this feature, though, make sure you've already adjusted the overall *exposure*, using the steps described on the previous pages.

Next, scan your photo for an area that should appear as a neutral gray or clean white. Slightly dark grays are better for this purpose than bright, overexposed grays. Once you've found that white or gray spot, you're ready:

- **iPhoto.** Click the tiny eyedropper icon next to the Tint slider.
- **Picasa.** Click the tiny eyedropper icon labeled Neutral Color Picker.

Your mouse pointer becomes crosshairs that you can position over your gray or white sample. Then simply click.

Instantly, the program automatically adjusts the color-balance sliders to balance the overall color of the photo. If you don't like the correction, use Undo and then try again on a different neutral area.

 Picasa Tip: Click the tiny magic wand next to the Neutral Color picker if you'd rather have Picasa fix the white balance automatically.

Thankfully, there's a good way to check how well the software corrected the image: Inspect an area in the picture that should be plain white. If it's clean (no green or magenta tint), you're probably in good shape. If not, undo the adjustment and try again.

 If you're a portrait photographer, here's a trick for magically correcting skin tones: Plan ahead by stashing a photographer's gray card somewhere in the composition that can be cropped out of the final print. Make sure the card receives about the same amount of lighting as the subject.

Later, in iPhoto/Picasa, click the gray card in the composition with the automatic color corrector, and presto: perfect skin tones. Now crop out the gray card and make your print, grateful for the time you've just saved.

Saturation

Once you're happy with the color tones of your photo, you can increase or decrease their intensity with the *Saturation* slider.

When you increase the saturation of a photo's colors, you make them more vivid; essentially, you make them "pop" more. You can also improve photos that have harsh, garish colors by dialing *down* the saturation so that the colors end up looking a little less intense than they appeared in the original snapshot. That's a useful trick in photos whose composition is so strong that the colors are almost distracting.

Here's how to find the Saturation slider in each program:

- **iPhoto.** Open a photo for editing. Press the letter A to open the Adjust panel.

- **Picasa.** Open a photo for editing. Click the Effects tab. Click Saturation.

Drag the Saturation slider to the right for more vivid colors, or to the left for less color. Heck, you can take the picture all the way to black-and-white, if you're so inclined.

Sharpening

The Sharpen slider in iPhoto and Picasa seems awfully tempting. Could technology really solve the problem of blurry, out-of-focus photos?

Well, no.

Instead, the Sharpen tool works by subtly increasing the contrast among pixels, which seems to enhance the crispness. In pro circles, applying a soupçon of sharpening to a photo is a regular part of the routine.

To sharpen one of your own photos, open it for editing. Then:

- **iPhoto.** Click the Adjust button on the toolbar (or press the A key) to make the Adjust panel appear.

- **Picasa.** Click the Effects tab, and then choose Sharpen.

Now drag the Sharpen slider to the right to increase the sharpness.

No sharpening *Some sharpening* *Too much*

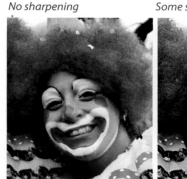 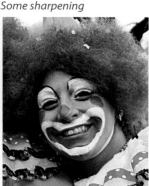

As you'll quickly discover, too much sharpening can totally *ruin* a photo; drag the slider all the way to the right, and your loved one's face dissolves into a rainbow of pixilated radiation sickness. Move the slider in small increments.

Generally speaking, sharpening should be the last adjustment you make to a picture. If you apply other corrections after sharpening, you may discover that you have to return and sharpen again.

Also, keep in mind that *softening* (or unsharpening) can be effective for portraits that are "too sharp," or for landscapes where you want to create a more dreamy effect. Sometimes applying just a little softening will smooth out skin tones and take the edge off the overall appearance of the portrait.

Cheesy Effects

It's here if you want it: a set of special photo effects to change the color, soften, or add focus to a photo. To open this palette, click the Effects button (iPhoto) or the Effects tab (Picasa). Now you're offered a tic-tac-toe board of buttons.

There's nothing to it. Click a button to apply the appropriate effect to the photo in front of you.

iPhoto

Picasa

iPhoto Effects

In iPhoto, you get nine options:

- **B & W (Black and White) and Sepia.** These two tools drain the color from your photos. B&W converts them into moody grayscale images (that Ansel Adams look); Sepia repaints them entirely in shades of antique brown (like 1865 daguerreotypes).

- **Antique.** A lot like Sepia, but not quite as severe. Still gets light brownish, but preserves some of the original color—like a photo from the 1940s.

- **Fade Color.** The colors get quite a bit faded, like a photo from the 1960s.

- **Original.** Click to undo all the playing you've done so far, taking the photo back to the way it was when you first opened the Effects palette.

- **Boost Color.** Increases the saturation, making colors more vivid.

- **Matte.** This effect whites out the outer portion of the photo, creating an oval-shaped frame around the center portion.

- **Vignette.** Same idea as Matte, except that the image darkens toward the outer edges instead of lightening.

- **Edge Blur.** Same idea again, except it creates an out-of-focus border around the main, central portion of the photo.

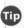 **iPhoto Tip:** You can click any of these buttons repeatedly to intensify the effect. With each click, a number appears on that tile, letting you know how many times you've applied the effect. You can use the forward and reverse arrow icons on either side of the digit to increase or decrease the effect.

Picasa Effects

In Picasa, you're offered 12 effects, which you can combine, if you like:

- **Sharpen.** Sharpening a photo really isn't an effect, and it's *definitely* not cheesy. It's a powerful tool that's described on page 210.

- **Sepia and B&W.** These tools drain the color from your photos. B&W converts them into moody grayscale images (a great technique if you're going for that Ansel Adams look); Sepia repaints them entirely in shades of antique brown (as though they were 1865 daguerreotypes).

- **Warmify.** Boosts the reds and yellows of your photo, giving it a warmer, sunsettier look. Don't you love (a) the crossfade that Picasa uses when it applies a special effect and (b) the word "Warmify"?

- **Film Grain.** Adds a sort of filmish texture to the photo.

- **Tint.** You, too, can add a color cast (or subtract one) from your photo in four easy steps. (1) Click this button. (2) Then, on the resulting panel, click the Pick Color button to make a palette appear, so that you can specify what *color* tint you want. (3) Drag the Color Preservation slider to indicate how much of the original color you want preserved. (4) Click Apply.

- **Saturation.** Increases the saturation, making colors more vivid. Drag the Amount slider to indicate how much, and then click Apply. See page 209.

- **Soft Focus.** Creates an out-of-focus oval. The main, central portion of the photo is left in focus, which helps to direct the viewer's gaze. Use the Size and Amount sliders to rein in the effect so it doesn't look too cheesy.

Drag the crosshair mark on the photo to move the center point of the *not*-blurry area—to your loved one's face, for example.

- **Glow.** Brightens the white areas of the photo, making the whole thing look dreamy. Use the Intensity and Radius sliders to control just how radioactive the whole thing looks.

- **Filtered B&W.** Simulates the look of a black-and-white photo, shot through a tinted camera filter of your choice. (Click in the color swatch panel to choose the color you want.)

- **Focal B&W.** A weird and wacky effect for fans of the movie *Pleasantville*, or maybe the end of *Schindler's List:* Turns a color photo into black-and-white *except* for a certain round patch. It's like a spotlight o' color, shining on a specified part of the photo. (You indicate which spot by dragging the little crosshair on the picture.) You can specify how large this color area is by dragging the Size slider, and how abruptly it fades into gray-scale by dragging the Sharpness slider.

- **Graduated Tint.** Remember the graduated ND filter (page 137)? Here's your chance to apply one after the fact, through software alone. The primary purpose, as before, is to make gray skies look bluer. Click Pick Color to choose a hue—blue, for example. (As you move your cursor, the entire top half of the photo changes its tint to reflect the shade you're pointing to.) Now you can control three aspects of the tinted upper half: how sharp or soft its bottom edge is (drag the Feather slider), how intense its tint is (drag Shade), and where that lower edge transitions into the transparent lower portion (drag the crosshair up or down).

Copy and Paste for Edits

Working an image into perfect shape can involve a lot of time and slider-tweaking. And sometimes, a whole batch of photos require the same fixes—photos you took at the same time, for example.

Fortunately, you don't have to re-create your masterful slider work on each of 200 photos, spending hours performing repetitive work. You can copy the adjustment settings from one photo and paste them onto others.

- **iPhoto.** Open a photo you've edited, open the Adjust palette, and click the Copy button at the bottom. Now move to the next shot (use the Thumbnails browser, for example) and then click the Paste button. All of your corrections are applied to the new picture. You can apply those copied settings to as many more photos as you wish.

- **Picasa.** In the thumbnails view, select the photo whose edits you want to copy. Choose Edit→Copy All Effects. Now select all the *other* photos that deserve the same treatment; they have to be in the same folder or album. Choose Edit→Paste All Effects. Picasa applies the same edits to the whole batch of pictures.

External Editing Programs

The editing tools in iPhoto and Picasa have come a long, long way. There's a lot less reason now to invest in a dedicated editing program like Photoshop.

But that doesn't mean that there are *no* reasons left. The Auto Levels command (in Photoshop and Photoshop Elements) is still a better color-fixer than the Enhance or I'm Feeling Lucky buttons. Photoshoppy programs also are necessary if you want to combine several photos into one, apply effect filters like Stained Glass or Watercolor, or adjust color in just a *portion* of the photo.

Photoshop is by far the most popular tool for the job, but at about $600, it's also one of the most expensive. Fortunately, you can save some money by buying Photoshop Elements instead. It's a trimmed-down version of Photoshop with all the basic image-editing stuff and just enough of the high-end features. It costs less than $100, and a free trial version is available online.

iPhoto Meets External Program

It's easy to open an iPhoto photo in another program for editing. You can use the Preferences dialog box to specify that you always want to edit photos in an external program. Or Control-click (right-click) any thumbnail, and then choose "Edit in external editor" from the shortcut menu.

Either way, the external program opens the photo. When you make your changes and use the Save command, iPhoto registers (and displays) the changes. Best of all, the Revert to Original command is still available; that is, iPhoto "knows about" the external editing.

Picasa Meets External Program

To edit a Picasa picture in another program, just right-click its thumbnail. From the shortcut menu, choose Open With→Photoshop Elements (or whatever program you want to use).

The photo promptly opens up in that program. When you're finished making changes, save them. When you return to Picasa, you'll see that the changes have been made to the photo there, too (because, of course, it's exactly the same picture!).

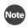 **Note** Remember, Picasa doesn't actually store any photos; it's just a database of photos already on your hard drive. At any time, you can jump directly to the original file on your hard drive; click the thumbnail of the photo, and then choose File→Locate on Disk (or press Ctrl+Enter). You switch back to the Windows desktop, where the actual photo file is sitting there in its actual folder, wagging its tail.

Juicy Bonus Features

iPhoto and Picasa are astonishingly alike. They have pretty much the same features, just tucked in different places and sometimes called different things. Each program does, however, have some editing strengths of its own.

iPhoto: The Histogram

Plenty of photos are ready for prime time after only a single click on the Enhance button. The beauty of iPhoto's Adjust panel, though, is that it permits *gradations* of the changes that that button makes. If a photo looks too dark and murky, you can bring details out of the shadows without blowing out the highlights. If snow looks too bluish, you can de-blue it.

Best of all, iPhoto offers a true *histogram,* a self-updating visual representation of the dark and light tones that make up your photograph, just like the one on an SLR (see page 65). It's a tool that's beloved by photographers. (Picasa has a histogram, too—click the tiny beanie icon in the lower-right corner of the editing window. But it's for display only; it doesn't have any adjustment handles.)

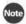 **Note** The iPhoto histogram displays three superimposed graphs at once. These layers— red, green, and blue—represent the three "channels" of a color photo. When you make adjustments to a photo's brightness values—for example, when you drag the Exposure slider—you'll see the graphs of all three channels move in unison. When you make color adjustments using, say, the Temperature slider, those individual channels move in different directions.

If the mountains of your graph seem to cover all the territory from left to right, you already have a roughly even distribution of dark and light tones in your picture, so you're probably in good shape. But if the mountains seem clumped one side of the graph, as shown in the first two examples on the next page, your photo is probably either muddy/too dark or overexposed/too bright. (Your eye could probably have told you that, too.)

To fix this situation, drag the right or left handle on the Levels slider *inward,* toward the base of the "mountain" (as shown on the image at right). If you move the *right* indicator inward, the whites become brighter; if you drag the *left* indicator inward, the dark tones change.

Way too dark and muddy

Hopelessly overexposed

Drag handles inward— much, much better

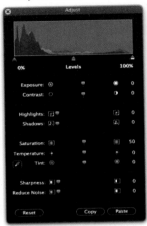
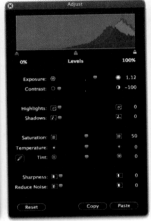
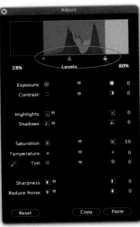

In general, don't move these handles inward beyond the outer edges of the mountains. Doing so adds contrast, but also throws away whatever data is outside the handles, which generally makes for a lower-quality printout.

Once you have your endpoints set, then adjust the middle marker which controls the midtones. The general rule: *Center* the midtone handle between the other two handles. Often, the result is a pleasing rendition of the photo.

> **Tip** The Reduce Noise slider in iPhoto can't perform magic, but on some photos it can help to eliminate the *noise* (page 83) in a picture. Zoom to 100 percent (press the 1 key); then keep an eye on a dark area or the sky as you move the slider. Generally speaking, moving the slider more than halfway softens the image too much. But a little noise reduction on a grainy shot can be a definite improvement.

Picasa: Captions

Once you've opened a photo for editing, simply begin typing; if you look sharp, you'll see that you're actually adding a *caption* to the photo. (Look at the colored strip just below the picture.)

You can read more about captions on page 162. But for now, note that these captions accompany your photo when you post them on the Web.

Chapter 11: Photos on Paper—and Everything Else

Sooner or later, most people want to get at least some of their photos on paper. You may want printouts to paste into your existing scrapbooks, to put in picture frames on the mantle, to use on homemade greeting cards, or to share with your Luddite friends who don't have computers.

Using iPhoto or Picasa, you can create such prints using your own printer. Or, for prints that look, feel, and smell like the kind you get from a photo-finishing store, you can transmit your digital files to an online print shop. In return, you receive an envelope of professionally printed photos that are indistinguishable from their traditional counterparts—but you've paid as little as 9 cents apiece.

Alternatively, you can turn your photos into custom greeting cards or gorgeous, glossy month-by-month calendars, or breathtaking hardbound (or softbound) photo books.

Who said paper is dead?

Making Your Own Prints

Using iPhoto and Picasa to print your pictures is pretty easy. But making *great* prints—the kind that rival traditional film-based photos in their color and image quality—involves more than simply hitting the Print command.

One key factor, of course, is the printer itself. You need a good printer that can produce photo-quality color printouts. Fortunately, getting such a printer these days is pretty easy and inexpensive. Even some of the cheapo ink-jet printers from Epson, HP, and Canon can produce amazingly good color images—and they cost less than $100. (Of course, what you spend on those expensive ink cartridges can easily double or triple the cost of the printer in a year.)

> **Tip** If you're really serious about producing photographically realistic printouts, consider buying a model that's specifically aimed at photographers, such as one of the printers in the Epson Stylus Photo series or the slightly more expensive Canon printers. What you're looking for is a printer that uses six, seven, or eight different colors of ink instead of the usual "inkjet four." The extra colors do wonders for the printer's ability to reproduce a wide range of colors on paper.

Even with the best printer, however, you can end up with disappointing results if you fail to consider at least three other important factors when trying to coax the best possible printouts from your photos: the resolution of your images, the settings on your printer, and your choice of paper.

Resolution and Shape

Resolution is the number of individual pixels squeezed into each inch of your digital photo. The basic rule is simple: The higher your photo's resolution, or *dpi* (dots per inch), the sharper, clearer, and more detailed the printout will be. If the resolution is too low, you end up with a printout that looks blurry or speckled.

Low-resolution photos are responsible for more wasted printer ink and crumpled photo paper than any other printing snafu, so it pays to understand how to calculate a photo's dpi when you want to print it.

Calculating Resolution

To calculate a photo's resolution, divide the horizontal or vertical size of the photo (measured in pixels) by the horizontal or vertical size of the print you want to make (usually measured in inches).

Suppose a photo measures 1524 × 1016 pixels. (How do you know? Click its thumbnail and then check iPhoto's Info panel or Picasa's blue Info strip, as shown here.)

iPhoto

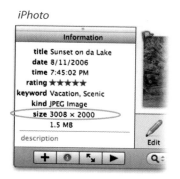

Picasa

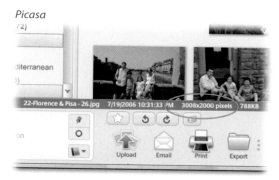

If you want a 4 × 6 print, you'll be printing at a resolution of 254 dots per inch (1524 pixels divided by 6 inches = 254 dpi), which will look fantastic on paper. Photos printed on an inkjet printer look their best when printed at a resolution of 200 dpi or higher.

But if you try to print that same photo at 8 × 10, you'll get into trouble. By stretching those pixels across a larger print area, you're now printing at just 152 dpi. You might see a noticeable drop in image quality.

 Tip It's great to print photos at a resolution over 200 dpi. But there's really no benefit to printing at resolutions higher than 300 dpi (like 600 dpi, 800 dpi, and so on). It doesn't hurt anything to print at a higher resolution, but you won't notice any difference in the final printed photos, at least not on inkjet printers. Some inkjets can spray ink at finer resolutions—720 dpi, 1440 dpi, and so on—and using these highest settings produces very smooth, very fine printouts. But bumping the resolution of your *photos* higher than 300 dpi doesn't have any perceptible effect on their quality.

Aspect Ratio

You also have to think about your pictures' *aspect ratio*—their proportions. Most digital cameras produce photos with 4:3 proportions, which don't fit neatly onto standard print paper (4 × 6 and so on).

 Note Just to make sure you're completely confused, some sizes of photo paper are measured *height by width (like 4 × 6, or 5 × 7)—but* digital photos are measured *width by height (like* 3968 × 2232 pixels).

If you're printing photos on letter-size paper, the printed images won't have standard Kodak dimensions. (They'll be, for example, 4 × 5.3.) You may not particularly care. But if you're printing onto, say, precut 4 × 6 photo paper (which you choose in the File→Page Setup dialog box), you can avoid ugly white bands at the sides by first cropping your photos to standard print sizes as described in Chapter 10.

Tweaking the Printer Settings

Every inkjet printer comes with software that adjusts various print quality settings. Usually, you can find the controls for these settings right in the Print dialog box that appears when you choose File→Print. (You may have to hunt around for them. In iPhoto, you don't get to these options until the Print dialog box appears—and you then click the Print *button*. In Picasa, once the Print dialog box appears, click Printer Setup.)

Before you print, verify that you've got these settings right. On most printers, for example, you can choose from several different quality levels when printing, like Draft, Normal, Best, or Photo. There might also be a menu that lets you select the kind of paper you're going to use—plain paper, inkjet paper, glossy photo paper, and so on.

Choose the wrong settings, and you'll be wasting a lot of paper. Even a top-of-the-line photo printer churns out smudgy, soggy photo prints if you feed

it plain paper when it's expecting high-quality glossy stock. So each time you print, make sure your printer is configured for the quality, resolution, and paper settings that you intend.

Paper Matters

When it comes to inkjet printing, paper is critical. Regular typing paper—the stuff you'd feed through a laser printer or copier—is too thin and absorbent to handle the amount of ink that gets sprayed on when you print a photo. You may end up with flat colors, slightly fuzzy images, and paper that's rippled and buckling from all the ink. For really good prints, you need paper designed expressly for inkjets.

Most printers accommodate at least five different grades of paper:

- **Plain paper.** The kind used in most photocopiers.

- **High-resolution paper.** A slightly heavier inkjet paper—not glossy, but with a silky-smooth white finish on one side.

- **Glossy photo paper.** A stiff, glossy paper resembling the paper that developed photos are printed on.

- **Matte photo paper.** A stiff, non-glossy stock.

- **Glossy film.** Most companies also offer an even more expensive glossy *film*, made of polyethylene rather than paper (which feels even more like traditional photographic paper).

These better photo papers cost much more than plain paper, of course. Glossy photo paper, for example, might run $25 for a box of 50 sheets, which means you'll be spending about 50 cents per 8 × 10 print—not including ink.

Still, by using good photo paper, you'll get much sharper printouts, more vivid colors, and results that look and feel like actual photographic prints. Besides, at sizes over 4 × 6 or so, making your own printouts is still less expensive than getting prints from the drugstore, even when you factor in printer cartridges and photo paper.

 Tip To save money, use plain inkjet paper for test prints. When you're sure you've got the composition, color balance, and resolution of your photo just right, load up your expensive glossy photo paper for the final printouts.

Resolution Warnings

Whether you print your own photos or order the prints online, keep an eye out for the tiny alert icons (little yellow triangles) that may appear in iPhoto or Picasa. You may see them, for example, on certain lines of the order form when you're ordering prints, or on the Review button in the Picasa printing-setup dialog box.

iPhoto

Picasa

These are warning symbols, declaring that certain photos don't have a high enough resolution—not enough little dots per inch—to be printed at the specified sizes. Unless you're the kind of person who thrives on disappointment, don't order prints, or make printouts, in a size that's been flagged with a low-resolution alert.

> **Tip** With today's mega-megapixel cameras, it's unlikely that you'll ever see the yellow resolution warning. But suppose you're trying to print some photos you downloaded from the Web, or that were sent to you by email; such graphics are usually much lower resolution than what you'd get directly from a camera.
>
> In any case, if the yellow triangle ever appears, remember that making smaller prints (4 × 6's, for example) compresses the dots of the photo into a smaller space, creating higher resolution, meaning better quality. A photo that looks terrible as a 16 × 20 enlargement may look great at 5 × 7.

The following pages walk you through the printing process—first from iPhoto, then from Picasa.

Printing from iPhoto, Step by Step

Here's the sequence for printing the iPhoto way:

Step 1: Choose the Photos to Print

Just highlight the ones you want, using the techniques on page 163.

When you're ready, choose File→Print, press ⌘-P, or click Print on the toolbar. The iPhoto Print dialog box appears.

Themes

Two photo layouts, one sheet of paper

Photo-layout size

As you examine this dialog box, it's important to understand the difference between a *photo layout* and a *page*.

Most people are used to printing one photo per sheet—for example, one photo on each 4 × 6 page. But in iPhoto, you can place several photos onto one 4 × 6 *photo layout,* and several layouts on each sheet of paper. For example, in the illustration above, each photo layout holds three pictures. And each letter-sized page holds two of those photo layouts.

No question about it: With great flexibility comes great complexity.

Step 2: Choose a Printing Style (Theme)

iPhoto offers a choice of printing styles called *themes,* some of which permit colored borders or even captions.

Your options include Standard (no borders, no nothing); Contact Sheet (many thumbnails per sheet, a handy photographer's reference tool); Simple Border (up to four photos per layout, like school portrait packages, complete with printed "frames"); Simple Mat or Double Mat (a printed version of a cardboard frame placed around the photo to give it more impact).

Click the theme you want. If you're printing more than one sheet (for example, more than one Standard, Border, or Mat picture), click the "Page 1 of 3" arrows to walk through the previews of each.

Step 3: Choose Print and Paper Sizes

At the bottom of the Print Settings dialog box, specify what size photo paper you're putting into the printer, and what size you want each photo layout to be.

Most of the time, if you have a standard inkjet photo printer, these will be one and the same. You'll want 4 × 6 prints on 4 × 6 paper, for example. But if the paper size is much larger than the print size, you might be able to get more than one print (that is, photo layout) per sheet.

Step 4: Adjust the Layout

The samples you see in the Themes dialog box are just starting points; you have many more options to choose from.

To see them, click Customize. Now you return to the main iPhoto window, where you land in the miniature page-layout program shown on the next page.

 Tip Until you either print or click Cancel, a new icon appears in your Source list, called Printing. While you're preparing your printout, you can click other Source-list icons and do other iPhoto work. You can return to your printout-in-waiting at any time by clicking that Printing icon.

You can also add new photos to the printout by dragging their thumbnails from other Events or albums right onto the Printing icon.

At the top of the window, you see the thumbnails of the photos you've selected for printing; a checkmark indicates a photo that you've already placed into a photo layout. (They all *start out* with checkmarks, but you might decide to remove a photo from a layout by dragging it out of its box.)

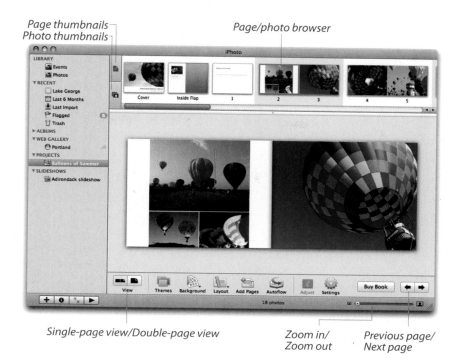

Single-page view/Double-page view

Zoom in/
Zoom out

Previous page/
Next page

> **Note** The two tiny icons to the left of the thumbnails govern which thumbnails you see:
> thumbnails for the page layouts themselves, or thumbnails of the actual photos
> targeted for printing.

You can drag a photo into one of the rectangular placeholder spots on the photo-page layout to replace whatever's there. You can even drag photos more than once, to get multiple copies.

Here, the pop-up buttons along the bottom of the window offer you hours of cosmetic tweaking pleasure. For example:

- **Print Settings.** Click to return to the main printing dialog box shown above.

- **Themes.** Choose among Standard, Simple Border, or a Mat option, as described previously.

- **Background.** Specify what color you want to fill the margins of the paper, even for Standard layouts.

- **Borders.** For all themes except Contact Sheet, you get a choice of border colors, thickness, and styles for the printed-on frame or mat. (For Contact

Sheet, you get a Columns slider instead, which lets you control how many columns of thumbnails appear on each page—and therefore how small they are.)

- **Layout.** There's a lot of design power hiding in this little pop-up menu. You can specify how many photos you want per page; whether you want horizontal (landscape) or vertical (portrait) orientation; and, for most themes, whether you want a caption text box to appear beneath the layout so you can identify what you're printing.

- **Adjust.** Click one photo (once) in the layout to make the Adjust button available. When you click Adjust, you get the Adjust *palette,* which you can use to fix the photo's color as described in Chapter 10.

 The changes you make here don't have any effect on the actual photos in your library. These are temporary changes that affect only this printed version.

- **Settings.** This button summons the dialog box shown below, which contains an oddball assortment of miscellaneous commands. Here's where you can specify the type size and font for your captions; make crop marks appear in the printout (for ease of aligning if you plan to use a paper cutter later); or turn on "Autoflow pages" (makes the photos you selected pour themselves into a multiphoto layout automatically).

The most interesting control here is the Photos Per Page pop-up menu.

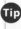 **This pop-up menu is dimmed unless you specified a page size large enough to hold more than one photo layout.**

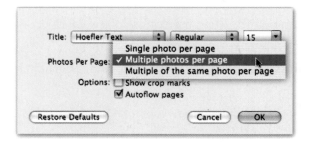

Ordinarily, iPhoto attempts to print as many photo layouts as possible on each sheet of paper; in other words, the factory setting is "Multiple photos per page." But if you don't want that paper-saving arrangement, you can choose

"Single photo per page" instead. You'll get *one* photo layout per sheet, with a lot of white space.

Or, if you choose "Multiple of the same photo per page," you get that school photo-sampler effect (one 5 × 7, two wallet-size…).

Step 5: Print

When the layout(s) look good, click the big Print button at the bottom of the window. Only now do you see the more standard Print dialog box. Here's where you choose which printer you want, how many copies, and so on.

Finally, click the Print button (or press Enter). Your printer scurries into action, printing your photos as you've requested.

Tip The PDF button, a standard part of all Mac OS X Print dialog boxes, lets you save a printout-in-waiting as a PDF file instead of printing it on paper. It lets you convert any type of iPhoto printout to PDF. Choose Save as PDF from the PDF pop-up button, name the PDF in the Save to File dialog box, and click Save. (Saving the file can take awhile if you're converting several pages of photos into the PDF.)

Printing From Picasa, Step by Step

Picasa's print options aren't quite as elaborate (or confusing) as iPhoto's, but it's hard to imagine anyone complaining about their flexibility. Here's the whole process, in words and pictures.

Step 1: Choose the Photos to Print

Just highlight the ones you want, using the techniques described on page 163. Their icons appear at the left side of the Photo Tray, the little holding area at the bottom of the Picasa window.

When you're ready, click the Print button in that photo tray (or choose File→Print). The Picasa Print dialog box appears.

Step 2: Choose a Layout

At the top left of the Print screen, you'll see that you have several layout options. Mostly, they indicate how many photos you'll get on a sheet—the more pictures, the smaller they'll be. (Physics is funny that way.)

Your options include Wallet (nine per page); 3.5 × 5 inches (four per page); 4 × 6 (two per page); 5 × 7 (two per page); 8 × 10 (one per page) or Full Page.

All of these options assume that you're printing on standard 8.5 × 11-inch paper.

Now, the thing is, your photos might not all *be* 3.5 × 5 inches or 4 × 6 inches. In other words, they might not fit into these standard-size prints; as described on page 195, most digital cameras produce photos with slightly different proportions.

Yes, you could go in and hand-crop them (Chapter 10). But if you're in a hurry, Picasa is happy to do that job for you. Just beneath the layout buttons, you'll find two choices for dealing with this problem:

- **Shrink to Fit.** Every photo will be miniaturized slightly, just enough so that you're seeing *all* of it within that 4 x 6 rectangle (for example). You may be left with empty white strips at the top and bottom or both sides, but at least you'll see *all* of each photo.

- **Crop to Fit.** Picasa will auto-trim every photo to fit in its allotted space. You might lose a little image at the top and bottom or both sides, but at least the entire print (4 × 6 or whatever) will be filled with image.

Once you've set up these options, you can click the arrow buttons beneath the preview to see how each page is shaping up (and how many pages there are).

Click the Printer button to specify which printer you want to use, if you're lucky enough to own more than one; the Printer Setup button takes you here, where you can tell the printer what kind of paper you've loaded, what percent size reduction you want applied, whether you want to use an ink-saving Draft mode, and so on. You can have hours of fun prowling through these tabs and pop-up menus. (Click OK when you're finished.)

Finally, use the Copies per Photo buttons (– or +) if you want duplicates of each photo. In fact, here's how you could create the school-photo-page-of-wallet-photos look: Select only *one* photo for printing in step 1. Then use this control to request nine copies. Presto—one sheet filled with copies of the same thing.

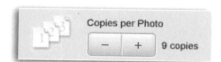

Step 3: Add a Border

Picasa is happy to add a handsome border around each printed photo, simulating a mat or frame. Click Border and Text Options to see this dialog box:

You can choose the color for the border (click "Border color") and its thickness (drag the "Border width" slider to the right). If you move the dialog box out of the way, you can see the preview screen behind it—and if you click Apply after each change, you can see the effect it will have on the printout.

"Bottom only" adds the border at the bottom of each photo—a look that's primarily useful when you're also printing text beneath each photo, as described next (use the "On border" text option). In other words, you can set up a lightly colored background for the text, to make it look nicer.

Finally, "Even width border" might seem obvious—who wouldn't want the border to be even all the way around? But if you turn *off* "Even width border," Picasa has the freedom to make a fatter border where you'll be printing captions and other information, as described below. Click Apply to see the effect on the preview.

 Note Picasa shrinks your photos to accommodate the borders. In other words, you don't have to worry that the border will eat into the image area.

Remember when you added captions to your photos (page 162)? Here comes the payoff: You can ask Picasa to add them beneath each photo, for the enlightenment of your audience.

Alternatively, Picasa can also print other stuff:

- **Filename.** Picasa will print each file's name, as it appears on your hard drive. That's useful when you're printing, for example, a contact sheet to submit to friends or clients. They can choose their favorites, and you'll be able to find the originals on your hard drive easily. (You can see the effect in the illustration on page 228.)

- **EXIF information.** EXIF stands for Exchangeable Image Format, and it refers to the technical camera details that are invisibly stored with almost every digital photo. Picasa might print, for example, "NIKON D90 Focal

Length: 32.0 mm (35mm equivalent: 48mm) 1/60x f/4.5 ISO: 800." That's the camera, zoom amount, shutter speed, aperture size, and light-sensitivity (ISO) setting.

If the text is too long to fit on one line (as it usually is for EXIF details), turn on "Wrap text" to get multiple lines of text.

In each case, you can also choose a text color (click Text Color). And you can specify whether you want the text to appear "Below image," "On image" (superimposed near the bottom of the photo), or "On border" (if you've created a border).

Remember: Click Apply after each change to see the effect on the preview. Click OK when you're finished setting up the borders and text options.

Step 4: Review the List

Before you commit your prints to paper, you can avoid mistakes that cost you precious inkjet ink and rainforest trees by reviewing what you've got. Use the ◀ and ▶ buttons to page through the entire printout.

If you find a picture that really doesn't belong in this printout, you don't have to start all over from step 1. Instead, click the Review button at the bottom of the screen. A new dialog box appears, listing each photo by name in a list. Click the one you don't want on the page you're about to print, and then click "Remove selected."

The Review box also gives you a chance to spot photos whose resolution (the number of dots) is too small for a high-quality printout. As you click each photo in the list, look at its caption on the right, where it will say either "Best Quality," "Good Quality," or "Bad Quality" (which you want to avoid). When "Bad" photos are present, you'll also see the dreaded yellow exclamation-point symbol right on the Review button, to get your attention (page 222).

You can always click "Remove low-quality pictures" to have Picasa omit *all* bad-quality shots from the printout, without your having to start over from the beginning.

Click OK to return to the Print Layout window.

Step 5: Print

When the layout(s) look good, click the big Print button at the bottom of the window. The printer leaps to life. Wait, collect, inspect, smile, and head over to the paper cutter.

Review for Printing

Some of your pictures are too small to print well. You can remove these pictures, print them anyway, or cancel and change the print size.

Fullscreen cap...59 PM.bmp

Low Quality: P7109983.jpg
Low Quality: Fullscreen cap...59 PM.bmp
Best Quality: 22-Florence & Pisa - 26.jpg
Best Quality: 22-Florence & Pisa - 10.jpg
Best Quality: David and David.jpg
Best Quality: 22-Florence & Pisa - 28.jpg
Best Quality: 22-Florence & Pisa - 31.jpg
Best Quality: 22-Florence & Pisa - 33.jpg

Bad quality (91 pixels/inch)

| Remove selected | Remove low quality pictures | OK | Cancel |

Ordering Prints Online

Even if you don't have a high-quality color printer, traditional prints of your digital photos are only a few clicks away—if you're willing to spend a little money, that is.

Thanks to deals with the popular online photo-printing companies, Apple and Google let you order prints directly from within iPhoto and Picasa. After you select the size and quantity of the pictures you want printed, one click is all it takes to have your computer transmit your photos to these online shops and bill your credit card for the order. The rates range from 9 cents for a single 4 × 6 print to about $23 for a jumbo 20 × 30 poster. Within a couple of days, you'll find, in your mailbox, finished photos printed on high-quality glossy photographic paper.

> **Tip** If you plan to order prints, first crop your photos to the proper proportions (4 × 6, for example) as described in Chapter 10. If you send them uncropped, you're leaving it up to the printing company to make the photos fit. (More than one photo fan has opened the envelope to find loved ones missing the tops of their skulls.) You can always restore the photos to their original uncropped versions using the Revert to Original/Undo All Edits command described on page 191,.

Here's how the print-buying process works. First, select the photos you want to print (page 163.) Now, to get the order form under way:

- **iPhoto.** Choose Share→Order Prints. Now the Mac goes online to check in with the Kodak processing center. (If you don't already have an account with Apple, click Set Up Account and fill in the blanks.)

 Now the order form appears, so you can select the sizes and quantities you want. If you want a 4 × 6 print or two of every photo, just use the Quick Order pop-up menu at the top of the dialog box. Or, for more control over sizes and quantities of individual photos, fill in the numbers individually for each photo, scrolling down through the dialog box as necessary. The total cost of your order is updated as you make selections.

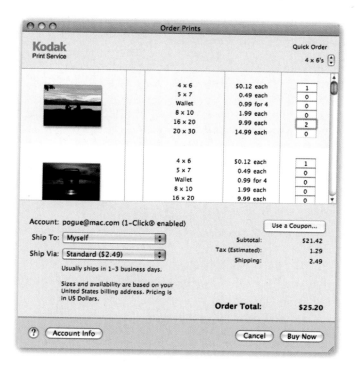

- **Picasa.** In the Photo Tray (the strip at the bottom of the window), click the Shop button. Now Picasa's order form appears.

As you can see, Picasa has deals with a huge list of online photo-printing companies. The logo of each appears here, along with a sample of the prices. Poke around a little, investigate the deals and the options, and then, when you've made up your mind, click the Choose button for the company you want.

Now you're sent to that company's Web site, where you have to create an account for that service. Mercifully, the next time you order prints, Picasa will list your preferred service at the top of the list of print shops—and, at your option, it will even remember your name and password for you.

Now, just click the Buy Now or OK button, and your photos are transferred.

If you're using iPhoto, your credit card is billed, and your work here is done. A dialog box appears, showing the reference number for your order and a message saying you'll be receiving a confirmation via email. Go sit by the mailbox.

If you're using Picasa, you now embark on a journey of your print-company's Web site. You'll use its own controls for specifying quantity, quality, and so on.

In any case, the genius behind this system is that you get to print only the prints that you actually want, rather than developing a roll of 36 prints only to find that just two of them are any good. It's far more convenient than having to take your film (or your memory card) to a drugstore and then wait, and it's a handy way to send top-notch photo prints directly to friends and relatives who don't have computers. Furthermore, it's ideal for creating high-quality enlargements that would be impossible to print on a typical inkjet printer.

Calendars, Cards, and Books

At first, gift-giving is fun. During those first 10, 20, or 40 birthdays, anniversaries, graduations, Valentine's Days, Christmases, and so on, you might actually *enjoy* picking out a present, buying it, wrapping it, and delivering it.

After a certain point, however, gift-giving becomes exhausting. What the heck do you get your dad after you've already given him birthday and holiday presents for 15 or 35 years?

Now that you have a digital camera, you've got an ironclad, perennial answer: custom photo books.

Travel

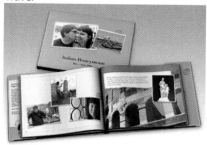

Family Album

Contemporary

Folio

The Web is filled with companies that let you design and order (via the Internet) gorgeous, professionally bound photo books, printed at a real bindery and shipped to the recipient in a slipcover. Your photos are printed on glossy, acid-free paper, at very high resolution, complete with captions, if you like. It's a handsome, emotionally powerful gift *guaranteed* never to wind up in the attic, at a garage sale, or on eBay.

These books (about $20 and up) are amazing keepsakes to leave out on your coffee table—the same idea as most families' photo albums, but infinitely classier and longer lasting (and not much more expensive).

You can also create equally great-looking calendars (covering any year, or an arbitrary bunch of months), postcards, and greeting cards.

Picking the Pix

Frankly, the hardest part of the whole book/calendar/card creation process is winnowing down your photos to the ones you want to include. Many a shutterbug eagerly sits down to create his very first published photo book—and winds up with one that's 99 pages long (that is, $109).

Winnowing down your brilliant pictures to the most important few can be an excruciating experience, especially if you and a collaborator are trying to work together. ("You can't get rid of that one! It's adorable!""But honey, we've already got 439 pictures in here!""I don't care. I *love* that one.")

You can choose the photos for inclusion in the book using any selection method you like. You can select a random batch of photos (page 163), or file them into an album as a starting point.

If you opt to start from an album, take this opportunity to set up a preliminary photo *sequence*. Drag the pictures around in the album to determine a rough order. You'll have plenty of opportunity to rearrange the pictures on each page later in the process, but the big slide-viewer-like screen of an album makes the process easier. Take special care to place the two most sensational or important photos first and last. They'll be the ones on the cover and the last page of the book; if you're making a hardbound book (which includes a paper dust jacket), you need special photos for the inside front and back flaps and back cover, too.

How to Design Your Book/Calendar/Card

What happens next depends on which program you're using.

- **iPhoto.** iPhoto contains an entire page-layout program for designing books. It has elaborate controls for specifying the number and placement of pictures on each page, the color and texture of the page backgrounds,

captions, individual photo cropping, page numbers, section introduction pages, and so on.

You can create hardcover or softcover books, linen-bound or wire-bound, in three different sizes (including tiny, wallet-size flip books, with one photo filling each page, edge to edge—a great handout to friends and adoring relatives).

It's a lot of fun, but there's a lot to it. If you want the full, 30-page, step-by-step tour, download the free bonus "Designing iPhoto Books" appendix from this book's "Missing CD" page at *www.missingmanuals.com*.

That same chapter (which comes from *iPhoto: The Missing Manual*) also contains instructions for designing and ordering photo calendars, greeting cards, and postcards.

- **Picasa.** Picasa doesn't have any layout or book-design tools of its own. Instead, it has something Google considers even better: links to a million Web sites that *specialize* in turning your photos into beautiful printed works of one-of-a-kind art.

Not all of the online companies offer photo books, but some do, including Shutterfly and Snapfish. Follow the same steps described previously for ordering prints—but once you arrive on the company's Web site, you'll find the tools for designing and laying out your own custom book.

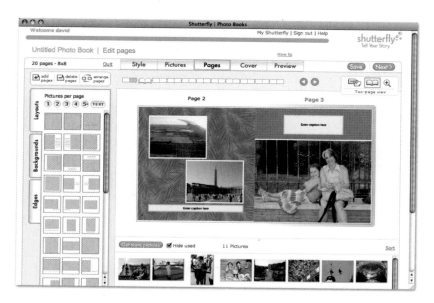

Way Beyond Paper

These days, digital photos have found their way onto all kinds of things besides printed paper. For example, Snapfish and Shutterfly alone invite you to slap your photos onto mugs, Christmas ornaments, mouse pads, stickers, diaper bags, key rings, luggage tags, canvas "paintings," notepads, address stickers, posters, purses, aprons, keepsake boxes, desk organizers, playing cards, pillowcases, photo ties, dog collars, bottles of wine, stationery, magnets, towels, t-shirts, tote bags, bracelets, jigsaw puzzles, place mats, serving trays, clocks, coasters, cutting boards (cutting boards!?), and a lot more.

Here are some especially cool examples that your lucky recipients will never, ever forget:

- **Photo stamps.** You can have your *own photos* made into actual, valid, legitimate U.S. mail postage stamps. (Snapfish offers this feature, for example.)

- **Photo blankets.** For about $100, you can turn a great photo into an 5 × 7-foot throw blanket (at right on the facing page—definitely not to scale). The photo is actually woven *into* the blanket — not just printed on.

 Shutterfly and Snapfish offer the blankets, but there's a greater variety of types, sizes, and prices at, for example, *www.customcreationsunlimited. com.* Talk about one-of-a-kind!

Usually, you start by uploading your photos to the Web sites in question.

- **iPhoto.** Choose the photos you want to work with. Choose File→Export. Make sure the Quality pop-up menu says Maximum, and then click Export. Save the photos into a new folder on your hard drive.

 Now go to the Web site that offers the custom printing, and use its own Upload button to grab the photos from your Mac.

- **Picasa.** Select the photos you want to work with, and then click the Shop button in the Photo Tray. When the list of custom printing companies appears (shown on page 234), click the one you want.

 Truth is, though, sometimes the best company for the job isn't listed in Picasa's Shop list.

 For example, *MyPublisher.com* offers superior photo-book options, including leather covers and 32 cover designs. It even offers a free, downloadable book-layout program for Mac and Windows, which makes the design phase effortless. But MyPublisher.com doesn't connect to Picasa.

 Similarly, CustomCreationsUnlimited.com offers more blanket options than the companies listed within Picasa.

 No big deal, though; just export your Picasa photos to a folder on your hard drive (select them, then click the Export button in the Photo Tray). Then visit the Web site and use its own Upload Photos or Choose File button to slurp in the pictures you've exported.

Measures 54" x 70".
Production time is typically 2-3 weeks.

Text (optional) : Happy St. Paddy's Day, Daddy!

Image file : Choose File no file selected

The idea is that once you've uploaded your photos from Picasa, the photos are just there, on the print shop's Web site, available to work with for any project that comes your way.

Really—try it out. These are phenomenal gifts. The best part is that, even though custom photo gifts are widely available (and reasonably priced), the public hasn't caught on to them yet. In other words, your recipients will probably exclaim that they never even knew such things were possible. And they'll think you're a genius.

Chapter 12:
Electronic Photos

Sure, holding a beautifully rendered glossy color print (or a handsome new refrigerator magnet) created from your own digital image is a glorious feeling. But these are *electronic* photos—and since they're digital, you can bring them to your audience in dozens of new ways. Distributing your pictures electronically—by email, on a Web site, as a screen saver, and so on—not only costs nothing, but also offers instant gratification and a brighter, more vivid presentation.

Emailing Photos

Email offers a perfect method for quickly sending off a photo—or even a handful of photos—to friends, family, and co-workers. But the most important thing to know about emailing photos is this: *Full-size photos are too big to email.*

Suppose that you want to send three photos along to some friends—shots you captured with your 10-megapixel camera.

A 10-megapixel shot might consume 3 megabytes of disk space. So sending just three shots would make at least a 9-megabyte package. But alas:

- It will take a long time to send, and a long time to receive on the other end.

- Even if they do open the pictures you sent, the average high-resolution shot is much too big for the screen. It does you no good to email somebody a 10-megapixel photo (for example, 2592 × 3872 pixels) when his

monitor's maximum resolution is only 1280 × 800. If you're lucky, his graphics software will intelligently shrink the image to fit his screen; otherwise, he'll see only a gigantic nose when he opens the first photo. But you'll still have to contend with his irritation at having waited so long for so much superfluous resolution.

- The typical Internet account has a limited mailbox size. If the mail collection exceeds 5 MB or so, then that mailbox is automatically shut down until it's emptied. Your massive 9-megabyte photo package will push your hapless recipient's mailbox over its limit. She'll miss out on important messages that get bounced as a result.

It's all different when you use iPhoto and Picasa. They offer you the opportunity to send a scaled-down, reasonably sized version of your photos instead. Your modem-using friends will savor the thrill of seeing your digital shots without enduring the agony of a half-hour email download.

Emailing Photos from iPhoto

If you currently use Apple's Mail program to handle your email, you're ready to start mailing photos immediately. But if you use AOL, Entourage, or Eudora, you have to tell it so. Choose iPhoto→Preferences (or press ⌘-comma), click General, and then choose the email program from the Mail pop-up menu.

Close the window. The Mail icon on the bottom toolbar thoughtfully changes to reflect the icon of your chosen mail program.

Once iPhoto knows which program you want to use, here's how it all works:

❶ **Select the thumbnails of the photo(s) you want to email.**

You can use any of the selecting techniques described on page 163.

❷ **Click the Email icon at the bottom of the iPhoto window.**

This dialog box appears:

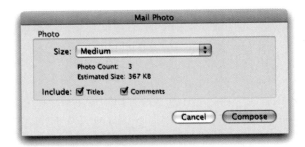

❸ Choose a size for your photo(s).

This is the critical moment. The Size pop-up menu in the Mail Photo dialog box, shown above, offers four choices.

Choose Small (Faster Downloading) to keep your email attachments super-small (320 × 240 pixels, not enough for prints). Your photos will consume less than 100 K apiece, making downloads quick and easy, even for people with dial-up connections.

Medium photos will fill a nice chunk of your recipient's screen. At about 640 × 480 pixels, it's enough data to produce a 2 × 3-inch print. Even so, the file size remains reasonable—under 150 K per photo.

The Large (Higher Quality) setting downsizes your photos to about 450 K, preserving enough pixels (1280 × 960) to make 4 × 6 prints and completely fill the typical recipient's computer screen. Send sparingly.

Despite all the cautions above, there may be times when a photo is worth sending at Actual Size (Full Quality), like when you're submitting a photo for printing or publication. This works best when both you and the recipient have high-speed Internet connections and large-capacity mail systems.

 Note iPhoto retains each picture's proportions when it resizes them. But if a picture doesn't have 4:3 proportions (maybe you cropped it, or maybe it came from a camera that wasn't set to create 4:3 photos), it may wind up *smaller* than the indicated dimensions. In other words, think of the choices in the Size pop-up menu as meaning, "this size or smaller."

❹ Include Titles and Comments, if desired.

Turn on these checkboxes if you want iPhoto to copy the title of the photo and any text stored in the Comments field into the body of the email. When Titles is turned on, iPhoto also inserts the photo's title into the Subject line of the email message.

❺ Click Compose.

iPhoto converts and shrinks the photos as you directed, opens your email program, creates a new message, and attaches your photos to it.

❻ Type your recipient's email address into the "To:" box; click Send.

Your photos are on their merry way.

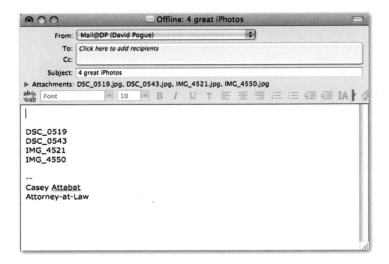

Emailing Photos from Picasa

Here's how to send photos from Picasa:

❶ Select the thumbnails of the photo(s) you want to email.

You can use any of the selecting techniques described on page 163.

❷ Click the Email icon at the bottom of the Picasa window.

The Select Email dialog box appears:

Picasa can send photos directly, without getting your email program involved, *if* you have a Gmail account (or a Google Account, which lets Google send mail through your regular email address). Call it a perk of Google's world domination.

 Tip Gmail is a free email account with a lot of really great features. For example, you can check your mail from any computer, since it's all available at *www.gmail.com*. Even if you have an email account already, having a Gmail account as a secondary one, a backup, makes great sense—especially since you can set up your Gmail to display the mail from your *other* email account automatically.

If you don't have a Gmail account, the dialog box shown on the previous page offers a link to sign up for one.

If you use another email program, like Outlook or Windows Mail, Picasa can hand off its photos to that program instead. If that program is already named in the dialog box, as shown, then great; you're all set. If not, you have to tell Picasa which program you use for email.

Note Here's how. In **Windows XP**, click Start→Control Panel→Internet Options. On the Programs tab, choose your email program's name, and click OK. In **Windows Vista**, click Start→Control Panel→Default Programs. Click "Set your default programs." On the next screen, find your email program's name in the list, click it, and then click "Set this program as default." Click OK.

From now on, you'll see that program's name when you click the Mail button in Picasa.

❸ **Click either your email program's name or Google Mail.**

The first time you send photos using Gmail or Google Mail, you're asked to type your account name and password. Do that, and then click Sign In.

If you click the name of your own email program (like Outlook or Windows Mail), however, that program now opens up automatically.

In either case, the next thing you see is a new, outgoing message, ready to address and send.

❹ **Address this note, edit the Subject line and body, and click Send.**

Your photos are on their way.

Now, at no time during this process were you ever asked what *size* you wanted for your email-attached photos. That's because Picasa scales them down *auto-*

matically to a very reasonable, if smallish, 480 pixels on a side (maximum), without even asking you.

You can control how much of this shrinkage goes on, though. Choose Tools→Options. In the resulting dialog box, click the Email tab.

Here, you'll find two settings. The first says, "When sending more than one picture, resize to"—and you can adjust the slider to scale the maximum dimensions up or down. (640 pixels is fine, but don't go overkill, for the reasons listed earlier.)

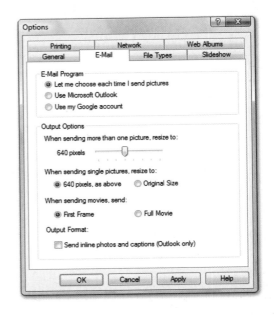

The second says, "When sending single pictures, resize to"—and offers you two choices. You can opt for the "as above" choice, meaning that single pictures will be scaled to the same dimensions as multiple attachments. Or you can click Original Size. Google's thinking here is: OK, you can probably get away with sending *one* full-sized photo per email message without choking the system. You might need that option now and then, like when you're sending your prize-winning emu shot to your editor at the magazine.

 While you're here, don't miss the options at the top. Here's where you can specify your preferred email account once and for all, so that you won't be asked to choose it every time you send photos. You'll eliminate step 3.

Publishing Photos on the Web

Putting your photos on the Web is the ultimate way to share them with the world. If the idea of enabling the vast throngs of the Internet-using public to browse, view, download, save, and print *your* photos sounds appealing, read on. It's amazingly easy to get your photos from iPhoto and Picasa to the Internet.

Web sites like *Flickr.com, SmugMug.com,* and *Fotki.com* are all over the Web, offering a place for you to exhibit your photos for all the world to see and to comment upon.

If you're more interested in creating a *private* Web gallery that neatly syncs with your copy of iPhoto/Picasa, both Apple and Google have made it utterly idiot-proof. (How does *one click* strike you?)

These galleries offer full-screen slideshows, the option to let your fans download full-res copies of your work, posting of new photos that sent from your cellphone, and other goodies that make it even more fun for your admirers.

The two companies take very different approaches to their gallery services:

- **Apple.** Apple's Web service, called MobileMe, costs $100 a year. Sure, it's too bad it's not free. However, that price gets you 20 gigabytes of storage, which can hold a lot of photos indeed. The Web gallery is also sophisticated, with a wealth of beautiful, smooth, and animated viewing options.

 And membership includes a host of other Web features, not just the Web photo-gallery thing. For example, it includes the infamous MobileMe syncing service, which keeps the email, calendars, address books, and Web bookmarks on all of your computers—Macs, Windows PCs, iPhones, and iPod Touches—synchronized in real time. (Infamous, because the service had major problems for its first few months in 2008.)

 You also get an iDisk, a virtual hard drive where you can park, back up, or transfer files that are too big to send by email, and a new email account with a very cool address: *yourname*@me.com.

- **Picasa.** Picasa's service is called Picasa Web Albums, and it's free. That's fantastic. However, that price gives you only 1 gigabyte of photo storage, which isn't much. Beyond that, you have to pay; for example, 40 gigabytes of storage is $75 a year.

 Tip You can use Apple's service if you have a Windows PC, and you can use Picasa's service if you have a Mac.

If you're a Windows person with a MobileMe account, log in at *www.me.com* and click the Photos button. Now you can upload your photos by clicking Upload (the up-arrow button above the thumbnails).

If you're a Mac person with a Picasa account, you can install a Picasa Web Albums plug-in (a little free software accessory) that lets you send pictures to your Picasa online galleries right from within iPhoto. You can get this plugin from this book's "Missing CD" page at *www.missingmanuals.com.*

iPhoto Web Galleries

Actually, iPhoto can get your photos onto the Web in three different ways—and only one of them costs money.

- **MobileMe.** This is the easiest, most hands-off approach: Publish your photos as a MobileMe Web Gallery. The steps appear below.

- **iWeb.** iWeb is Apple's Web-page design program, one of the programs included with the iLife suite ($80 buys you iWeb, iPhoto, iMovie, and GarageBand). iPhoto can hand off any batch of photos to iWeb with only a couple of mouse clicks; from there, you can post them online with a single command.

- **Your own site.** If you already have a Web site, you can use iPhoto's Export command to produce ready-to-upload HTML documents and folders full of Web graphics. You can upload these files to your Web site, whether that's a MobileMe account or any other Web-hosting service. (Most Internet accounts, including those provided by AOL and Earthlink, come with free space for Web pages uploaded in this way.)

 This is the most labor-intensive route, but it offers much more flexibility to create more sophisticated pages if you know how to work with HTML. It's also the route you should take if you hope to incorporate the resulting photo gallery into an existing Web site (that is, one in which the photos aren't the only attraction).

> **Tip** To export Web files in this way, choose File→Export; in the dialog box, click the Web Page tab. Set the page attributes, including the title, grid size, background, thumbnail size, full-image size, and whatever text you want to appear with each photo. Finally, click Export.
>
> You end up with a series of HTML documents and JPEG images, properly linked and stored in folders—the building blocks of your Web-site-to-be. It's up to you to figure out how to post them on the Internet where the world can see them—using an FTP program, for example. Only then do they look like real Web pages.

In any case, here's how you publish your photos onto the Web using a MobileMe account:

❶ Choose the photos you want to publish.

You can click an album or an Event, or you can just select a random batch using the techniques described on page 163.

❷ Choose Share→Web Gallery.

If, at this point, iPhoto doesn't yet know your MobileMe account information, then a dialog box offers you a Sign In button (in case you're already a member) and a Learn More button (in case you're not).

You see this dialog box.

Would you like to publish "Summer Fun" to your Web Gallery?

This will create an album in pogue's Web Gallery on .Mac. The album can be viewed with Safari or any modern web browser.

Album Viewable by: [Everyone ⬍]

Options: ☑ Show photo titles
☑ Allow visitors to download photos
☐ Allow visitors to upload photos
☐ Allow photo uploading by email
☐ Show email address to visitors

[Cancel] [Publish]

❸ Specify who can see your pictures.

The "Album Viewable by" pop-up menu lets you specify who can see your photos. After all, not every picture in your life is appropriate for viewing by the general public. (You know who you are, senators' children.)

If you choose Everyone, there are no restrictions on who can call up your photos. If you choose Only Me, then you've pretty much guaranteed that nobody sees your pictures unless they're sitting there beside you.

There is, fortunately, an in-between option. If you choose Edit Names and Passwords, you get a dialog box where you can create a name and password for the album. You can distribute this name and password to a few friends and relatives to ensure that only the lucky few can get in.

After you've created some names and passwords and clicked OK, you return to the Options dialog box. Make sure that the correct name and password are visible in the pop-up menu.

❹ Turn on the other checkboxes to configure your gallery.

"Show photo titles" means the names of your pictures (as you've typed them in iPhoto) will appear on the Web.

"Allow visitors to download photos" means the Download button in the Web gallery will be available. Anyone who clicks it can download the full-size, full-resolution copy of that photo. If you're worried that people

might try to make money off your masterful photographic work, don't turn this on.

"Allow visitors to upload photos" is even more intriguing. It means visitors to your gallery can post photos of their own, adding to the online album, whether they're on a Mac OS X or Windows.

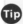 **Tip** You can upload photos from an iPhone directly to one of these Web galleries, too (assuming you've entered your MobileMe account information on your iPhone, and assuming you've already published at least one Web gallery). In the phone's photo-viewing program, tap the Send icon, and then choose Send to Web Gallery. Choose the gallery you want to receive your photo, and then click Send.

It's important to note that iPhoto performs a *two-way sync* with Web galleries. If you add photos to the published album, then they show up on the Web automatically—and if someone *else* adds photos, then they show up in your copy of *iPhoto* automatically.

"Allow photo uploading by email" may be cooler yet. It lets anyone add photos by sending them to your Web gallery's secret, unique email address.

You won't discover the private email address until after you've published the gallery. Once you do, you'll find it in the upper-right corner of the iPhoto window.

If you turn on "Show email address to visitors," then the Web gallery's email address appears when visitors click the Send to Album button at the top of the Web gallery itself.

If you leave that option turned off, then nobody will know the gallery's email address…unless you email it to them.

❺ **Click Publish.**

iPhoto sends your photos off to Webland and posts them in your gallery. It can take quite a while—a minute per picture, for example.

When it's all over, there are some changes in the iPhoto window:

- In the Source list, there's a new heading called Web Gallery. Your newly published gallery's name is listed here. So are any other galleries you publish.

- You can change what's in the gallery by adding, deleting, or editing the thumbnails in it. Then click the Published icon on your gallery's name.

- At the top of the window, the name, Web address, and email address of this gallery appear. Click the tiny right-pointing arrow to open the published version of the gallery in your Web browser.

- At the bottom of the window, click Settings. The box shown on page 249 reappears so that you can change your gallery's options.

- Click Tell a Friend, also at the bottom of the window, to fire up your email program. iPhoto generates a new outgoing message: "Greetings! I just published some new photos to my MobileMe Web Gallery that I'd like to share with you. To check them out, just visit the link below."

 The message goes on to provide the user name and password, if you've established one. If you've enabled downloading or uploading, it adds, "You can download high-quality versions of all the photos, or even add new photos of your own for everyone else to see. Enjoy the pictures!"

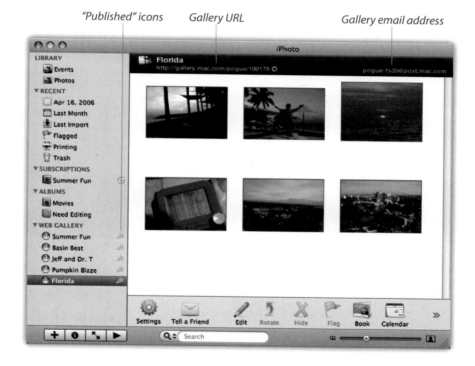

Viewing an iPhoto Web Gallery

Once your fans arrive at the Web address you've given them, they can walk through your little art show using any of four super-slick slideshows: Grid

(photos appear as thumbnails, which you can click for a larger view); Mosaic (a "table of contents" of thumbnails on the right side; click one to see that photo at full size); Carousel (a lot like Cover Flow in Mac OS X or on the iPod, where the photos fly past as you drag the scroll bar, enlarging to a decent size as they pass the center point); and Slideshow (a traditional slideshow, where the viewer doesn't have to do anything but sit back and watch as the pictures parade across the screen, complete with crossfades between them).

In the Slideshow mode, a control bar with Download, Previous, Next, Pause, and Exit Full Screen buttons is available. It appears when the viewer wiggles the mouse.

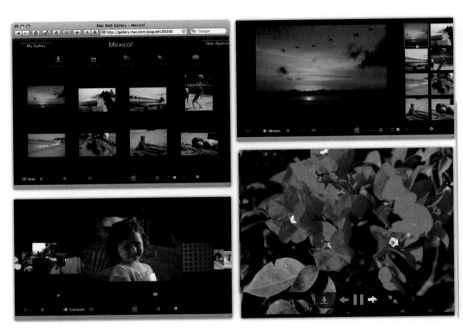

There are some handy buttons across the top, too:

- **Download.** If you've given permission, visitors can download the full-resolution photos to their own hard drives. This is a great way to supply your pictures to other people, anywhere in the world, who might want to print them—without dealing with the hassles and file-size limits of email.

- **Subscribe.** If your screaming fans *also* use iPhoto, they can *subscribe* to your gallery. That means that if you make changes to the gallery—adding or removing pictures, say—those changes are soon reflected in the iPhoto libraries of your subscribers. Photo-feed subscriptions are a

fantastic way for grandparents and other interested parties to keep in touch with the photos of your life, with zero effort on their part and very little on yours.

All they have to do is choose File→Subscribe to Photo Feed. In the resulting box, paste the Web gallery address, and then click Subscribe.

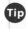 **Tip** Ordinarily, your copy of iPhoto doesn't check the Web gallery to see if there are changes until you click the G button next to the gallery's name. But if you have an always-on Internet connection (like a cable modem or DSL), you can also request that iPhoto check for changes *automatically;* there's no downside, and you're saved a few exhausting clicks. To do that, choose iPhoto→Preferences→Web Gallery. From the "Check for new photos" pop-up menu, you can choose "Every hour," "Every day," or "Every week."

- **Upload.** Your public can click this button to upload new photos to your gallery, if you've permitted it. Once they prove that they're human and not spam-sending software robots (by taking one of those "type in the nonsense word you see here" tests), they click Choose Files. Next, they find and highlight their own photos to upload, and then click Select. The files are automatically uploaded and posted on your gallery.

- **Send to Album.** Viewers can click this button to reveal the gallery's private email address, if you've permitted emailing photos.

- **Tell a Friend.** This lets your friends click to send a link to your gallery to someone else by email. Spread the word!

At the bottom of the window, the four Color buttons let viewers change the background color of the gallery: black, dark gray, light gray, or white. Finally, the size slider at the lower right controls the thumbnail size in Grid and Mosaic views.

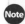 **Note** It's very easy to take down a Web gallery once it's outlived its usefulness: Click the gallery's name, and then press Delete. It disappears, not only from your Source list, but also from the Web and from any subscribers' copies of iPhoto. And you reclaim that much of your MobileMe storage space.

Picasa Web Galleries

Once you've imported, arranged, and edited your pictures in Picasa, you're probably brimming with excitement about posting them online for all the world to see. Well, here's your chance. Here's how the whole thing goes:

❶ Choose the photos you want to publish.

You can click an album, or you can just select a random batch using the techniques described on page 163.

❷ Click Upload.

This button appears in the Photo Tray at the bottom of the Picasa window.

If you see the box shown here at left, then either (a) you haven't signed in to your Web Albums account, or (b) you don't *have* a Web Albums account.

To solve the first problem, type in your Google name and password, and then click Sign In. To solve the second one, click "Sign up for Web Albums," fill in the forms, and then return to this paragraph when you're ready.

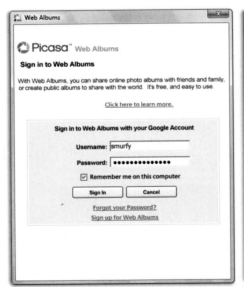

If you *do* have a Google account and you *have* signed in, you see the box shown at right above. It's the Upload to Web Albums dialog box, and it presents you with all kinds of important decisions to make.

❸ Specify what online album these pictures will go into.

If you've created some albums online already, then you can use the pop-up menu to choose one of them. Otherwise, click New, and then type

a name for it in the Album Title box. (And a description, if you're feeling eloquent.)

➍ Choose a size for your uploaded pictures.

Remember, you've got only 1 gigabyte of storage for all your photos (in the free account), so it's nice that Picasa offers to scale down your multi-megabyte jumbo-JPEGs to a size that's more realistic for onscreen viewing. (Remember: You need very little resolution to show a photograph on a computer screen—just a fraction of what you'd need for a printout.)

Your options, in the "Size to upload" pop-up menu, include Original size. Use this option only if you're using Picasa Web Albums as a backup service, or if you intend for your photos to be published (or printed at poster size).

Choose Recommended: 1600 pixels if you think your audience might want to download your pictures and print them or use them as screen savers on big monitors. Medium: 1024 pixels is great for full-screen slideshows right there on the Web. Small: 640 pixels is useful if you don't want your pictures used for anything but appearances on Web pages that *also* have text—like blogs or eBay ads.

➎ Specify who can see your pictures.

The "Visibility for this album" buttons let you specify who can see your photos. After all, not every picture in your life is appropriate for viewing by the general public, as any political candidate with teenage children can tell you.

If you choose Public, then there are no restrictions on who can call up your photos. And your gallery's Web address will be something simple, like *http://picasaweb.google.com/Casey/Vacation*. If you choose Unlisted, then your Web gallery will have a ridiculously complicated Web address that nobody can guess; the only people with access to your gallery will be those you invite by email (or anyone they share that email with). In other words, security through obscurity.

The third option, "Sign-in required to view," is the most secure of all. It ensures that *nobody* can see your album's pictures unless (a) they have a Google account name and password, and (b) you've invited them. This way, only the lucky few can get in.

❻ Click Upload.

Picasa begins sending your photos to your Web Albums account. A dialog box keeps you posted of its progress.

When it's all over, you can click the View Online button to see what the masses will see when they visit your new gallery. You'll also notice a few changes in the Picasa program itself:

- **In the upper-right corner** of your album, a link says, for example, "View online: public (31)." It's saying: "Click here to see the gallery online. You designated it as public, and there are 31 pictures in it."

- **A tiny globe icon** appears next to each uploaded folder in the folder list.

- **The pop-up menu** just below it lets you *change* the album's status from Public to Unlisted to Sign-in Required. It also lets you delete the album online, update it, or copy its URL (Web address) to your clipboard, ready for pasting into an email to a new prospective patron. And it contains the Enable Sync command, described below.

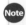

- **You can change** what's in the gallery by adding, deleting, or editing the thumbnails within it. Then right-click the changed thumbnail and, from the shortcut menu, choose Online Actions→"Update online photo." (Sound like a lot of work? It is. That's why "Sync to Web" was invented; read on.)

- **Little up-arrow badges** appear on the thumbnails to let you know that they're "live" on the Web.

Viewing a Picasa Web Album

When your fans arrive at the Web address you've given them, they first meet the thumbnails for your album. They can open one up for viewing with one click, or they can enjoy the buttons across the top of the window:

- **Slideshow,** of course, is a traditional slideshow, where the viewer doesn't have to do anything but sit back and watch as the pictures parade across the screen. There's even a streamlined version of the slideshow control bar that lets your fans speed up, slow down, or pause the show.

- **Share** lets your audience invite *other* people (if it's a Public gallery).

- **Download** is a pop-up menu that lets your admirers copy the photo or album to their own PCs, print it directly, or download it and turn it into a collage or movie (described later in this chapter).

- **Prints** offers an "Order prints" command that works much as described in Chapter 11. Your fans can order commercial prints of your photos from Snapfish, Shutterfly, Walgreens, and so on—and you'll never even be aware of it.

- **Edit** doesn't really let anyone edit your photos; it's for editing the *album*, like adding captions, dragging thumbnails into a new order, editing the name and description, and so on.

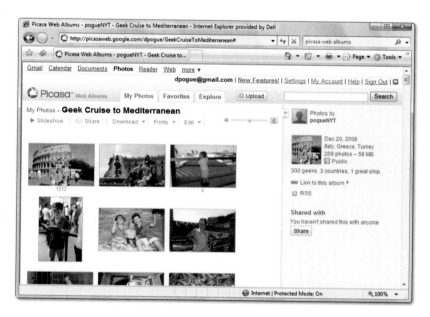

Syncing a Picasa Web Album

What you've read so far about uploading photos from Picasa is a one-time deal. You post, they look. Your online album is completely disconnected from your PC after the upload is complete.

If you turn on the *sync* option, however, then your Web album is *live.* Any time you make a change to an album on your PC—add photos, delete photos, edit photos—Picasa quietly updates the Web copy of the album, so it's always up to date. Pretty cool.

Using this feature is almost exactly like the one-time upload feature described earlier. Begin by clicking the Sync to Web button just above the thumbnails of the album.

You see the dialog box shown here at left:

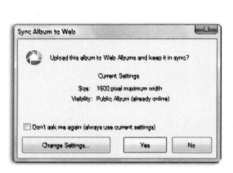

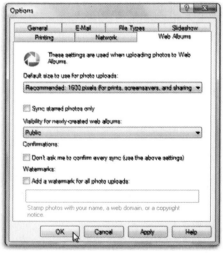

This time, it's not asking you what album to store the photos in; it's going to be *this album*—a perfect mirror of what's on your PC. Of course, you can always click Change Settings to adjust the picture size, privacy settings, and so on.

 Tip As shown above at right, Change Settings also gives you some additional hidden options, like "Sync starred photos only" (save space—post only your winners!) and "Add a watermark for all photo uploads" (prevent evildoers from profiting from your photographic genius—stamp a faint copyright notice across each shot!).

When you finally click Yes, the synchronization begins. A little G symbol appears on each thumbnail to let you know that it's being synced, as well as on its folder icon in the Albums list. Any changes you make in Picasa are instantly propagated to the Web.

 Note You're not really syncing with the Web, of course—changes people make *there* are not reflected on your PC. (Unless you use the Refresh Online Status command described on page 256, of course.)

The Screen Saver

Every year, thousands of people buy those little digital picture frames—small, coarse-looking, expensive LCD screens that do nothing but display a slide-show of photos. But if you stop to think about it, you've got a *much* nicer digital picture frame already. It's called your computer.

Set up your photos as a screen saver, and after a few minutes of inactivity, your photos fill the screen in bright, full-size glory. It's something like a slideshow, except that the pictures don't simply appear one after another and sit there on the screen; they're much more animated. They slide, zoom, and dissolve from one to the next.

The iPhoto Screen Saver

Collect the photos in an album, if they're not in one already. Click the album in the Source list, and then choose Share→Set Desktop.

iPhoto takes you straight to the Desktop & Screen Saver panel of System Preferences. Click the Screen Saver tab.

In the list at left, there's a long list of different screen saver options. But if you scroll down into the list of Pictures folders, you'll find your iPhoto albums listed. Click the one that contains your screen saver-bound photos. (While you're here, set up your screen saver options—for example, what interval of inactivity should pass before the screen saver kicks in.)

Want to *see* your new screen saver? If you have the patience of a Zen master, you can now sit there, motionless, staring at your Mac for the next half an hour or so—or as long as it takes for it to begin displaying your images on the screen.

Or you can just click the Test button to see the effect right now.

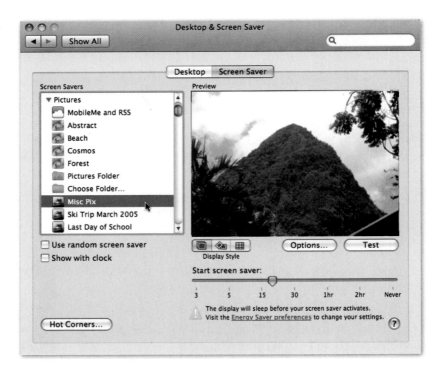

The Picasa Screen Saver

Highlight some photos, and then choose Create→Add to Screensaver. Windows opens up its Display Properties control panel; as you'll see on the Screensaver tab, "Google Photos Screensaver" is already selected. Click Preview to check out how it will look; click Settings to fool with the animation settings; and click OK when you're finished.

After that, you'll find a new album, sitting there in your Picasa folder list, called Screensaver. Feel free to move photos in or out of this album to edit your PC's new screen saver repertoire.

Photo Wallpaper

Here's a great way to drive home the point that photos of your children (or dog, or mother, or self) are the most beautiful in the world: Pick one spectacular shot, and plaster it across the entire screen as your computer's new desktop wallpaper picture. It's like refrigerator art on steroids.

Creating wallpaper like this is so easy that you could change the picture every day—and you may well want to.

Start by clicking the thumbnail of the photo you want to use as your wallpaper. Then:

- **iPhoto.** Choose Share→Set as Desktop.
- **Picasa.** Choose Create→Set as Desktop. Click Yes.

That's it; there is no step 2. Even though the iPhoto/Picasa window is probably blocking your view of it, your desktop is now filled with the picture you chose.

 iPhoto Note: If you choose *several* thumbnails or an album, iPhoto assumes that you intend to make Mac OS X rotate among your selected photos, displaying a new one every few minutes on your desktop throughout the day. To confirm its understanding, Mac OS X opens up the relevant panel of System Preferences so you can specify how often you want the photos to change.

From Slideshow to Movie

Those iPhoto and Picasa slideshows sure are great. Once you select your images and choose the music to go with them, you get a fully orchestrated production, presented live on your computer screen as a slideshow.

Which is great, as long as everyone in your social circle lives within six feet of your screen.

The day will come when you want friends and family who live a little farther away to be able to see your slideshows. The trick is to convert your well-composed slideshow into a standalone movie. You'll then have a file on your hard drive that you can email to other people, post on your Web page for downloading, burn onto a CD, and so on. When it's played on the computer or TV screen, your grateful audience will see your photos, large and luscious, accompanied by the music and effects you chose for them.

iPhoto Slideshow Movies

Start by choosing which photos to include:

- **If several thumbnails are selected,** then only they make it into the slideshow movie.

- **If no thumbnails are selected,** then the entire album's worth of photos wind up in the show.

Either way, once you're ready to convert your presentation to a QuickTime movie, choose File→Export. The Export Photos dialog box appears. Click the QuickTime tab. Here, you have to make some important decisions:

- **The movie dimensions.** The width and height for your movie also affect its file size, which may become an issue if you plan to email the movie to other people. iPhoto generally proposes 640 × 480 pixels. That's an ideal size: big enough for people to see some detail in the photo, but usually small enough to send, in compressed form, by email.

- **Seconds per photo.** How many seconds do you want each picture to remain on the screen before the next one appears? You specify this number using the "Display image for ___ seconds" box in the QuickTime Export dialog box.

- **Background color.** The color or image you choose in the Background section of the dialog box will appear as the first and last frames of the export. It will also fill in the margins of the frame when a vertically oriented or oddly proportioned picture appears.

 To specify a solid color, click the color swatch next to the Color button. The Mac OS X color picker appears. Generally speaking, white, light gray, or black makes the best background. If you click the Image button and then the Set button next to it, you can navigate your hard drive in search of a *graphics* file to use as the slideshow background.

Now click Export. Specify a name and folder location for the movie (leaving the proposed suffix *.mov* at the end of the name), and then click Save. After a moment of computing, iPhoto returns to its main screen.

Press ⌘-H to hide iPhoto; then navigate to the folder you specified and double-click the movie to play it in QuickTime Player, the movie-playing program that comes with every Mac. When the movie opens, click the Play triangle or press the space bar to enjoy your newly packaged slideshow.

Whenever playback is stopped, you can even "walk" through the slides manually by pressing the right-arrow key twice (for the next photo) or the left-arrow key once (for the previous one).

 The resulting movie file is fairly compact, perhaps even small enough for emailing. It's also fairly boring: Every picture stays on the screen for the same amount of time, and every slide uses the same transition style.

iPhoto, however, offers a more elaborate feature called a *saved* slideshow (page 157). This technique gives you ridiculously complete control over the timing and effects for every individual slide. Unfortunately, exporting this show as a movie creates a huge file—say, 50 megabytes for a 25-picture show. That's way too big for sending by email, although it's fine for playing off your hard drive or burning to a CD or DVD.

To export a *saved* slideshow, you begin by clicking its *slideshow icon* in the Source list. Choose File→Export. This time, the Export dialog box asks you to make only three decisions: what you're going to name the file, where you're going to save it on your hard drive, and what its dimensions are. Make your selections, click the Export button, and then go walk the dog. iPhoto takes some time to create the a QuickTime movie.

Picasa Slideshow Movies

Picasa's moviemaking abilities are rich and fun to use. Start by choosing the slides you want to include (page 163)—or just click a folder or album—and then choose Create→Movie. Or click the tiny, unlabeled Create Movie Presentation button just above the thumbnails.

Either way, the Movie Maker dialog box appears.

Slide tab

New blank text slide Delete this slide Play full screen

Work through the creative process like this:

- **Audio Track.** Click Load and find some non-copy-protected music file (or a folder full) to serve as your background music.

> 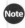 Once you've added an audio track, a new Options pop-up menu appears—and its factory setting is "Fit photos into audio." Be careful! That could mean that each picture sits on the screen for a *very* long time. "Truncate audio" might be a better choice; it means that the music will fade out when the photos finish. ("Loop photos to match audio" is the other choice.)

- **Transition Style.** Use the pop-up menu to specify an animated cross-fade effect from one slide to the next.

- **Slide Duration.** Use this slider to indicate how long each slide should hang around on the screen. Two seconds is usually plenty, no matter how much you love your family. However, remember that some of the photo's time on the screen will be sapped away by the crossfading into the next slide—depending on what percentage you dial up with the Overlap slider.

- **Dimensions.** This pop-up menu determines the frame size for the finished movie. The factory setting, 640 × 480, is a very nice size for emailing or posting on the Web. It's certainly not big enough to fill your computer screen, though. If you'll be playing it off your hard drive or a CD or DVD, feel free to choose a larger size.

Tip In fact, the 1280 × 720 and 1920 × 1080 choices create *high-definition* slideshow movies that look amazing on—and fill the screen of—a hi-def TV set.

- **Show Captions.** Do you want your captions to appear on the screen during the slideshow? If so, turn on this checkbox.

- **Full frame photo crop.** What should Picasa do about photos that aren't the same shape as the movie "frame"? Ordinarily, Picasa just shrinks them down enough to fit, even if that leaves black borders on either side (or top and bottom). If you turn on this option, though, Picasa blows up every slide to fill the frame—even if it chops off parts of the photos in the process.

As you work, you can preview the movie in progress by clicking the ▶ button, adjusting the volume slider, or even clicking the "Play full screen" button. You'll be surprised at how polished and professional the whole thing looks. (Not bad for a free program, eh?)

If you click the Slide tab, you can also go to town with slide captions. Scroll through the thumbnail browser at bottom to call up a particular slide. Then you can use these full-blown font, size, style, and color options for the caption; the text box where you can add or edit captions; and the Template pop-up menu, which lists various animated-text caption *styles.* For example, you'll find Scrolling Credits, Caption-Typewriter (the letters appear in sequence as though being typed), Center, and even I'm Feeling Lucky (Picasa chooses a text animation style *for* you).

Tip Each Picasa movie starts out with a title slide bearing the title and date of the album. But you can create additional title slides—for example, to introduce each new segment of your slideshow. To do that, click the "New text slide" button, identified in the picture on page 264. It adds a blank, black text slide right *after* whatever slide is currently showing. (Edit the text on the Slide tab.)

The third tab of this dialog box, mysteriously labeled Clips, is a weird little way for you to add *more* slides to the slideshow without having to start all over again. (You can add movie clips to your slideshow, too, which may be why this tab is called Clips. Or maybe not.)

When you click the Get More button, you return to the main thumbnail view, where you can highlight some more thumbnails, or a different album; click the Back to Movie Maker button (lower-right of the screen) to return to the Clips tab. Your new thumbnails appear here—raw material for new slides.

To add them to the movie in progress, select them and then click the big + button above the thumbnails browser. Picasa adds them to the end of the movie, but of course you can drag their thumbnails into any sequence.

Note To *remove* a slide from the movie, click it and then click the big X button next to the thumbnails browser—or just press your Delete key.

When the whole movie looks good, you have two options:

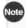

- **YouTube.** Google owns YouTube, too, remember? So it's no surprise that Picasa has a direct link to the world's largest online video site. A dialog box appears, where you're asked for a name, description, category, and tags (searchable keywords) for your video. Then you'll be prompted to log in with your YouTube account information—and off you go to fame and fortune.

- **Create Movie.** Click to begin the video-creation process, which can take quite a while. A progress bar appears in the corner of your PC screen, and the words "DRAFT—In Progress" appear on your screen.

When it's all over, the movie begins to play automatically in this screen:

This is another opportunity to send the thing to YouTube. Or, by clicking Export Clip, you can save it as a standalone, double-clickable WMV (Windows Media video format) file on your hard drive, ready to double-click, play, and send off to your contacts in Hollywood.

> **Tip** If you leave this screen before exporting the movie, all is not lost. The movie is actually hiding in your Home→Pictures→Picasa→Movies folder. You can always get at it manually.

Each slideshow movie gets stored in the Movies folder in the list at the left side of the Picasa screen (in the Projects category). That's handy, because it

means that you can always return to a movie and make changes to it without having to start from scratch.

Slideshow DVDs

Let's face it: So far in this chapter, all the cool ways to show off your prize photos—email, Web, desktop picture, and so on—involve making your audience sit, hunched and uncomfortable, around a computer screen.

Now imagine seating them instead in front of the big-screen TV in the family room, turning down the lights, cranking up the surround sound, and grabbing the DVD remote to show off the latest family photos.

You can do it. You can create DVD-based slideshows from your photo collection, complete with soundtracks and navigational menus and screens just like the DVDs you rent from Blockbuster.

- **iPhoto.** iDVD, another program that's part of the iLife suite (and that came preinstalled on your Mac), can take finished slideshows from iPhoto and burn them to DVD. For complete step-by-steps, download the free PDF appendix to this chapter, "Burning Slideshows in iDVD." It's on this book's "Missing CD" at *www.missingmanuals.com.*

- **Picasa.** By itself, Picasa can't turn photos into DVDs of the sort that play on a TV. But plenty of other programs can, including Nero, Photo Story, Roxio DVDit, and so on.

Tip There's a bonus feature in iPhoto: sharing photos with other iPhoto fans on a small network. There's a bonus in Picasa, too: making collages from batches of your photos. Both of these added goodies are described in the free downloadable Appendix to this chapter. They're waiting for you on this book's "Missing CD" at *www.missingmanuals.com.*

Appendix A:
Where to Go From Here

Your trusty digital camera and this book are all you need to *begin* enjoying the art and science of modern photography. But as your skills increase and your interests broaden, you may want to explore new techniques, add equipment, and learn from people who've become just as obsessed as you. Here's a tasty menu of resources to help you along the way.

Most of it is online. The Web is *crawling* with useful information—and because real estate is unlimited, it's perfect for displaying and annotating photos.

Camera Reviews

- **Imaging Resource** *(www.imaging-resource.com)*, **Digital Photography Review** *(www.dpreview.com)*, **Digital Camera Resource** *(www.dcre-source.com)*, and **DigitalCameraReview** *(www.digitalcamerareview.com)*. These thriving sites offers equipment reviews, price comparisons, and forums, all dedicated to putting the right digital camera in your hands.

Learning and Discussing Photography

- **Flickr.com** *(www.flickr.com)*. The ultimate community of photo enthusiasts, and an amazing place to get inspired. You're almost guaranteed to find a group that focuses on your kind of photography.

- **Photo.net** *(www.photo.net)*. A huge community of shutterbugs, with discussions about equipment, technique, and everything in between.

- **Luminous Landscape** *(www.luminous-landscape.com)*. A great resource for nature and landscape photography.

- **MediaStorm** (*www.mediastorm.org*). Powerful, inspirational multimedia journalistic presentations. Makes you feel you can save the world with photography.

- **Strobist** (*www.strobist.com*). The ultimate site for flash photography.

- **The Online Photographer** (*www.theonlinephotographer.com*). A twice-daily blog for "photodawgs" of every stripe. Funny, friendly, fascinating.

- **ShortCourses.com** (*www.shortcourses.com*) offers short courses in digital photography techniques and how to use current equipment.

- **Google** (*www.google.com*). The ultimate photography site.

 No, really. No matter what the question, the camera, or the photographic puzzler, Googling it will give you the answer in 2 seconds. Need a replacement lens cap? Search "Nikon D80 lens cap." Don't understand depth of field? "Depth of field basics." Taking your camera to Antarctica? "Camera tips cold weather." How to photograph wildlife? "How to photograph wildlife."

 And for goodness' sake, use Google to research anything you're tempted to buy. "Canon Digital Rebel XT review." "Photo blankets." "Lightweight tripods reviews." You get the idea.

 Whatever interest, lesson, or experience you have, somebody out there has been there before you—and written about it.

Online Printing

- **Shutterfly, Snapfish, and KodakGallery.com** offer cheap standard-size prints and a long list of very cool custom photo gifts—mugs, t-shirts, stickers, the works. *www.shutterfly.com, www.snapfish.com, www.kodakgallery.com*

- **Mpix.com** is a lab for photographers of all abilities, but its hallmark is high-end output: beautiful enlargements, photos on canvas, photos on foamcore board, life-size "wall clings," and so on. They also mount photos, make custom frames, and even retouch your photos.

The Real World

There are also some excellent resources that don't involve the Internet:

- ***Popular Photography.*** Great magazine. The writing is fresh. The camera tests are scientific. The how-to articles are practical. Even the ads are enlightening. *www.popphoto.com*

- **Photo workshops.** There's nothing like spending a couple of days in the field with a few other students, shooting spectacular wildlife or scenery and getting personalized, real-time feedback from an experienced professional. That's what you get when you sign up for a photo workshop. They take place in scenic places all over the world, from Montana or Florida to exotic international locations. You can find ads for these workshops in the back of photo magazines.

 Note If traveling for a couple of days is beyond your schedule/budget, don't forget that local colleges and adult-education programs usually offer photography courses, too.

Beyond the Software Freebies

iPhoto and Picasa are amazing, as far as they go. But as you get more serious and more proficient with your digital photography, you might find yourself wanting a digital shoebox/editing program with more under the hood. Here are the most likely suspects.

You'll note that they fall into two broad categories: photo organizers, like Picasa and iPhoto but far more powerful; and photo editors, which actually let you paint or draw on your photos, pixel by pixel.

Photo Organizers

These programs focus on the cycle of digital photography: taking photos off your camera, organizing them, performing light edits, printing them, and showing them to other people—but with far more power and flexibility than the freebie programs offer.

- **Adobe Lightroom.** Lightroom (about $250 online; for Mac or Windows) is organized as five modules—Library, Develop, Slideshow, Print, and Web—that cover the life cycle of your photos. Floating panels provide a huge amount of editing power. And it's all nondestructive editing, too; you can always undo any change you've made to any photos. And a tool

called the Adjustment Brush lets you paint color and exposure adjustments directly onto the parts of the photos that need help, without affecting the rest.

Of course, when you need high-end image manipulation, Lightroom effortlessly hands off photos to Photoshop.

- **Apple Aperture.** Aperture ($200), for Macintosh only, is Lightroom's blood rival. Once again, it's a high-end, professional's version of what iPhoto is, with far more power and flexibility.

The biggest draw is the design of the program itself. For example, the Inspector, a single, floating palette, lets you switch between Projects, Adjustments, and Metadata with one click. There's a high-powered image search engine and numerous ways to sort and view your images. Aperture works seamlessly with Apple's iLife software, MobileMe's Web galleries (Chapter 12), and the iPod and iPhone.

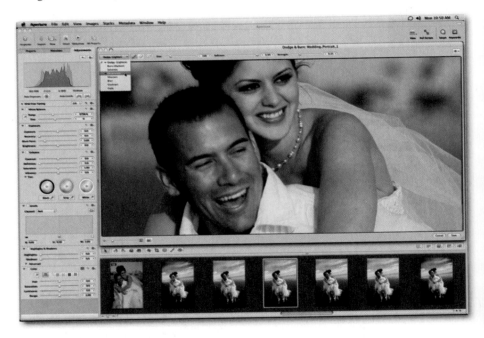

Photo Editors

iPhoto and Picasa (and Lightroom and Aperture) offer basic photo-fixing tools: exposure, color correction, redeye fixing, retouching. But what if you want to overlay text across a photo, superimpose a ghost image from another photo, or draw a mustache on Uncle Bert? In cases like those (and thousands of oth-

ers), you need to be able to edit a photo with pixel-by-pixel control. You need paintbrush and pencil tools—and you need programs like these:

- **Adobe Photoshop.** When your product's name becomes a verb, as Photoshop's has, you know you've got a hit. Adobe's Photoshop has become the industry-standard professional photo editing software. It lets you manipulate and create images in a way unmatched by any other program on any kind of computer.

 Photoshop's key advantage is its ability to edit photos on multiple layers. That is, you can stack the parts of an image on top of one another, as though they were on transparent sheets—or even stack effect layers on top of one another—one for exposure, another for color correction, and so on—and turn them on and off at will. As a result, you can do far more complicated editing than working with a flat, one-piece image.

 Photoshop also lets you edit your image pixel by pixel, actually drawing or painting; that's something iPhoto and Picasa can't do. As a result, Photoshop is so capable of changing photos that you might never trust a published photo again.

 However, the price and complexity are both legendary and staggering; the program goes for $600 online and has more than 900 menu commands. (That includes the menu commands that let you edit other menu commands.) So Photoshop is something that, in general, only serious photographers consider.

Fortunately, for the non-professional, there's a reasonable alternative; read on.

- **Abode Photoshop Elements.** If you haven't exactly been hankering for 16-bit editing, custom CMYK separations, layer comps, Web animations, non-square pixels, and HTML exports, then you probably don't need the full-blown Photoshop.

 Photoshop Elements lacks those abstruse, high-end features—and most people won't miss them a bit. As a result, Elements' learning curve isn't nearly as steep as Photoshop's.

 Yet the core Photoshop functions are still there, including the ability to edit images in layers and paint individual pixels. Elements even has photo-management tools, too, much like Picasa or iPhoto. There's also a guide that walks you through every step of Elements, making editing easier to learn.

 Another draw for Elements is the price: less than $100. That's 80 percent of Photoshop's power for a fraction of the price.

All of these programs are available in free trial versions from their companies' Web sites (*www.adobe.com* and *www.apple.com*); there's no reason not to try before you buy.

Appendix B: The Top Ten Tips of All Time

There's a lot to learn about photography. It's *endless*. Between all the books, the Web sites, the courses, the workshops, the discussion groups, and, of course, your own experience, the enlightenment just never stops.

Even this book has 300 pages of dense text and pictures. How are you supposed to keep it all in your head?

Well, here's a cheat sheet: a collection of the juiciest tricks from this entire book. Clip and save (unless it's a library book).

1. Take a lot of shots.

Once you've bought the camera, digital photography is free. You can shoot as many pictures as you want, and you'll never pay a nickel for film or developing.

So if you ask any professional the secret to great photographic results, one of the first things you'll hear is, "Shoot a lot." Yes, yes, it's true—you'll wind up deleting most of them. But shooting a lot increases the odds that, somewhere in that massive pile of pictures, there are some true gems.

In particular:

- **Portraits.** Shoot the same thing a few times in a row. The smile or the eyes might change slightly between shots—and one of them might be

the winner you'd have missed. (That's *especially* true of group shots. The more people in the shot, the greater the odds that someone's eyes are closed.)

Change the angle and keep shooting. Take a step to the right, or zoom out, or ask your subject to shift head positions. And keep shooting.

- **Scenic shots.** The sun is always moving in the sky; the light is constantly shifting. Shoot a lot. Change angle, change camera settings, change zoom power.

- **Action.** Sports and action shots have some of the lowest keepers-to-junk ratio of any type of photography. Shoot 100, keep 2.

When people see an amazing picture, they never stop to think about all the photos that *didn't* make the cut—how many attempts were slightly off. But rest assured: There were probably a lot of them.

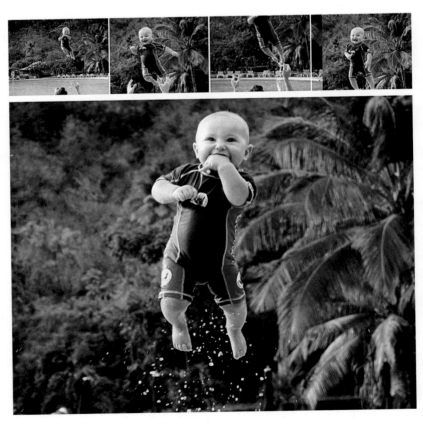

2. Half press the button to eliminate shutter lag.

True story: I was lying next to a hotel pool once, watching the kids, when the guy on the next chaise suddenly swore out loud.

He was peering at his little camera, really steamed. "This is the stupidest @$#(*&@!! camera," he said. "I've just tried three times to take a picture of my son going off the diving board, but the delay is so bad, I miss it every time."

Yep, he was a victim of shutter lag, the maddening time it takes for compact cameras to focus and calculate exposure after you've squeezed the shutter button but before the shot is captured.

"And even the half-pressing trick doesn't work, eh?" I said.

He looked at me as though I had just spoken Aramaic. "The what?"

Yes, that's right: There are still people on earth who don't know about the half-pressing trick.

Which is this: You can eliminate the shutter lag by half pressing the shutter button before the action begins. The camera prefocuses, precalculates, and locks in those settings as long as you continue to half press. Then, when the kid finally leaves the diving board, you press the rest of the way down to capture the shot. No lag.

3. Get close.

Not one amateur in 20 thinks about this one when composing a shot: *Get close.* Fill the frame. In most photos, a subject that bursts the borders of the photo has greater impact than a subject surrounded by a lot of background (see page 34).

Of course, you can always crop away the background later, on the computer (Chapter 10). That works, too. But it's better to get up close the first time.

 Tip Or, if you're worried about losing that sense of place, do the smart thing: Take *two* shots. One that's zoomed in close, one that's got some background.

4. Don't buy into the megapixel myth.

More megapixels do not give you better pictures. Period.

Megapixels measure the maximum size of each photo. For example, a 10-megapixel camera captures pictures made up of 10 million tiny dots. Trouble is, camera companies hawk megapixel ratings as though they are a measure of photo quality.

In fact, the number of megapixels is a measure of *size*, not quality. There are terrible 14-megapixel photos, just as there are spectacular 3-megapixel shots. (Sensor size is a much better predictor of photo quality; see page 29.)

Meanwhile, more megapixels means you have to buy a bigger memory card to hold them. And you have to do a lot more waiting: between shots, during the transfer to your computer, and opening and editing.

 Tip Photos intended for display on the screen—the Web, email, slideshows—don't need many pixels at all. Even a 2-megapixel photo is probably too big to fit your computer screen without zooming out. High megapixel counts are primarily related to *printing*, which requires much higher dot density.

5. To get the blurred-background effect, back up and zoom in.

If you have a digital SLR—one of the big, black, removable-lens cameras—then your portraits automatically have that delicious soft-focus-background look.

But compact cameras tend to keep everything in focus, near and far.

You can boost your odds of getting that blurry background, however, by using these three steps:

- **Choose the Portrait mode on your camera.** If your camera has an aperture-priority mode (most pocket cameras don't), you can create the effect even more efficiently by choosing a large *aperture,* like f2. But most pocket cameras don't have aperture-priority mode.

- **Move the subject away from the background.** If the background—like a wall or a forest—is too close, it's hard to get it blurry.

- **Move farther away, and then zoom back in.** It sounds nutty, but it really works. Zooming in magnifies the blur effect, so if *you* back away from the subject and then use the zoom to reframe the shot, you'll increase your chances.

6. Turn off the flash whenever you can.

Unfortunately, the typical compact camera tries to use its flash *way* too often. "If in doubt, flash," seems to be its motto.

But flash photography is usually harsh, bright, and unsubtle. The flash makes your subjects look bleached-out and nuclear, and simultaneously creates the "cave effect" behind them (the room turns pitch dark).

You can get much more beautiful, realistic, nuanced photos by *turning of the flash.* On a pocket camera, you generally press the lightning-bolt button and then scroll to Flash Off.

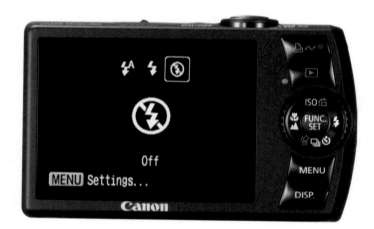

The problem now is that you'll get blur if the camera isn't perfectly steady. So hold your breath and keep your elbows tight against your rib cage. Better yet, prop your arms or the camera on a table, door frame, tree, car roof, fence post, whatever's nearby and not moving. Boost the ISO, too (page 82).

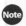

7. Turn on the flash for sunny outdoor portraits.

It might not occur to you to use the flash when you're taking pictures of people on a bright, sunny day. It *certainly* doesn't occur to the camera.

Problem is, the camera "reads" the scene and concludes that there's tons of sunlight. But it's not smart enough to recognize that the face you're photographing is in shadow. You wind up with a dark, silhouetted face.

The solution is to *force* the flash on—a common photographer's trick. The flash can provide just enough fill light to brighten your subject's face. It eliminates the silhouette effect. Better yet, it provides very flattering front light. It softens smile lines and wrinkles, and puts a nice twinkle in the subject's eyes.

8. No tripod? Improvise.

Another chronic problem with pocket cams is getting blur when you don't want it—which is just about anytime you're indoors without the flash.

Yeah, yeah, we know: "Use a tripod." But come on: For the average person on vacation or at a school event, buying, hauling around, and setting up a tripod is a preposterous burden.

So look around for something solid. Often, there's a wall, parked car, bureau, tree, pillar, door frame, or some other big, stationary object you can use to prop up either the camera or your arms.

But here's the best part: It turns out that the threads at the top of just about any lamp—the place where the lampshade screws on—are precisely the same diameter as a tripod mount! In a pinch, you can whip off the lampshade, screw on the camera (just a couple of turns—don't force it), and presto: You've got a rock-steady indoor tripod.

It looks nutty, but it works.

 And don't forget about the string-tripod trick on page 81.

9. Use the self-timer when sharpness counts.

Most people think of the self-timer as a feature for group photos. But using the self-timer has another huge advantage: It lets you fire the shutter *without touching the camera*. In low light, at slow shutter speeds, even the act of pushing the shutter button is enough to jiggle the camera—and that guarantees you'll get a blurry shot.

10. Exploit the magic hour.

The hour after sunrise, and the hour before sunset, are the *magic hour* or the *golden hour*. You get what photographers call "sweet light"—a golden glow that makes everybody and everything look peaceful and beautiful, with no harsh shadows or severe highlights. Very sweet indeed.

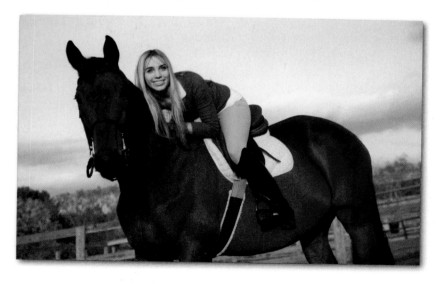

Appendix C: Photo Credits

David Pogue took most of the photos in this book.

This list credits the others. They include contributions from this book's photo editor, Tim Geaney, as well as the treasure trove known as *iStockPhoto.com*.

iStockPhoto is a a massive, instantly searchable catalog of millions of beautiful photos. When people need photos for their newsletters, ads, brochures, Web sites, magazines, newspaper layouts, books on digital photography, and so on, they can download and use these images, royalty-free. A typical high-res photo might cost $3 or $5, which is a fraction of what you'd pay to a commercial stock company.

(And where do these millions of pictures come from? That's the best part: you. Anyone, professional or amateur, can upload photos to iStockPhoto.com's catalog and start making money from them while they sleep. There is an application and screening process, however.)

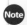 **Note** Camera-equipment photos were provided by the camera companies.

Chapter 1
Cameraphone (page 13): John Sommer, iStockPhoto.com

Chapter 3
Girl on horseback (page 34): Tim Geaney
Mountain reflection (page 37): Paul Tessier, iStockPhoto.com
School buses (page 38): Justin Horrocks, iStockPhoto.com

Chapter 4
Redeye (page 50): public domain, photographer unknown, from the Wikipedia article "red-eye effect"
Santa-hat girl (page 53): Tim Geaney
Fireworks (page 56): Jeremy Edwards, iStockPhoto.com
City panorama (page 56): Chris Pritchard, iStockPhoto.com
White-balance snowy yard (page 59): Tim Geaney

Chapter 5
Barrel (page 72): Goce Risteski, iStockPhoto.com
Aperture (page 73): Geoffrey Holman, iStockPhoto.com
Sweaty soccer player (page 75): Daniel Hurst, iStockPhoto.com
Tripod (page 79): Jean Schweitzer, iStockPhoto.com
Monopod photographer (page 80): Gary Martin, iStockPhoto.com
Photographer leaning on tree (page 80): Mitja Mladkovic, iStockPhoto.com
String tripod (page 81): Tim Geaney

Chapter 6
Panorama, girl and pond (page 90): William Fawcett, iStockPhoto.com
Fireworks (page 95): Suebsak Chieocharnyont, iStockPhoto.com
Lightning (page 96): Martin Fischer, iStockPhoto.com
Star trails (page 97): Jeff Strauss, iStockPhoto.com
Ballerina onstage (page 103): José Carlos Pires Pereira, iStockPhoto.com
Stagehand on set (page 103): Slobo Mitic, iStockPhoto.com
School of fish (page 104): Tammy Peluso, iStockPhoto.com
Teenage girls taking pictures (page 114): Justin Horrocks, iStockPhoto.com
Blond cherubic children (page 116): Tim Geaney
Three little girls on porch (page 118): Tim Geaney

Chapter 7
Neutral-density filter (page 137): Ben FrantzDale
Hot-air balloon festival shots: Lesa Snider King

Chapter 8
Camera on computer (page 141): Mladen Mladenov, iStockPhoto.com

Appendix B
Horseback rider at sunset (page 281): Tim Geaney

Index